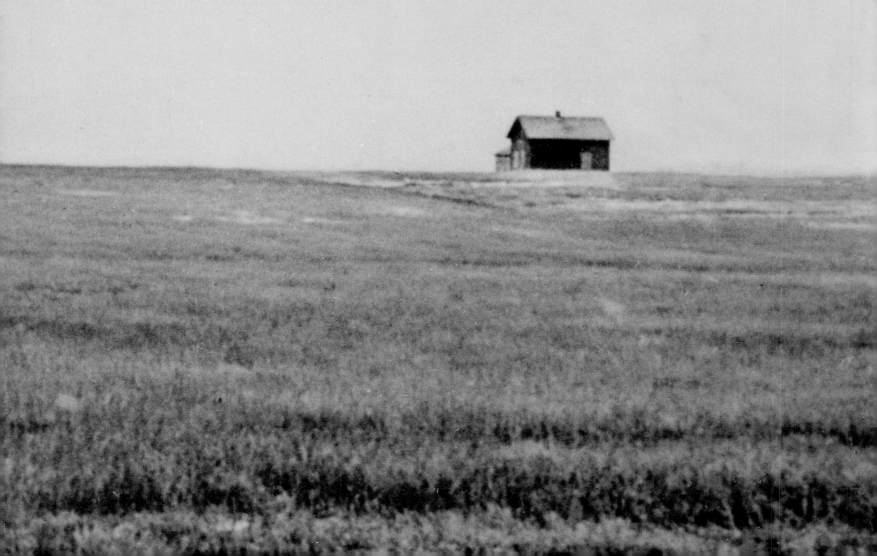

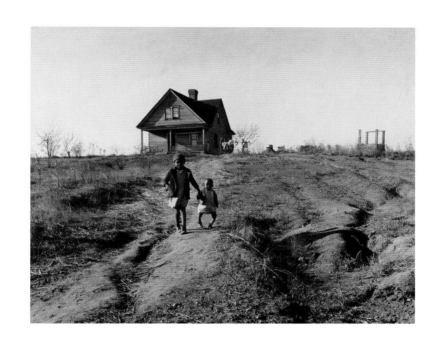

THE BITTER YEARS

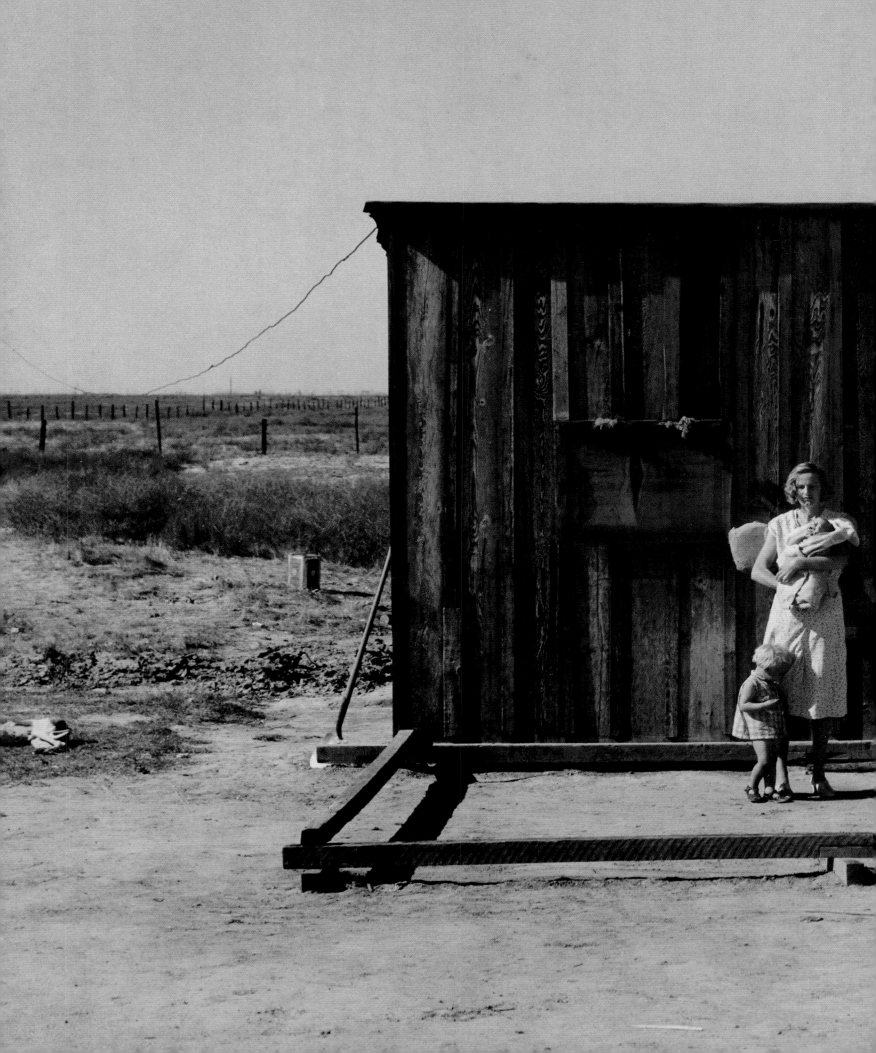

THE BITTER YEARS

EDWARD STEICHEN
AND THE FARM SECURITY ADMINISTRATION PHOTOGRAPHS

Edited by Françoise Poos

d·a·p

Front endpaper **John Vachon**
Dewey County, South Dakota. February, 1942.

Back endpaper **Dorothea Lange**
Home of a FSA borrower. Priest River Peninsula,
Bonner County, Idaho. October, 1939.

p. 1 **Marion Post Wolcott**
Negro children and an old home on badly
eroded land near Wadesboro, North Carolina.
December, 1938.

pp. 2–3 **Dorothea Lange**
Home of rural rehabilitation client, Tulare
County, California. November, 1938.

Published and distributed in North America by
arrangement with Thames & Hudson Ltd, London

D.A.P./Distributed Art Publishers, Inc.
155 6th Avenue, 2nd Floor
New York, NY 10013
artbook.com

LE GOUVERNEMENT
DU GRAND-DUCHÉ DE LUXEMBOURG
Ministère de la Culture

Designed by Sarah Praill
Essays by Gabriel Bauret and Ariane Pollet translated
from the French by Ruth Sharman

Library of Congress Cataloging-in-Publication Data
A catalog record for this book is available
ISBN 978-1-935202-86-8

Printed and bound in China by
C & C Offset Printing Co. Ltd

Note to the reader

The plates in this book correspond to the photographs
selected by Edward Steichen from the archives of the
Farm Security Administration (FSA) for his exhibition
"The Bitter Years 1935–1941," that was initially held at the
Museum of Modern Art in New York in 1962. It seemed
important to us not only to reveal a succession of images,
but also to reproduce the material dimension of the
original photographic panels conserved by the Centre
National de l'Audiovisuel in Dudelange, Luxembourg.
In 1962, the prints were mounted directly on solid wood
fiberboard so they could endure the strains and hazards
to which a traveling photography collection was exposed
during a long itinerary, first through the United States,
then through Europe. The panels were preserved, but
time has left its marks – often visible to the naked eye
– and they are now part of the history of the exhibition
objects. These traces are apparent on some of the plates
in this book.

The exhibition at MoMA was divided into themed
sections and we have followed these as much as possible
from the information available. In addition, display texts
played an important part in Steichen's concept of the
exhibition. A quote from Franklin D. Roosevelt's inaugural
speech from 1937 set the tone, and citations from Carl
Sandburg's epic prose poem *The People, Yes* (1936)
emphasized the heroic vision of the American people.
The men, women, and children themselves seemed
to address the visitor directly through reflections and
exclamations taken from interviews that were conducted
by the FSA photographers during their photographic
missions. In the book, the texts appear in bold type
among the group of plates they were associated with
in Steichen's original exhibition.

The original FSA photographs were accompanied
by captions comprising not only the name of the
photographer, information about the location and
the date, but also notes from the photographers about
their subjects. These captions were not part of the
exhibition, but they were carefully noted on the backs
of the panels, together with the call numbers of the
original photographs held in the Library of Congress.
For the sake of completeness, we have decided to
publish the captions, retaining the original wording
but with small changes for readability and corrections
to errors in the place names and dates. The Library of
Congress call numbers are listed in the picture credits.

State Street is the proud sponsor of
"The Bitter Years" exhibition.

CONTENTS

VANTAGE POINT: "THE BITTER YEARS" RECONSIDERED

Jean Back

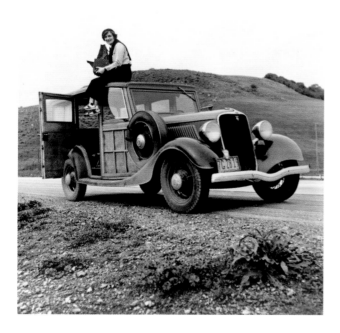

Dorothea Lange on a photographic trip in California in 1936. She contributed 84 images out of 208 to "The Bitter Years" exhibition.

The 1962 exhibition

"The Bitter Years 1935–1941" was the last exhibition that Edward Steichen presented as Director Emeritus in 1962 at the photography department of the Museum of Modern Art in New York. He selected 208 images by 12 photographers from the archives of the Farm Security Administration (FSA), the famous documentary project that began thirty years earlier as part of the New Deal implemented by President Franklin D. Roosevelt. The title that Steichen chose is evocative: the term "Bitter Years" places the emphasis on the human drama of the Great Depression, featuring the most poignant photographs of an agricultural population hit by an economic breakdown and an environmental disaster.

Among the images chosen for "The Bitter Years," works by Dorothea Lange, who was a close friend of Steichen, greatly outnumber those of the remaining eleven photographers. Steichen had always valued Lange's commitment to migrant communities and the work that she had conducted with her husband, Paul S. Taylor, prior to the FSA project. She is represented by a total of eighty-four images. Russell Lee is featured with twenty-two photographs and Arthur Rothstein with twenty. Jack Delano totals seventeen and Walker Evans sixteen images, whereas the exhibition features just two photographs by Paul Carter and only one by Theodor Jung. This focus on the work of specific photographers is certainly a reflection of Steichen's preference for the genre of the portrait and the fascinating expression that faces or body postures can convey. On the other hand, the selection was guided by the exhibition's main theme: the tragedy of human life, the extreme poverty, the strain of rural labor shown in moving and heroic images of men, women, and children. Landscapes, small towns, or villages are almost absent, though they abound in the original FSA archives.

Steichen's choice of images was resolutely personal, as was his (editorial) method of conveying his convictions. "To him, the best way to communicate his message to a broad public was to arrange other people's photographs in a skilful way in order to place them in a dramatic context," commented his wife, Joanna Steichen. What is remarkable was his manner of establishing new dialogues between photographs, organizing them in visual, thematic units, and combining form and content to create a continuous visual flow. This talent was best expressed in Steichen's "The Family of Man" exhibition (1955) and it remains a fascinating field of study and learning. "The Bitter Years" is equally revealing about Steichen's powerful role as a curator who did not mind cropping or reframing the works of other artists if it fitted his vision. It is also a reminder of Steichen's interest in documentary photography, and finally it is a testimony to his own patriotism. We know that Steichen felt a lifelong admiration and gratitude toward the United States, where his family had emigrated from Luxembourg in 1880.

At MoMA, the exhibition was arranged across thirty walls, comprising fifteen themed sections: *Drought and Erosion, Disaster, Cotton, Sharecroppers, Tractored Out,* *Eviction, On the Road, Field Workers, Tents, Old Age, Houses, Jobless, Schools, Couples,* and *Heroic Women,* according to Steichen's detailed preparatory list. The works were punctuated by carefully arranged texts, with Roosevelt's quote from his 1937 inaugural speech setting the general tone: "I see one third of the nation ill-housed, ill-clad, ill-nourished." Citations from Carl Sandburg's epic prose poem *The People, Yes* (1936) emphasized the monumental view of the American people together with comments and quotes from the photographed subjects. Introductory notes by Edward Steichen, Rexford G. Tugwell, the head of the FSA, and Grace M. Mayer, Steichen's assistant, focused mainly on the FSA documenting mission. The last thematic ensemble showed a series of "Heroic Women," a recurring subject in Steichen's curatorial work. It ended with a large image of a luminous white cloud and a wide view of the land, serving as broadening perspectives for the future but also reinforcing the power and the emotional impact of the exhibition's display. Both images were missing from the traveling collection.

The exhibition opened on October 15, 1962, and was followed on October 25 by a symposium on the FSA photography project, with MoMA Director René d'Harnoncourt as moderator and speakers including

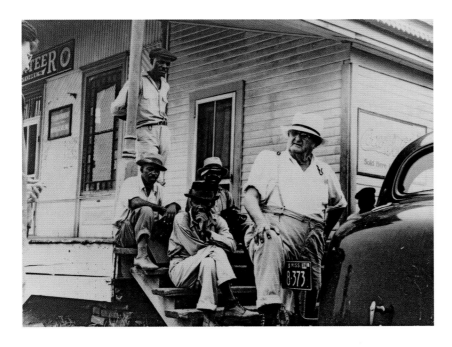

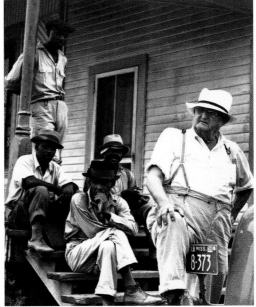

Dorothea Lange, *Plantation owner, Mississippi Delta, near Clarksdale, Mississippi*, June, 1936. In his cropped version, Steichen stressed the dichotomy between the (rich) land owner and the (poor) land workers.

Arthur Rothstein, Ben Shahn, and Roy E. Stryker. Documentary films from the Depression era were shown at the museum on November 8 and 15: *The Home Place* (Raymond Evans, 1941), *The River* (Pare Lorentz, 1937), *The Plow that Broke the Plains* (Pare Lorentz, 1936), *Power and the Land* (Joris Ivens, 1940), and *The Land* (Robert Flaherty, 1940).

Today, "The Bitter Years" remains compelling, through the tragedy contained in each of the images, and through the art of Edward Steichen, who knew how to communicate his own humanity toward his fellow Americans on the brink of the abyss by highlighting their extraordinary courage, strength, and heroism. However, the selected works also remind us of the art and passion of their authors, and of the authenticity of their gaze. Their testimonies are historic milestones for all documentary photography.

Steichen and Luxembourg

Edward J. Steichen was born in Bivange, Luxembourg, on March 27, 1879. His family left the country eighteen months later for economic reasons. Steichen kept his family ties with the Grand Duchy and, throughout his life, considered himself a *Lëtzebuerger Jong*. However, he experienced a period of tension and estrangement from his native country: in 1952, Steichen had been refused the opening of "The Family of Man" world tour in Luxembourg for reasons of space, timing, or the finances. But reconciliation followed the dispute; at the end of their itineraries, "The Family of Man" and "The Bitter Years" exhibitions were both donated by the Museum of Modern Art to the Luxembourg government, in 1964 and 1967 respectively, at the special request of Edward Steichen.

The fame of "The Family of Man" as well as its international scope, but also the fact that it was a donation from the United States, drew a lot of attention in Luxembourg. The collection was presented a number of times in various locations throughout the Grand Duchy by the State Museum (today the Musée National d'Histoire et d'Art). Steichen's personal visit in 1966 together with his young wife, Joanna, consolidated the bonds of friendship. Despite the earlier prickly episode, the relations between the celebrated artist and his country of birth ended on a note of generosity and sympathy.

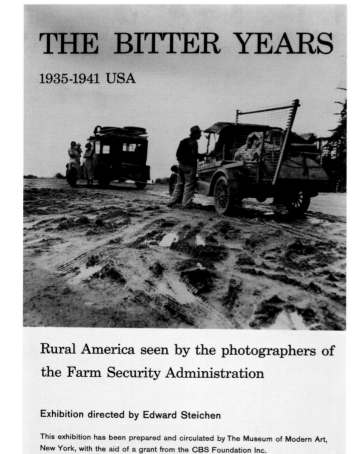

The poster for "The Bitter Years" exhibition, 1962. Refugees on the road were a core theme in Edward Steichen's selection from the FSA archive.

First efforts to give the collections validity

Despite the success of "The Family of Man" in the late 1960s, the interest of the Luxembourg public in photography and its artistic, documentary, or historical attributes remained modest. It was only during the mid-1980s that the Ministry of Culture, among other bodies, made the first efforts to explore in depth the means of audiovisual expression, including of course photography.

The Centre National de l'Audiovisuel (CNA) was created in 1989, its main missions being to conserve and honor the national audiovisual heritage. The institute is actively collecting and archiving film, photography, and sound documents from around the country to preserve them from disappearing from our collective memory. Today, the photography collection comprises over two hundred thousand documents of various origin and testifies to the photographic art of the past as well as to the richness of contemporary image creation in Luxembourg. The two Steichen collections from the Museum of Modern Art are considered part of the national heritage.

"The Family of Man" was the first large project through which the newly created CNA put its concept of celebrating photography into practice. Its permanent installation in a new museum space in the castle of Clervaux, in the north of the country, completed the rebirth of this important collection. "The Family of Man" has been on display since 1994, and in 2003 it was included in UNESCO's Memory of the World Register.

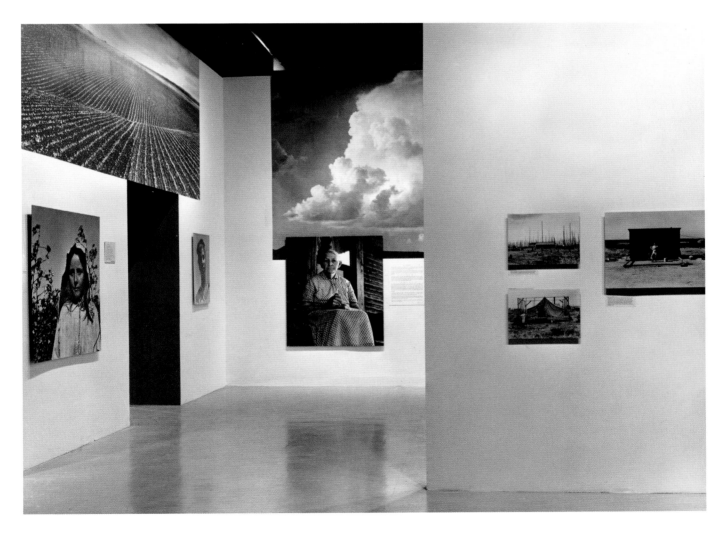

An exhibition shot of Edward Steichen's original display of "The Bitter Years" at MoMA shows the final section, a series of "Heroic Women" accompanied by views of the land and of the sky.

"The Bitter Years" collection was restored in 1993 and was exhibited in Luxembourg in 1995 and Tokyo in 1996. More conservation work followed in 2010 in preparation for its inauguration in 2012 in a newly created exhibition space.

The architecture of industry and the archeology of photography

The 1980s were an era of cultural renewal in Luxembourg. It was during this time that the idea was conceived to install "The Bitter Years" in a disused industrial building in the south of the country: the Château d'Eau, the water tower of a closed-down steel mill in Dudelange. The choice may seem surprising. It was the result of a happy combination of circumstances: the demolition of the tower would apparently have been too expensive for its owners, the steel company ARBED, today ArcelorMittal. At the same time there was a political will emerging from the municipal authorities to keep this vestige as a symbol of a past era that had helped to make Dudelange one of the most important centers of the steel industry in Luxembourg. Concurrently, the concern of the Service des Sites et Monuments Nationaux to find a future use for the water tower after its renovation met the wish of the CNA to exhibit the historical collection near its new headquarters.

The project was challenging. From a conceptual point of view we needed to develop an archeological approach to Steichen's work as a curator for photography at the Museum of Modern Art. We wanted to preserve the original thematic groupings as much as possible and present them as such to the public. Simultaneously, it seemed important not to lose sight of the sources of the collection, the vast FSA archives.

From an architectural point of view, we were confined to the particularities of the water tower, the intimate circular spaces on the ground floor and in the cistern that were to contain the famous procession of images. A new dialogue encompassing the site and its content had to be established. Furthermore, conservation requirements for the recently restored documents needed to be respected. In order to make the original photographic panels accessible to the public for many years to come, exhibition conditions correspond to the highest international standards of safeguard and climate control.

A waltz between heaven and earth

With the help of Claudine Kaell and her team of architects, we could imagine a tour of the premises that would combine the new museum space and its industrial past, a promenade between fiction and reality, history and present-day life, between heaven and earth. The adjacent pumping station was integrated into the project. This functional annex to the water tower is a well-proportioned red-brick building, and it surprises visitors by its sense of an alluring industrial and architectural heritage. It has been renovated minimally so that its history remains apparent. Renamed *pomhouse*, the former pumping station has become the visitor center for "The Bitter Years," but it also hosts contemporary photographic exhibitions.

Owing to the limited space, the tower can contain only half of the images from the historic collection. Regular alternate hangings, however, will make Steichen's whole selection accessible to the public over time. This "rotation" will ultimately be beneficial for the whole exhibition site. Not only will it help those who wish to explore the different themes of "The Bitter Years" more closely, but it will also stimulate a dialogue between the gripping photographs from the FSA archives and contemporary image creation featured at the *pomhouse*. One of the first examples was Stephen Gill's poetic work, commissioned from the English artist by the CNA specifically for the inauguration of the new photography spaces.

Should visitors wish to do so, they can explore "The Bitter Years" museum at their leisure, guided by inspiring information programs. They can explore the exhibitions of contemporary photography at the adjacent *pomhouse*, extend their stroll to the nearby CNA with its Display 01 and Display 02 galleries, or consult books and DVDs in the media center. And why not finish their stay with a movie at the Starlight cinema? Whatever their choice, visitors will experience at the site an immediate and moving sense of contact with both its past and present, with the reality of a city and a region that spares no effort to construct a new identity after the steel industry's years of crisis. "Our" bitter years have left us with an industrial wasteland like an open wound, which only art and culture will eventually be able to heal and fill with both hope and meaning.

OF POWER AND POLITICS: STEICHEN AT MOMA

Ariane Pollet

"Exhibitions were always asking, 'What is art?' But art had already taken the lead by asking, 'What is an exhibition?'"

Tobia Bezzola[1]

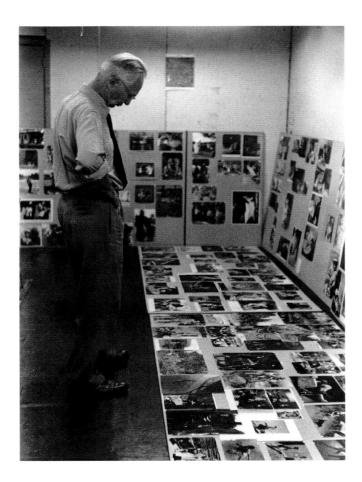

Edward Steichen working on "The Family of Man" exhibition, 1955. Photograph by Homer Page.

In the autumn of 1962, Edward Steichen was no longer head of the photography department at New York's Museum of Modern Art, having recently been replaced by John Szarkowski.[2] "The Bitter Years 1935–1941" was Steichen's final exhibition, which he curated as a visiting director, and it brought together over two hundred photographs from the archive belonging to the Farm Security Administration (FSA).[3] It was the finale to a series of forty-four exhibitions curated by Steichen during his fifteen-year tenure, from 1947 to 1962.[4] The exhibition was not a resounding success with the public (although the sales of the 36-page book were healthy). Nonetheless, the museum's director, René d'Harnoncourt, congratulated Steichen in the warmest terms: "Yours is the magic gift of the great orchestra leaders who bring to life the creative potential in composer and performer."[5] This comparison gives some idea of the high regard in which Steichen was held at the end of his career and is a useful insight into his working methods. The metaphor of the "orchestra leaders" points up an important aspect of his role as a director: his task was to collaborate with guest artists, to marshal and to unify, but Steichen interpreted this very much in his own way, refusing to curate solo exhibitions and opting instead for themed group exhibitions.

All of his shows, with one exception, revolved around technical, esthetic, or historical themes (color, abstraction, Pictorialism) and involved multiple contributors, the smallest show being a three-man exhibition and the largest being "The Family of Man," featuring 273 contributors. The one exception was the exhibition entitled "Steichen the Photographer," which Grace M. Mayer (curator and assistant) curated in 1961 at a time when Steichen himself was already ill and frequently absent from the museum. The idea was simply to pay homage to Steichen's career and, in view of the circumstances, to avoid any kind of controversial

debate. However, this unique retrospective raised a series of questions concerning the director's status, his power, and his role in relation both to history and to his contemporaries.

MoMA was the first museum of fine art to welcome photography as an artistic practice in its own right, and there were as yet no fixed rules regarding how the medium should adapt to a museum setting. The museum had been exhibiting photographs since its earliest days – "Murals by American Painters and Photographers" in 1932 was the first such show – but the scarcity of photography galleries and the lack of a market for prints meant that MoMA had no real backup in the outside world. Sole responsibility for bringing recognition to the medium lay with its directors, and this lack of emulation in the establishment of criteria gave them a kind of absolute power.

The reflection of a career

By the time Steichen took up his post as director of photography at MoMA, he was already a hugely successful photographer in his own right, the highest paid of his generation. Steichen was involved in the Pictorialist movement at the turn of the century; he was a painter, an art-gallery curator, and later a portrait photographer, and he worked as a fashion photographer for Condé Nast from the early 1920s and as a photojournalist during World War II. During the course of his full and varied career, he succeeded in combining wholly different ways of working – both as an independent artist and in response to commissions. He had a foot in two different worlds – art and commerce – but was equally comfortable in both, thereby sweeping aside the taboo surrounding artistic creation as a money-making affair. And despite his critics, he approached his curatorial role in the same spirit. From the moment he took up his post – and despite the fact that he had stopped working as a photographer so as to avoid any potential conflict of interest[6] – he envisaged his role as strictly in line with his experience and began exploring every possible avenue of photographic practice. Put another way, he was equally interested in images as art and in images as a means of communication, and he was keen to give them equal weight or even to favour amateur or press photographs over more "esthetic" approaches.

One of the early pioneers campaigning for recognition of photography's artistic status, Steichen was very much a part of the secessionist and modernist milieu of Alfred Stieglitz's Little Galleries (better known as 291) in the early years of the twentieth century – before his dramatic change of course. The gallery held exhibitions of avant-garde European artists such as Picasso, Matisse, and Rodin along with some of the best Pictorialist photography (work by Strand and Demachy, for example), and Steichen could immerse himself here in contemporary esthetic theories and test the impact of his work in a boldly experimental setting[7] – only subsequently to move on to the commercial worlds of fashion and advertising.[8] Between the years 1920 and 1940, his involvement with high-profile publications and with MoMA led him to experiment with the illustrative qualities of the image and to familiarize himself with questions of layout and the effective use of space. As director of photography for *Vogue* and *Vanity Fair*, and later artistic director for *U.S. Camera Annual*, Steichen became immersed in the rapidly expanding world of the mass media. He discovered the potential of the illustrated page – passively through his role as a fashion photographer answerable to a magazine editor, and then in a more hands-on way as art director. And as a curator, he came to see that setting up a photographic exhibition was not unlike the process of film montage.

In 1942, while Steichen was serving as a naval commander in charge of coordinating a team of photojournalists, MoMA invited him to curate the exhibition "Road to Victory"[9] on the theme of war. He collaborated on the project with the Austrian artist Herbert Bayer – an encounter that was to prove decisive for Steichen. Bayer's "scenographic" approach was inspired by Bauhaus experiments and his experience of organizing commercial exhibitions in Germany prior to 1938. He saw the exhibition as "an apex of all media and powers of communication":[10] it was like cinema, giving form to ideas as the sequences of images unfurled in front of the viewer. The photographs were affixed directly to the wall, without frames, at varying heights and angles, or in some cases hanging freely, and supplemented by written texts that punctuated or underlined the message contained in the images. Although in itself static, the installation was conceived as a "procession" that invited the viewer to step into the

composition and walk around inside it, as the subtitle indicates: "A Procession of Photographs of the Nation at War." The act of wandering around the exhibition was what drove the mechanism: without the physical participation of the spectator, it would have been a frozen landscape, nothing more. Thanks to its subject matter and the dynamic nature of the installation, "Road to Victory" was a resounding success with the public, and Steichen was invited back to curate another exhibition, "Power in the Pacific," which followed three years later. Bayer and Steichen did not work together again, but Steichen had been deeply impressed by Bayer's scenographic ideas, and he went on to produce a number of similar large-scale installations designed to encompass the visitor in a narrative universe.

"Road to Victory" helped to define a new kind of photographic vocabulary, which corresponded to other developments symptomatic of what was occurring on the global stage. The 1940s were a period of change for MoMA, which was becoming more populist in its policies in an attempt to attract more visitors and so absorb the deficit resulting from the economic crisis. The museum was familiar with the latest developments in publicity materials[11] and now welcomed mass-media methods as a way of heightening public awareness of America's need to enter the war. The museum's administration, which had been fully committed to the idea of American intervention since the outbreak of hostilities, now rapidly organized a series of didactic exhibitions that were intended to be part of a fully fledged political campaign.

Two years before "Road to Victory," in December 1940, "War Comes to the People"[12] opened this series of photographic exhibitions and was followed a few days later by the official opening of the photography department with a private view of "Sixty Photographs: A Survey of Camera Esthetics." Curated by Beaumont Newhall (director of the photography department until 1943) and the photographer Ansel Adams, "Sixty Photographs" offered a radically different approach from the war cycle. Its purpose was clearly formulated in the title: to present the "esthetic" value of the image, or in other words its most creative and artistic aspects.[13] Separated by only a few days, these two events embodied the two key concerns that characterized the museum definition of photography – separately rather

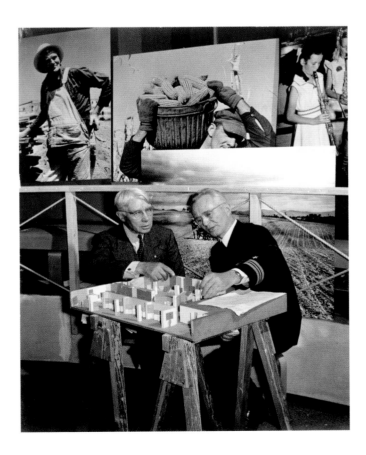

Edward Steichen (in Navy uniform) and Carl Sandburg working on the exhibition model for "Road to Victory," c. 1942.

than simultaneously, it was a documentary technique on the one hand and an art form on the other. Since photography had found a niche for itself in the museum, the epithet "creative" had come to be applied to its expressive and artistic function, as distinct from its documentary aspect. During his time at MoMA, Steichen tried to relax these rigid definitions so as to present the medium in all its complexity. The press image seemed to be the ideal means of opening up the frontiers.

What kind of photography for what kind of museum?

MoMA's first two photography exhibitions – "Murals by American Painters and Photographers" in 1932 and "Photography 1839–1937" in 1937 – demonstrated the artistic and technical applications of the medium. The definition of its museum role, however, soon crystallized around a rigid set of esthetic rules that emerged out of the predominantly black-and-white work of a handful of leading practitioners – "Walker Evans: American Photographs," 1938, "Seven American Photographers," 1939 (Berenice Abbott, Ansel Adams, Harold Edgerton, Walker Evans, Man Ray, Ralph Steiner, and Brett Weston),[14] and "Charles Sheeler," 1939. Based on art-historical criteria, this definition drew on traditional notions of form, era, and style. A handful of connoisseurs were responsible for establishing these photographic norms: Alfred Barr, the museum's director; David McAlpin, collector and trustee of the museum; the collector Lincoln Kirstein; the photographer Ansel Adams; and Nancy and Beaumont Newhall, the curators in the photography department.

These were the people responsible for founding MoMA's photography department, but they were not the only champions of photography. There were others whose commitment was no less active, but whose aims were the reverse of academic: Nelson Rockefeller, president of the museum's board of trustees; the trustee Henri Allan Moe; Willard Morgan, director of the Photography Center; Thomas Maloney, editor and publisher of *U.S. Camera Annual*; and Edward Steichen. They were not collectors but "imagemakers" following a career in the illustrated press, in politics, or in finance, whose shared purpose was to make photography an accessible medium and to short-circuit the fine-art tradition, which they regarded as elitist.

The declaration of war actually furthered their cause. The majority of these powerful promoters supported the museum's political commitment, and it was thanks to them that the department organized no fewer than eight patriotic exhibitions between 1940 and 1945,[15] thereby serving as a powerful organ of national propaganda. It was a case of respect for the established ideology that was absolute and unquestioning, "a form of political awareness before its time":[16] the Army and the Navy were partners with whom such promoters could collaborate in a spirit of mutual trust. As it so happened, Steichen was a naval commander at the time and Nelson Rockefeller was Coordinator of Inter-American Affairs (CIAA) from 1940 to 1944.

Although these individuals were united in their crusading ambitions, their aims diverged. For some, the purpose of the populist agenda was to increase the number of visitors to MoMA; others were interested, not in revenue, but in the question of educational potential. The common focus on the museum's visitors, however, signified a radical change in its organization. Formerly a receptacle for cultural treasures destined to be viewed by a tiny minority of the population, MoMA now aspired to become a bright star in the capitalist economy and in mass culture, a concept that became the focus of an intense debate regarding the purpose of exhibitions and the role of the museum.

The challenge was no longer to regard photography as a precious entity, a link in the chain of "high culture," but to stress its popularist nature, its accessibility, and its potential as a communication tool. Steichen was firmly convinced that an art gallery should be a socially diverse environment, a place open to everybody: "Works of art might only be understood at the time by a handful of people as well as such forms of modern art that had large audiences,"[17] he said. His first exhibitions, "Road to Victory" and "Power in the Pacific," proved his point. As far as he was concerned, photography was art: that debate was over. What was needed now was to promote its diversity and exploit its potential for creating social cohesion.

Clearly, such a perspective was bound to influence selection, and once Steichen took up his position at the head of the department, he concentrated his efforts on acquiring works from genres such as photojournalism and colour and amateur photography, flouting the

rules of what was "artistic" or conventionally acceptable and challenging the sociocultural determinism that predefined the purpose and use of images. Press and amateur photographs had previously been destined for the pages of newspapers or family albums: their appearance on the walls of a gallery was the result of profound changes that were only possible due to the flexibility of the medium. Such changes provoked as much fertile interaction as stormy debate, as we may gather from the following remarks: "A great deal has been said in recent years about bringing the museum to the people and the people to the museum. Paragraphs have been written about snobbism of scholarship, about the need for popularization of museums, of making them available and necessary to the mass. There should be no contradiction in such a program."[18] The "contradiction" would not go away, however: it became a source of conflict that would divide the members of MoMA's photography department for a decade, from 1940 to 1950, and it continues to fuel arguments to this day.

At the crossroads of power and influence

The political backdrop (both national and international) to this esthetic controversy only served to heighten the tension. To understand how its exhibitions were curated, we need to look at how MoMA itself was structured and to recognize that its trustees had a much greater say in terms of policy and the running of day-to-day affairs than was the case with most other private American museums. Headed by the Rockefeller family, the board of trustees was made up of people with money and influence in politics and the media, most of them collectors, who received expert advice from a handful of eminent art historians. MoMA was an institution where art had always been linked with power, and this concentration of money and influence at the top was typical of the way it functioned. The role of the trustees was to support the museum and enable it to build up its collection by releasing funds, but this role went beyond patronage when it came to guaranteeing MoMA's reputation through the development of promotional strategies worthy of top advertising agencies and key government bodies.[19]

Organized around a strict administrative hierarchy, including a president, a board of trustees, a number of executive directors, and a great many committees

in charge of supervising the various departments, the museum was structured like a corporation and managing its cultural affairs was no different from managing a business. Pragmatism and expansion were key ideas in both its conception of modern art and its methods of displaying this art – methods that have been imitated by the majority of museums around the world.

If we analyze the evolution of the photography department, we can see what lay behind every major decision that shaped its development over a period of some fifteen years. In so far as the financing of the department appeared to influence the administrative decisions, it is interesting to take a broader look at the economic interests involved: so long as collectors were taking care of the finances, it seems, the department remained in the hands of esthetes, but as soon as the financiers stepped in, the levers of the mass media shifted into action.

Although the museum's first director, Alfred Barr, had already mooted the idea in 1929, the photography department only opened in 1940, once the trustees were convinced of the relevance and viability of the project. It was directed by Beaumont Newhall and later – when he left for the Front in 1942 – by his wife Nancy, who continued what her husband had begun in terms of establishing a coherent collection with a bias towards fine art. The trustees were impressed by the quality of the exhibitions and the public success of the war cycle and, in 1943, decided to expand the department and house it in a separate annex. The inauguration of the Photography Center marked a new development in the history of museum-based photography.[20] Straddling the two domains of academic and amateur photography, it was conceived as a research laboratory open to practitioners of every kind, from the Sunday photographer to the most highly acclaimed professional.

In appointing Willard Morgan as director of the new center, the museum was marking a break with tradition. Morgan, who was married to the artist Barbara Morgan and had edited an encyclopedic survey entitled *The Complete Photographer*, kept a foot in several different camps, remaining open to fine art, commissioning works and amateur photography equally. His appointment was short-lived, however, ending with his first – and last – exhibition, "The American Snapshot," which proved to be a dismal failure. The trustees so disliked this selection

of amateur photographs from Kodak's collections that, in 1944, they decided to close the Photography Center. Their decision was not directed at photography itself: it was a way of controlling the image and the coherence of the department, which they judged to be straying too far from the artistic standards established to date. It was important to welcome in the public, but not, as they saw it, to allow amateur photographers complete carte blanche. With the closure of the center, the museum's photographic collection returned to the main building, where fourteen more exhibitions were held prior to Edward Steichen's appointment.

In short, MoMA's photography department had experienced something of a checkered history under the direction of a connoisseur-cum-art historian and later an author-cum-editor when – at the end of the 1940s – it was entrusted to the care of an artist convinced that the time was ripe for all visual forms of communication and that his own art – photography – had a special part to play.

The silence of history
Looking back over a career such as Steichen's can tell us something about the formulation of a particular artistic canon, and it can highlight conflicting critical and theoretical points of view as well as show how these relate to the history of art itself. From this angle, we can appreciate some of the cultural shifts that occur when art becomes museum art, although a specific set of conditions apply in this instance. Traditionally, art history as a discipline invites us to consider objects and to describe their content while reflecting on the esthetic essence of their forms. Here, however, the focus is on the social, political, and ideological context of the works, rather than an evaluation of their esthetic qualities. In other words, the photographs are not viewed for what they are but for what they reveal in terms of the institutional choices to which they relate. What we need to do is to reconstruct the installation methods and track down whatever evidence is available regarding the reception of these ephemeral events. The available sources are frequently incomplete, but sometimes the very lack of information itself reveals important questions relating to the history of an institution. The question of silence is inherent in this type of study, but the quality of the silence that surrounds Steichen's

years as director of photography at MoMA is surprising and worthy of closer examination. Of those sixteen years, the only thing we know about in detail is the organization and reception of "The Family of Man." The critical and media hype surrounding the success of this exhibition contrasts so strikingly with the silence in which the remainder of Steichen's photography program is shrouded that we have to ask whether what we are dealing with here is a simple admission of lack of interest or a strategy of deliberate concealment.

As regards reception, Benjamin Buchloh states that he knows of "no moment in the 20th century where the blocking of a paradigm, or the suppressing of the implications of an artistic practice, or the marginalization of an artist or entire movement, was not a constituent, and necessary, element of the construction of the official history."[21] The process of writing MoMA's history is no exception and seems to involve a deliberate intention to overlook Steichen. Mary Anne Staniszewski's lively scenographic analysis offers a possible explanation: "For the past twenty-five years, the Museum of Modern Art's photography department has presented exhibitions that feature the esthetics of photography, which is, of course, a fundamental area for those creating exhibitions in an art museum to explore. But esthetics is only one aspect of a complex medium. And exhibitions such as the 1970 'Photo-eye of the 20s' and the 1978 'Mirrors and Windows' have, without exception, reinscribed photography within modernist – and avowedly formalist – installations. This approach to the medium has been continued by Peter Galassi, who succeeded Szarkowski as director of the department of photography in 1991. Since 1970, the photo department's installation methods, with rare exception, have consistently worked to establish exclusively formalist and estheticized exhibition conventions – and appreciation of the medium – within the Museum."[22] Steichen's approach was diametrically opposed to such a policy. He preferred to highlight the multiple uses to which photography could be put and its potential as a means of communication, opting more often than not for monumental installations that exploited the reproducibility, the theatricality, and the flexibility of the photographic image.

Going back to what we know of MoMA's emphasis on art photography, we can be clear that during his

time as director of photography, Steichen's approach signified a profound shift from the line developed by his predecessors and his successors alike. His ideas swept aside the established credos. For an art form to receive official validation traditionally involves the creation of norms and rules that are set in stone. Cross the boundary line and we tip over into a different definition. During Steichen's time, the limits of applied photography were fixed by the limits of artistic practice, and the latter was formulated as a rejection of the former. Colour and press photography were "everyday things" and could not therefore aspire to creative status. We might well ask whether demolishing its cult value would not have been a necessary step in the institutionalization of photography – and a means of broadening the "closed circle" approach that MoMA was busy promoting, with a small stable of practitioners simply responding to predefined criteria.

From the form to the message

Steichen's strategy was to combine the different approaches and uses of photography in a way that involved decompartmentalizing practices and genres. His refusal to make any kind of distinction between art and document was an important aspect – we might even say the principal thrust – of his career.

Without going back over the biographical evidence supporting this fact, it is interesting to measure its impact on departmental planning and, more broadly, on the history of art. "The Bitter Years" concluded a cycle of nearly twenty exhibitions devoted to showing documentary images in a museum context,[23] completing this process of contextualization of the image as an instrument of communication.

The origins of "The Bitter Years" can be dated back to 1938, when Steichen saw Willard Morgan's installation at New York's Grand Central Palace devoted to a selection of photographs from the FSA archives. These images had a profound impact on Steichen, who decided to publish them less than a year later in an issue of *U.S. Camera*[24] and to display them thirty years later on the walls of MoMA's photography department. Despite the time delay, it is important to emphasize the double use that Steichen made of this single series of images, first publishing them in the press and later exhibiting them in the museum's galleries. A bridge was thus created between these two worlds, underpinned by the analogy between page layout and exhibition display. Steichen's displays highlighted numerous parallels between the two media, replicating the magazine grid on the gallery wall ("Memorable *Life* Photographs"), so treating the exhibition space as

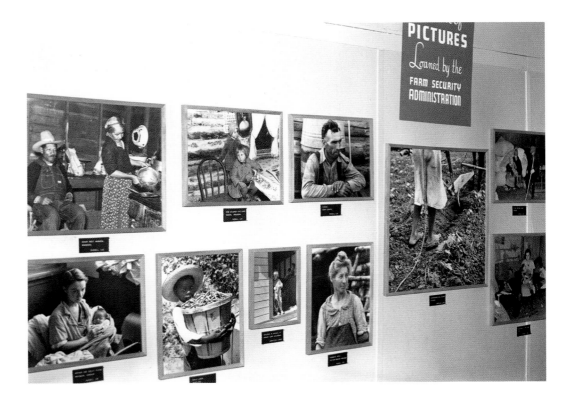

The "First International Photographic Exposition" with a selection from the FSA archives at Grand Central Palace in Manhattan, 1938. Photograph by Arthur Rothstein.

U.S. Camera Annual 1939. Less than a year after having discovered the FSA images at the Grand Central Palace exhibition in New York, Steichen dedicated a 12-page spread to Roy Stryker's documentary mission in the 1939 volume of *U.S. Camera.*

a three-dimensional blank page, or – more blatantly – affixing newspaper pages to the wall itself ("In and Out of Photography," "The Exact Instant"), or supplementing the visual sources with sections of text ("Road to Victory," "The Family of Man").

In an interview given in 1955, Steichen discussed his reasons for abandoning painting, justifying his decision in the following terms: "I wanted a medium that would give me closer contact with life and also reach a larger number of people. Now to me the real value of photography, the real importance of photography is the printed page. I think it much more important to get a picture on the printed page than it is to have a beautiful box of portfolios in your house or in any museum or in any place else. That's my own personal preference for photography."[25] The display experiments that led him to modify his images by superimposing shots and then reprinting them were more typical of the approach of a magazine editor, and it reflected the shift in priorities and values that accompanied his abandonment of painting and subsequent indifference to questions of formalism. He had successfully turned his back on a traditional esthetic focus in favour of an approach familiar to all readers of the big colour magazines (*Fortune*, *Life*), who were now invited to gather at the museum. Although a magazine was a superior medium for the diffusion of ideas, impacting on a much wider cross-section of the public than an art exhibition

resolutely destined for a somewhat limited audience, what Steichen was doing was not simply transferring the methods of one medium to the other. The aim of these exhibitions – and it was not a negligible one – was to remove documentary images from their everyday context in order to see them differently: it was a different way of looking, offered as much to the readers of magazines as to the museum-goers.

The approach that Steichen developed for "Road to Victory" was one that he repeated until "The Bitter Years": these were architectural installations that took viewers with them on a visual journey, *encompassing* visitors in a way that accentuated the emotional impact. The images were like words that, when taken together, formed sentences whose meaning the visitors were invited to decipher.[26] Steichen described these particular exhibitions as "photo essays," using a notion first developed by *Life* in 1936:[27]

The genesis of the "theme" exhibitions produced at The Museum of Modern Art – "Road to Victory," "Power in the Pacific," "The Family of Man," and "The Bitter Years" – lay in the desire to have a series of photographs collectively communicate a significant human experience. This is something that an unrelated collection of even the finest photographs obviously cannot accomplish. Photography, including the cinema and television as well as the

printed page, is a great and forceful medium of mass communication. To this medium the exhibition gallery adds still another dimension.

In the cinema and television, the image is revealed at a pace set by the director. In the exhibition gallery, the visitor sets his own pace. He can go forward and then retreat or hurry along according to his own impulse and mood as these are stimulated by the exhibition. In the creation of such an exhibition, resources are brought into play that are not available elsewhere. The contrast in scale of images, the shifting of focal points, the intriguing perspective of long-and-short-range visibility with the images to come being glimpsed beyond the images at hand – all these permit the spectator an active participation that no other form of visual communication can give.

The creation of this kind of exhibition is more like the production of a play or novel, even a philosophical essay, than it is like planning an exhibition of pictures of individual works of art. An exhibition of this nature is not necessarily limited to photography but the technical and practical aspects of photography make it eminently suitable. The ease with which any given image can be made small or large, the flexibility of placement and juxtaposition, the great range of material available in photographs – all these factors make photography the obvious medium for such projects. No amount of technical bravura, however, can make up for the lack of a fundamental idea from which the exhibition must grow. There must first be a desire to convey a feeling or a thought about a moment or a condition, to build upon the elements furnished by nature and the experience amassed in the art of living, and to orchestrate these into a unified force.[28]

This idea of orchestration echoes the remark made by René d'Harnoncourt when he was congratulating Steichen and comparing the role of the curator to that of an "orchestra leader" and his selection of material for an exhibition to a musical interpretation.[29] Steichen envisaged the majority of his exhibitions as single coherent works for which he was creatively responsible, with each image forming part of the whole and helping to articulate a predefined theme. The exhibits were the fruits of a careful selection that was not governed by chronology or series and they followed one another

rather like notes on a stave. The arrangement of images was designed to create a harmony, in the manner of a musical score. There is an underlying paradox here, which it is worth noting if not exploring. Although the point of Steichen's scenographic approach was to exploit the potential of the image as a means of mass communication, in seeking to communicate a powerful message, it paradoxically created a form of estheticized communication through its very quest for coherence, balance, and rhythm.

The orchestral analogy may apply to the curator responsible for arranging an exhibition, but it also applies to the art director, in charge of the visual aspects of a magazine. Steichen worked in both capacities at different times and even combined them for a period. His publishing role involved selecting and arranging images to illustrate a particular theme. The relationship between an art director and "his" photographers tended to be a very hierarchical affair in which the freedom of the latter was strictly limited. The director would determine the nature of the project, and the photographer would go off and take photographs according to the guidelines (regarding the type of camera and film to be used) and the timescale that had been set. Once the photographer had completed the assignment, the magazine retained control of the images and could decide not to print them if it chose. Nor were photographers at liberty to develop the negatives themselves, even if they were as well known as Henri Cartier-Bresson or Bill Brandt (both of whom were exhibited by Steichen). It was standard practice for photographers to send rolls of film to the magazine's lab as they went along, and the contact sheets then went to the art director so that he could make his selection. None of this was intended to undermine the photographers, but it does show what scant control they had over proceedings.[30]

There are similarities here with Steichen's practice in curating an exhibition. He would start with a huge number of images – the press files frequently mention dozens and even hundreds of thousands of photographs – and out of these he would select only a few hundred for display. Steichen's relationship with the photographers was also very hierarchical, given that he was in a position to abandon a series if he chose, to buy photographs at derisory prices, and even to

obtain all the rights to the negatives, as he did in the case of "The Family of Man."[31]

From one paradox to another

Tensions were inevitable, given the circumstances, and Steichen's detractors were swift to voice their criticisms. Beaumont Newhall and Ansel Adams were among the first to accuse his exhibitions of being tendentious and oppressively moralistic. The biggest concerns, however, were not about the themes but about the integrity of the photographs themselves and the situation regarding copyright. Steichen's break with tradition was not just an infringement of esthetic rules and criteria of taste: it went much further than that, raising questions about the creative act itself. Steichen regarded his exhibitions as architectural constructions and the photographs themselves as raw materials that he was at liberty to play around with, altering their dimensions – sometimes quite dramatically – to suit his needs. This put the photographers in an awkward position, their debt to the museum conflicting with a natural desire to defend the integrity of their work. No matter how high the stakes, it was never easy to surrender one's rights to a curator, even when he was a famous photographer.

While Steichen was repeatedly criticized for corrupting art by opening up the museum to media logic, magazine publishing could perhaps be regarded as the inspiration for a paradoxical avant-garde approach, thanks to its tendency to sidestep formalism through the creative potential inherent in non-artistic forms. Experimentation of this kind pushed the structure of the institution to its limits, modifying the functions exercised by the departmental director, whose role came to resemble that of the magazine editor rather than the curator.

The criticisms were not all from the outside world: while never questioning his relationship with the photographers, Steichen himself recognized the limitations of his media strategies. The best example of this concerns his last war exhibition, "Korea: The Impact of War in Photographs." Although it was popular with the public, Steichen expresses some frustration that the political fallout from this exhibition and the persuasiveness of his message were so short-lived: "They found some pictures revolting, some deeply moving. There even were tears shed, but that was as far

as it went. They left the exhibition and promptly forgot it. Although I had presented war in all its grimness in three exhibitions, I had failed to accomplish my mission. I had not incited people into taking open and united action against war itself. This failure made me take stock of my fundamental idea."[32] From now on, he would stop trying to denounce and instead adopt an approach that focused on more positive aspects of humanity, as in "The Family of Man" and "The Bitter Years."

In his particularly lucid critique, Christopher Phillips comments: "One can, with Allan Sekula, see productions like 'The Family of Man' as exercises in sheer manipulation; but one can also see in their enthusiastic reception that familiar mass-cultural phenomenon whereby very real social and political anxieties are initially conjured up, only to be quickly transformed and furnished with positive (imaginary) revolutions. From this standpoint, in 'Korea: The Impact of War' (1951), doubts about dispatching American soldiers to distant regional battles are acknowledged (in a careful juxtaposition of the photographs of David Douglas Duncan), only to be neutralized in an exhibition setting that emphasized stirring images of American military might."[33]

What emerges from this brief survey is the undercurrent of constant tension that accompanied Steichen's exhibitions – a tension that influenced the administrative structure of the museum as much as the collections themselves and the artistic ideas they embodied. Given such a strong ideology, it is interesting to note how much freedom Steichen actually enjoyed and what risks he was able to take – and consequently the level of influence he exerted over New York's art scene and, more broadly, on the history of photography itself. He had an expansive vision of an art form – one that was newly emerging – which broke down the boundaries between genres and embraced color photography and photojournalism as welcome elements of the sacred canon. These practices would eventually gain recognition, but only after several decades had passed, during which time the trend for large-scale installations decreased – notably following Steichen's departure in 1962 – and finally died out, leaving the way clear for a flourishing market in prints. And as the process of legitimizing photography accelerated, formalism prevailed once more at MoMA.

TESTIMONY OR INSTRUMENT OF PROPAGANDA: WHAT IS THE ROLE OF PHOTOGRAPHY?

Gabriel Bauret

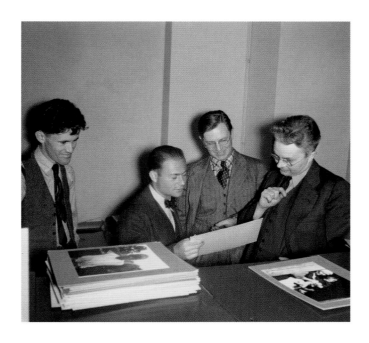

The FSA photographers (left to right) John Vachon, Arthur Rothstein and Russell Lee conversing with Roy Stryker (on the right) about their work. The photograph is signed by Beaumont Newhall, the famous historian of photography.

The Farm Security Administration occupies an important position in the history of twentieth-century photography, alongside various other group initiatives, collective exhibitions, esthetic movements, and educational programs that have helped to shape this particular art form. In the United States, for example, there was *Camera Work* and the 291 gallery, which owed their existence to Alfred Stieglitz; Group f/64, formed in 1932 by Edward Weston and Ansel Adams in response to the Pictorialist esthetic that was in vogue during the early years of the twentieth century; and a cooperative created in 1936 through the efforts of Paul Strand and Berenice Abbott known as the Photo League, which was particularly concerned with the documentary aspect of photography. Across the Atlantic too, in Germany and France, and also in the Soviet Union, a great many similar group initiatives emerged, driven by common themes or stylistic concerns. The interwar years proved an unusually fertile period for creative developments in photography. These were matched by extraordinary technical advances, and it would probably be fair to say that photographers now had all the necessary means at their disposal to experiment in whatever way they saw fit. This applied equally to documentary photography and to photography as a medium for artistic expression.

How should we view the FSA's photographic archive today? Should we judge the photographs in isolation or as part of this rich historical context to which we have just alluded? Things have moved on since the 1980s, when the first exhibitions and major publications (notably in France) focused attention on this episode in the history of the FSA, and today our knowledge of the history of American photography is a great deal broader and deeper. The new installation of "The Bitter Years" in Dudelange – only one approach among many from the FSA, it should be emphasized – offers the opportunity

Five photographs of Roy Stryker by Angus McDougall.

to revisit the visual heritage of this critical episode in American history. The FSA's photographic archive is inextricably linked with its historical context, shaped by the stock-market crash of 1929 and the Depression that followed, in particular as it affected rural communities. Although the program expanded to include material from the industrial and urban worlds and the theme of nationwide unemployment, the handful of iconic images with which the FSA is associated – by names including Dorothea Lange and Walker Evans – relate to the tragedy specifically as it affected the farming population.

Whatever the community concerned, however, the FSA's photography program as a whole was politically determined, as was Soviet photography during the same period, albeit in a different way. Photography served a particular cause and the FSA photographers themselves were bound by a precise set of rules. Their role was to provide a record of the social situation as it existed in an America that was in crisis and simultaneously to "introduce Americans to America," in the words of Roy Stryker,[1] head of the FSA's Information Division and the man responsible for creating a corporate identity for the photographers united under the FSA banner. Stryker was in a sense the voice of the FSA, just as André Breton was said to be the voice of Surrealism.

Edward Steichen, who curated "The Bitter Years" at New York's Museum of Modern Art in 1962, emphasized the collective nature of the project: "It is not the individual pictures nor the work of individual photographers that make these pictures so important, but it is the job as a whole as it has been produced by the photographers as a group that makes it such a unique and outstanding achievement."[2] The group was more important than the individuals within it – but this did not mean that the photographers involved were particularly interested in exchanging ideas. Rather the reverse was true, in fact, each of them being very much driven by their own agenda. We tend to think of the FSA as a single coherent entity, but it was a long-term project and the photographic section itself existed for almost a decade. The first photographs date from 1935 and the last from 1943, and during this period there were some changes of emphasis, in particular with regard to subject matter. It is important to remember that the

FSA was created in response to the need for agricultural reforms and its initial focus was therefore inevitably the rural community. The most pressing concern was to document the situation of farmers, who were among the first victims of the economic crisis and faced a series of natural disasters that confounded efforts to restore agricultural production in some regions. In a more general sense, the FSA followed the program for economic recovery – known by all students of history as the New Deal – implemented by Franklin D. Roosevelt during his first term in office, in 1933.

The FSA's photography project would not have come into being without the Wall Street Crash of 1929, and it would never have become such a celebrated part of the history of the FSA without the personality, passion, and determination of its director, Roy Stryker. Stryker's influence is felt less at the artistic level than through the collective message of the project's diverse images. If we take a closer look at these images, it is difficult to ascribe a particular point of view to any individual photographer, and when we examine their works as a whole, in one of the many publications devoted to them (both monographs and anthologies), we are forced to acknowledge the relative uniformity of the project in terms of strictly formal choices. One possible exception is Dorothea Lange, whose images have a peculiar intensity that is almost theatrical. A particularly good example is Lange's iconic "Migrant Mother";[3] Roy Stryker stated that this single photograph embodied the FSA and what it stood for – an idea apparently espoused by the Library of Congress in Washington, which houses the project's entire archive and features Lange's photograph on its homepage.

The contribution of Walker Evans is markedly different from the other works associated with the project. It is not extensive (comprising a few hundred images) and is characterized by a thoughtful restraint and a preference for the large format, avoiding portraiture, or social documentation, in favour of the objects and surroundings that form the natural habitat of a farming community. The resulting images are carefully worked in terms of centering and composition, setting them apart from their fellows in the FSA archive. Evans also produced another, rather unusual series of photographs, featuring the sort of signs, hoardings, and advertisements to be seen on an urban street or lining a major road, which strike us as somewhat unexpected within this context. Although it incorporates a fairly diverse range of images, the series is less an inventory than an invitation to the viewer to reflect on the contemporary environment as experienced by the American people. It was this urban environment that Evans preferred to rural landscapes, and images such as these were his contribution to a powerful revival of the landscape genre, providing a model for future photographers for several generations to come.

The diversity of subjects, coupled with relative uniformity in terms of treatment, was what characterized the FSA's photographic project: the FSA was not conceived as a group of photographers sharing a similar esthetic or known for their common style. Roy Stryker himself declared somewhat abruptly: "I don't care about the damn esthetics."[4] What was important was the subject matter, nothing else. The brief was to capture the situation on the ground – such as it existed at any given moment in time – and render it visible and comprehensible to the viewer. It was of no consequence how this was done, and whether the interpretation was literal or symbolic; whether photographers chose to shoot from close up or far away, whether in composing their images they conformed to the rules of the pictorial tradition, and whether their images were instantaneous or arranged in the form of tableaux. Each of the FSA photographers was given a road map setting out the themes that they were required to treat, and each was also given a designated geographical area to cover – elements to which Stryker dedicated a great deal of care. We should note that, while they were allowed a certain freedom in terms of methodology, their careers and experiences prior to joining the FSA were extremely varied. Dorothea Lange and Walker Evans were already well established before Stryker engaged them. Lange had worked on a similar project in California and was already photographing the unemployed and the homeless – those whose existing problems were only exacerbated by the new economic difficulties. The year 1936, the date when Lange joined the program, saw the start of a series of photographs focusing on the theme of exodus. When Stryker approached Walker Evans, on the other hand, his artistic bias was already evident in his work.[5]

Carl Mydans – one of the first names to be associated with the FSA, along with Evans, Arthur Rothstein, and Ben Shahn – was a journalist (specializing in economics) and a photographer only out of office hours. When Stryker took him on in 1935, Mydans was using a Leica – an unusual choice for an FSA photographer – and he would go on to shoot far more photographs than the likes of Evans. Mydans left the FSA a year later to join the newly created *Life* magazine. Despite Mydans's journalistic contribution, Stryker made it absolutely clear that there was no place for news stories in the FSA program. Arthur Rothstein took a few shots of President Roosevelt in 1936, when he was visiting a region badly affected by the drought, but these were the exception: the photographers' brief was to avoid shooting current events and well-known people.

Arthur Rothstein was a chemist by training and Stryker employed him initially to supervise the developing and printing side of the program. (The FSA produced some 270,000 negatives, while 170,000 prints have been archived by the Library of Congress in Washington, D.C.) However, Rothstein soon began taking photographs himself. While not especially interested in composition and criticized for being too free with his subject matter, he engaged fully with his theme – the effects of the drought that devastated America's Midwest in 1936.

Ben Shahn, another of the FSA's first photographers, was even less experienced than Arthur Rothstein. He was a well-known artist – a painter and lithographer – and a friend of Walker Evans, when Stryker first made contact with him and thrust a Leica into his hands. Shahn was sent to Ohio in 1935 and produced an abundance of photographs in a free and experimental style. In the introduction to his book *FSA: The American Vision*, Gilles Mora speaks of Shahn's "use of a subjective point of view as a documentary tool."[6] Following his involvement with the FSA, however, Shahn returned to painting without looking back. Paul Carter made a brief appearance in late 1935, but had trouble engaging with his theme, and his photographs and name barely feature in the books that have been written about the FSA. Edward Steichen nevertheless included his work in "The Bitter Years," while omitting Edwin and Louise Rosskam, who joined the FSA in 1939 and were thus part of the second wave of contributors. It is worth noting

that Stryker approached Edwin Rosskam – who also worked with his wife Louise on a photographic survey of sugar-cane and tobacco production in Puerto Rico – initially because of the latter's knowledge of page-setting and photographic printing.

During the FSA's final phase, which coincided with the war years, the photographic unit was subsumed under the Office of War Information (OWI) and a number of contributions differed markedly from the early works, in terms of both subject matter and approach. The photographer Gordon Parks, for example, working in 1943, restricted himself to a single sphere of activity within narrow geographical confines: the Fulton Fish Market in New York. Stryker was interested in gaining an African-American's point of view on the question of working-class black America and, though he did not say as much, he may even have been anticipating possible unrest of the kind that did in fact occur in the aftermath of the war. In choosing Parks, however, he was not only selecting the person he regarded as best suited to the task in hand, but probably also recognizing a very promising talent. Parks was to become one of the most productive American documentary photographers of his generation – though his career was not limited to photography – and was particularly noted for his collaboration with *Life* magazine. Another FSA contributor who stands out for her original and idiosyncratic images is Esther Bubley. Bubley's photographs – capturing travelers on those Greyhound buses that criss-cross America and are part of the whole road-movie mythology – do not tell a story as such, but the traveling theme and the subjectivity of her approach were utterly new in the context of the FSA.

The photographs of Parks and Bubley were not featured in Edward Steichen's "The Bitter Years," nor in *A Vision Shared: A Classic Portrait of America and its People, 1935–1943*, which appeared in 1976 and is one of the authoritative works on the FSA.[7] We might wonder why, in the books and exhibitions devoted to the FSA, certain aspects of the program and certain names are omitted in favour of others. In Nancy Wood's portrait of Roy Stryker, entitled *In This Proud Land*, we are offered a selection of photographs put together by Stryker himself – photographs that he considered as representative of the FSA's achievement – and we are told that Stryker did not like the choices made by

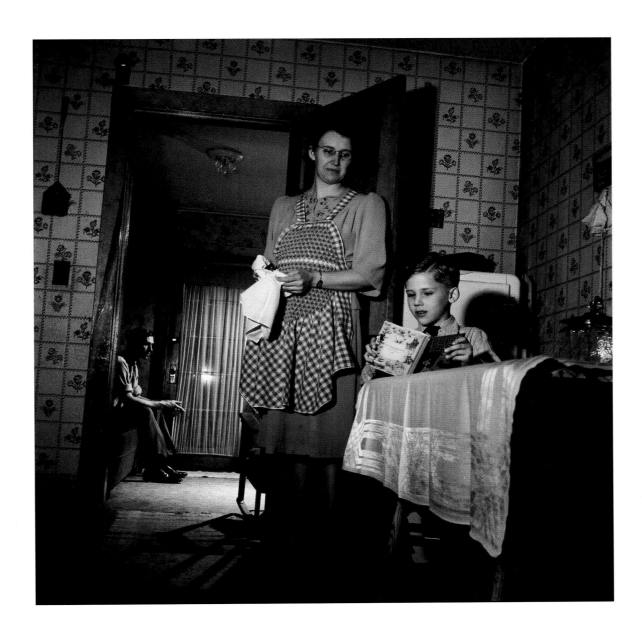

The Campbell family at home after church, Washington,
D.C., March 1943, by Esther Bubley. In contrast to
the early FSA commissions that focused on rural
America, Esther Bubley worked in an urban setting.
Her composition of this group goes beyond the
documentary.

Steichen for "The Bitter Years." He thought Steichen's vision was negative and laid too much emphasis on the human suffering involved, and he regretted the absence of documents creating a more constructive and optimistic picture. Steichen's reasons for making his choices had nothing to do with photography and may have been rooted in the renewed social and political tensions of the early 1960s: he was looking to America's past from a humanist perspective, seeking model responses to adversity that would serve in the current crisis.[8] Steichen's appropriation of the FSA underlines the importance of circulating the photographers' work as widely as possible – something that always preoccupied Stryker and that for him was linked with the question of the complementarity of text and image, in particular where press publications were concerned.[9] "In fact, no clear editorial policy for publications and exhibits was defined until Ed Rosskam's arrival at the FSA in 1939," writes Gilles Mora.[10]

An international photography exhibition held in New York's Grand Central Palace in 1938 had brought the first of the FSA's works to public attention. For Steichen, there were links between this show and the convictions that underpinned his own monumental exhibition, "The Family of Man," held at MoMA in 1955, which was a milestone in the history of photography. According to Steichen, "The mission of photography is to explain man to man."[11] "The Bitter Years" may not have been to Stryker's taste, but for Steichen the 1938 FSA exhibition was a defining moment in his perception of the role of photography and provided the rough draft that he would elaborate in "The Family of Man."

The role of photography was a question that Steichen took as seriously as Stryker did. In a 1973 essay entitled "The FSA Collection of Photographs,"[12] Stryker looks back and reflects, with the benefit of hindsight, on what he feels the program was really about. Was it art, he asks himself? Where Walker Evans and Ben Shahn are concerned, he is tempted to answer in the affirmative. Was it sociology? He recalls, perhaps ironically, what the photographer Ansel Adams said about the FSA: "What you've got are not photographers. They're a bunch of sociologists with cameras."[13] Was it journalism? The answer is unclear: Stryker stressed that the program was not about news stories, and yet the FSA's images

appeared in magazines such as *Life* and *Look*, "for which some of our old staff later worked." Was it history? "Of course. At least it was a slice of history....But you'll find no record of big people or big events in the collection." There was one other possibility, and here Stryker is quite emphatic: "Was it education? Very much so and in more ways than one....If I had to sum it up, I'd say, yes, it was more education than anything else." Once again emphasizing the importance of the group as opposed to the individual, he goes on to explain: "We developed the camera team, in contrast to the cameraman, and the full effect of this team's work was that it helped connect one generation's image of itself with the reality of its own time." We should add that in Stryker's view the FSA project was every bit as exciting as the historical moment to which the photographers were asked to bear witness, and Nancy Wood quotes him as saying: "My goal was to write the history of the Farm Security Administration. We didn't collect many documents. We collected pictures. Many think I went down to Washington with a big plan. I didn't. There was no such plan."[14]

What these words reveal – apart from the modesty of the speaker – is the overlap in Stryker's mind between the history of the program and History with a big H. The Château d'Eau gallery in Toulouse hosted an exhibition of the FSA's work in 1980, using a title that echoed Steichen's ("Les Années amères de l'Amérique en crise"). The gallery's founder and director, photographer Jean Dieuzaide, wrote in the exhibition catalogue: "The FSA marks an important date in terms of both history and the use of photography."[15]

In a collection of essays about photography published in 1977, the American essayist and critic Susan Sontag judges that "The FSA project...was unabashedly propagandistic."[16] She was not the first to raise the issue. Walker Evans had already weighed up the notion of propaganda versus document: "This is pure record not propaganda. The value and, if you like, even the propaganda value for the government lies in the record itself which in the long run will prove an intelligent and farsighted thing to have done. NO POLITICS whatever."[17] One of his commentators, Michael Brix, points out that "Evans's strategy was...to use the documentary as a stylistic mode, not as a means for effecting political reform."[18] Put another way, what

this approach amounted to was a quest for objectivity, and as such it gained widespread popularity. It was only as time passed and the images began to appear in new contexts that their value gradually came to be established.

Adopting an attitude not dissimilar to Walker's, Steichen himself maintained that the FSA's work could not be considered propaganda: "Pictures in themselves are very rarely propaganda. It is the use that is made of pictures that makes them propaganda."[19] Russell Lee, one of the first photographers associated with the program, echoes Stryker's earlier comments about the FSA's educational bias when he remarks in 1941: "I am a photographer hired by a democratic government to take pictures of its land and people. The idea is to show New York to Texans and Texas to New Yorkers."[20] The neutrality to which Dorothea Lange aspired was encapsulated in a remark made by the English philosopher Francis Bacon that particularly appealed to her: "The contemplation of things as they are, without error or confusion, without substitution or imposture, is in itself a nobler thing than a whole harvest of invention."[21] But, in examining the potential impact of her work, Lange found she could not entirely escape the notion of propaganda: "Everything is propaganda for what you believe in, actually, isn't it? I don't see that it could be otherwise. The harder and the more deeply you believe in anything, the more in a sense you're a propagandist. Conviction, propaganda, faith. I don't know, I never have been able to come to the conclusion that that's a bad word."[22]

It is interesting to reflect on why this notion of "propaganda" features so prominently in discussions of the FSA, whether these remarks were made by the photographers themselves or by other people, and whether they were made at the time or long after the program had been disbanded. One thing we can safely say is that the FSA's work cannot be viewed independently of its political implications. It is reasonable therefore for some of the photographers to have felt exploited by the Roosevelt administration, even though Stryker denied retrospectively that there had been a "plan" (see above). There were similarities between their reaction and the reactions of some of the photographers in Steichen's "The Family of Man" – Robert Frank, for example – who sought to assert

their independence and distance themselves from the collective nature of the project. In his essay devoted to the early FSA photographs exhibited in 1938 in New York (see above),[23] Steichen described photography as having three general objectives: it could document; it could tell a story; or it could serve as propaganda. To judge from what he is saying, the FSA photographs tend to move for the most part between document and narrative; or, in other words, between the work of a Lewis Hine – whose photographs of child labor at the turn of the century were admired by Stryker for their acute observation of real life – and the photo essay as typified by the post-war work of W. Eugene Smith for *Life* magazine.

Steichen associates propaganda, on the other hand, with Soviet photography – propaganda, that is, accompanied by what he sees as the manipulation of reality. He draws a distinction between the "official" photography of the FSA and the "official" photography emanating from the Soviet Union. Whereas the former endorses realism and objectivity, the latter is intended to "correct" and sublimate reality in the service of political discourse and in order to further revolutionary ends. While acknowledging the excellence of Soviet photography, Steichen describes the skewed version of reality filtered through the photographs: "The Soviet is represented as the home of fine, healthy, vigorous boys and girls marching in Moscow, working in factories in fields, or in clubs; well fed, plump, gay children in government nurseries; lineups of tractors and automobiles giving the impression of miraculously synchronized high-speed production."[24]

In 1930, Alexander Rodchenko, a prominent figure of the Russian avant-garde, co-founded the photographic section of the October group (founded two years earlier) with Boris Ignatovich and the German photographer Otto Umbehr. Their esthetic was inspired by Constructivism and their aim was to help build an idealized vision of the regime. Experimenting with oddly angled shots and photomontages, they sought to reflect progress, in both industry and agriculture, and to create symbols of social and economic dynamism. But October, which was based on the principle of a fusion of the arts and politics, proved short-lived. The regime criticized what it saw as a "bourgeois formalism" threatening to overwhelm the political message and

One of the images from a photo essay by members of the agency Soyouzphoto, published in the German magazine *Arbeiter Illustrierte Zeitung* in 1931. It shows various moments in the life of the Filippovs, a working-class family in Moscow.

the photographers' failure to play their part in the task of constructing Socialist Realism, and the group was dissolved in 1931. While the October photographers appeared to favor form at the expense of content, a photo essay by Max Alpert and Arkadi Shaikhet that appeared in a German weekly newspaper[25] in 1931 – a day in the life of the Filippovs – featured an exemplary family living in a workers' collective. There are no stylistic effects, or very few, compared with the formalist experiments of a Rodchenko: this is photography of an essentially documentary nature – more in line with what one might expect, given the political context.

It seems, therefore, that we can identify two distinct tendencies in the documentary photography of the 1930s, corresponding to two different parts of the globe, and in particular two quite distinct ideologies. The way Steichen describes it, East and West were divided by a whole range of different values, relating to questions of morality as much as to the role each attributed to photography. But what this actually amounts to is an extremely schematic analysis: freedom of expression on the one hand, ideological constraint on the other, truth versus manipulation, testimony versus formalism. The real question – looking beyond these divisions – is the one posed by Dorothea Lange, when she asked "what can photography do?" It is a question that still haunts a great many reporters and documentary photographers. And the same question – with regard to literature – has fueled debates between writers such as Jean-Paul Sartre in his inquiry into the notion of "engagement." Dorothea Lange questions whether her famous "Migrant Mother" portrait did anything at all to help that particular woman. The answer she gives – perhaps a somewhat paradoxical one – is that the woman photographed has actually helped the photographer, rather than the other way around – if only to understand human nature a little better.[26] It is a humble answer and demonstrates an unusual degree of wisdom.

"A VERY LIVING DOCUMENT OF OUR AGE": CONSTRUCTING AND DECONSTRUCTING THE FSA ARCHIVE

Miles Orvell

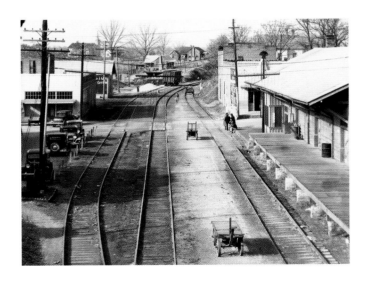

This picture by Walker Evans, *View of Railroad Station. Edwards, Mississippi*, 1936, had a special meaning for Roy Stryker: "The empty station platform...the quiet stores, the people talking together, and beyond them, the weatherbeaten houses where they lived, all this reminded me of the town where I had grown up. I would look at pictures like that and long for a time when the world was safer and more peaceful."

"The Bitter Years 1935–1941" was Steichen's last exhibition as curator of photography at the Museum of Modern Art and as such, it was something of a swansong, a final tribute to photography as Steichen had come to understand it. That he would dedicate the exhibition to Roy Stryker and his photographers was itself an act of generosity, a gesture of recognition to those who had created the archive of the Farm Security Administration (FSA) photographs on which Steichen had drawn. (The FSA was merged into the Office of War Information in 1942, and the total photographic file now is known officially as the FSA-OWI archive.) It was also a way of acknowledging, perhaps, the pivotal role the FSA had played in his own education as a photographer; for it was in 1938 that Steichen's eye had first been attracted to the work of Stryker's group of photographers, who were using the camera in ways that went beyond the esthetic practice of his own early years in photography – the Stieglitz years – and beyond the later career in advertising that had made Steichen the most sought-after of commercial artists. The social documentary mode represented by the work of the FSA declared, for Steichen, a new contemporary function for the camera, one that would see the image as a means of mass communication, an object that existed within a rich context of history and social change.[1]

The FSA work had been a part of the 1938 First International Photographic Exposition at the Grand Central Palace exhibition in Manhattan, where it raised the hackles of the more traditionally esthetic Pictorialist photographers. For the general public, the FSA work was a powerful statement about the times, and it was also something of a coming-out party for the Stryker crew, whose work stole the show, at least as Steichen saw it. Writing for *U.S. Camera* magazine in 1939, which featured the FSA work, Steichen enthusiastically proclaimed the

images to be "the most remarkable human documents that were ever rendered in pictures," and he pointed to the stories the images tell: "weird, hungry, lovable, heart-breaking images; and then there are the fierce stories of strong, gaunt men and women in time of flood and drought." In offering his response to the FSA enterprise in 1938, Steichen mentioned not a single photographer. Instead, he stressed the collective nature of the FSA enterprise: "It is not the individual pictures nor the work of individual photographers that make these pictures so important, but it is the job as a whole as it has been produced by the photographers as a group that makes it such a unique and outstanding achievement."[2] In doing so, he was anticipating Stryker's view of "the camera team," as he later called it, over the individual cameraman.[3] And they are both surely right about that: it is often impossible to tell from a single picture who created it, though it's also true that we can see patterns of perception and composition in the work of individual photographers when we look at separate gatherings of their work.

In 1938 – when the Grand Central Palace exhibition was held – rural scenes were at the heart of the FSA mission, and the story of America's farming communities was the core story of the FSA itself, the starting point for Stryker's efforts, which were designed to provide visual evidence of the desperate conditions in rural America that needed to be addressed by the helping hand of the Federal government. Thus a good many of the images identify their subjects as clients of the FSA, or persons who should be. The whole argument of the file – in its depiction of the rural victims of an unprecedented economic Depression who were likewise victims of lasting drought and sporadic dust storms that immeasurably worsened things – was that attention must be paid, help must be given, and the government, in these dire times, was the last resort. Brought in by Rexford G. Tugwell, Franklin D. Roosevelt's Under Secretary of Agriculture, Stryker knew what the focus of the job was, and he summed it up in 1973 as "a pictorial encyclopedia of American agriculture," a larger vision of rural America: "It's the farms and the little towns and the highways between."[4]

Still, the rural story was only one part of the larger scope of the FSA project as it evolved through the eight years of its existence. So fixed is this archival

monument in our minds that we must force ourselves to remember that it was entirely unfixed and unachieved when it began in 1935. Out of the chaos of its gradual construction, three main questions emerge: Where did it come from? How was it organized? And how have we come to view it in the years since its origin?

Where did it come from?
The FSA project began, one might say, in confusion. Stryker had no idea how to undertake an assignment that had no real precedent, and he was frequently seeking advice from his former Columbia professor, Tugwell, who had recruited him to come to Washington and create a photographic record of the Roosevelt efforts in rural America.[5] Stryker's experience in his years at Columbia was in using photography for educational purposes, in the classroom and in textbooks, and he was familiar with employing images to illustrate concepts, trends, practices, customs, and events. In terms of photographic precedents, his own touchstones, as he wrote in an article on "Documentary Photography" for a 1942 encyclopedia of photography, were Mathew Brady, Eugène Atget, and Lewis Hine.[6] All three created photographic documents, but what unites them is their ability to conceptualize the camera as a tool to create not just single images but a body of work that represented society and the times. Brady's ambition to record the Civil War was virtually unprecedented, and he employed teams of photographers across the battle zones to capture the destructive aftermath of the action (for the camera was too slow in the 1860s to freeze motion).[7] Atget's exhaustive record of Paris (from 1898 to 1927), featuring streets, shops, and houses, had been brought to the United States by Berenice Abbott in the late 1920s and was yet another inspiration. But perhaps the most direct model for Stryker's team was Lewis Hine, who had been photographing recent immigrants at Ellis Island and on the Lower East Side of Manhattan since the early years of the twentieth century, and whose images of child labor and rural schools, along with his portrait of the Pittsburgh steel miners, were created with a passionate commitment to social justice. Hine's industrial images in Pittsburgh were taken for a progressive journal called *The Survey*, and the idea

of a photographic survey of society offered the FSA a model for what the camera could do in the right hands. While Hine's work reflected his consciousness of photography as an art form, he was also devoted to the camera as a vehicle for mass communication in print journalism, and he devised effective formats for the combination of words and images.[8]

The more specific (and more systematic) projects of Edward Curtis and August Sander might also have served as inspiration for Stryker. Curtis had begun in 1906, with financial backing from J. P. Morgan, to photograph the North American Indian tribes, eventually publishing a series of twenty volumes with superb prints; he concluded his exhaustive survey of forty thousand images in 1930, by which time he was virtually bankrupt and had sold the rights to the images to Morgan's son. (The Library of Congress, with 2,400 prints, possesses a fraction of the total collection.) Sander's contemporaneous archive, *People of the 20th Century*, resulted in hundreds of images representing a cross section of German society, a selection of which was published in 1929 as *Face of Our Time*. Sander, with an esthetic rooted in the Weimar Republic, was hounded by the Nazis. Whereas Curtis was motivated by the desire to preserve what was passing, Sander was capturing an anatomy of present-day society. Stryker was doing some of both – preserving the passing of small-town America and offering an anatomy of an American society that was struggling, with dignity, to survive.

Stryker was also informed and influenced by Walker Evans, one of the first photographers he hired for the project, though also – because of Evans's independence and resistance to government bureaucracy – one of the first to be let go. Evans had written as early as 1931, in an article for *Hound and Horn*, about the need to theorize about photography as a medium for exploring and recording modern society. Picking up on the example of Sander, whose *Face of Our Time* he was reviewing, and linking that effort with Atget's, Evans wrote: "This is one of the futures of photography foretold by Atget. It is a photographic editing of society, a clinical process; even enough of a cultural necessity to make one wonder why other so-called advanced countries of the world have not also been examined and recorded."[9] Evans's influence on Stryker, as the project was getting off the ground in 1935, served to crystallize the latter's own sense of what he was doing.[10]

Beyond these specific influences, it's important to note the general cultural climate in the early 1930s, which was pervaded by the idea of the photograph as a new medium of mass communication with unlimited potential for representing contemporary culture and the changing nature of society. In 1932 *A Picture of America: The Photostory of America* appeared, using text and photographs in a carefully counterpointed argument, from a socialist perspective, that attacked the root causes of the economic collapse in the US.[11] In 1934 historian Frederick Lewis Allen brought out a picture book called *Metropolis: An American City in Photographs*, featuring photographs by Edward M. Weyer that portrayed a day in the life of New York, aiming for the "typical" diurnal cycle. "In general, it is the exceptional, not the typical, which takes the photographer's eye; and we were interested in the typical," the editors proclaimed, offering a work that was pictorially dramatic but that reverberated with social science.[12] And in 1936 Henry Luce, building on the success of his own *Time* and *Fortune* magazines (both of which used photographs to illustrate print stories), sketched out the basis for a new kind of magazine – it became known as *Life* – that would use pictures not as illustration but as the main vehicle for storytelling. Writing with Archibald MacLeish, Luce proclaimed the purpose of the new magazine:

> To see life; to see the world; to eyewitness great events; to watch the faces of the poor and the gestures of the proud; to see strange things – machines, armies, multitudes, shadows in the jungle and on the moon; to see man's work – his paintings, towers and discoveries; to see things thousands of miles away, things hidden behind walls and within rooms, things dangerous to come to; the women that men love and many children; to see and to take pleasure in seeing; to see and be amazed; to see and be instructed; Thus to see, and be shown, is now the will and new expectancy of half mankind.[13]

It was out of this creative ferment in photography in the first half of the 1930s that Stryker's FSA project was born, and the images produced by the FSA would

be fed back into the magazines and newspapers of the US (free of charge), just as FSA photographers would themselves be employed, when the project was ended, as staff photographers for *Life*, *Look*, and other picture magazines. In this sense, the creation of the FSA archive, while completely fortuitous, was almost inevitable – the product of multiple examples, contemporary and historical, that set the stage for Stryker's work.

How was it organized?

As first defined, the photographers were being sent far and wide across America (each in a specific geographical region) to gather images relating to agricultural policies, images that would support the programs of the Department of Agriculture. But the FSA project soon gained a broader purpose, following Stryker's consultation in 1936 with the esteemed sociologist Robert Lynd at Columbia University in New York. Lynd had spent the last ten years or more researching and writing, with his wife Helen Lynd, the two comprehensive studies of a "typical" American town, *Middletown* (1929) and *Middletown in Transition*, which would come out in 1937 (Middletown was in actuality Muncie, Indiana), and he responded to the sample images Stryker brought with him with great excitement. Stryker left the meeting with his own head full of Lynd's suggestions, which he hastened to write down and which he drafted into one of his famous shooting scripts. The scope of the FSA project became immediately expanded and clarified, as Stryker elaborated the kinds of images his photographers should be seeking, under such broad categories as "Home in the evening," "Attending church," "Where can people meet?," "Backyards," "People on and off the job," "The effect of the depression in the smaller towns of the United States," "The wall decorations in homes as an index to the different income groups and their reactions," and so on.[14] This new expansion of the purpose of the FSA file would lay the foundation for the great achievement of the archive.

Stryker's passion was contagious, and is nowhere more evident than in a 1937 memo written by one of the FSA team, "Standards of the Documentary File," which affirms the centrality of documentary to American culture. Unlike the incidental pictures of America that appear in Hollywood films, the memo

Roy Emerson Stryker at work, sometime between 1940 and 1943. Though he went into the field on occasion, most of Stryker's work was in Washington, D.C., managing the file and the many requests for FSA pictures. Photographer unknown.

begins, "we are today making a conscious effort to preserve in permanent media the fact and appearance of the 20th century." The author, John Vachon, leaving his graduate studies in English, entered employment at the FSA as a file clerk and was therefore, we may assume, obsessed with the file and its arrangement. (He was also beginning his career as one of Stryker's longest-term photographers in the field.)[15] The camera, Vachon intoned, "should leave for the future a very living document of our age, of what people of today look like, of what they do and build. It should be a monumental document comparable to the tombs of Egyptian pharaohs, or to the Greek temples, but far more accurate."[16] Vachon argued that the FSA file – "the only important file of this sort" – should not encompass the whole of the world; it should not be a complete picture collection, nor an art collection, nor an antiquarian's file. Neither should it be a technical collection, a display of farming techniques or architectural plans. What should the FSA be, then? Vachon answers that it should capture the "typical" (again that word), the rural and the urban, the upper and the lower classes; in short, it should contain "the honest presentation and preservation of the American scene."[17] Vachon offers as examples specific images by Russell Lee, Walker Evans, Arthur Rothstein, and Dorothea Lange, and he insists on the intelligence and sensibility of the photographer as essential requirements, along with the ability to capture a definite "feeling" about the American scene.[18]

Vachon concludes with a brief statement about the archive itself, which he views as an end in itself and quite apart from its use for any publications: "As a picture of our country, the separate photos should be divided into the concrete units of our country, the states of the United States. They should be kept in a well organized file of states. And this file should be considered the things we are building."[19] And so they were, until Stryker brought in an outsider, in 1942, a librarian with a passion for organization, Paul Vanderbilt.

Vanderbilt had trained in art history at Harvard and had served as librarian at the Philadelphia Museum of Art during the 1930s; he met Stryker through Beaumont Newhall when Vanderbilt was in Washington to help the US Navy archive its photographs. The FSA archive before Vanderbilt contained not only pictures taken by the Stryker photographers but also photos taken by the military services, industrial firms, and the Office of Emergency Management, which later became the Office of War Information (OWI).[20] Images were sorted by state and by assignment within the state. Some of the headings within the states gathered images together according to subject (e.g. Cities, Towns, Roadsides, Farming); and there were some general categories that transcended the states (e.g. Finance, Food Products, Manufacturing). Vanderbilt's reorganization comprised two major principles: first, he would gather all the photographs taken by a photographer on a single assignment and keep these together in "lots"; and second, he would sort the prints into a classification scheme that erased the state boundaries and used six regional headings instead; within each region, Vanderbilt created topical subject headings. Given that he usually had only one print to work with, the creation of the lots was done by gathering the prints together and microfilming them in a numbered sequence. (Eventually he formed 2,200 lots.) Then he would sort the prints, each mounted on stiff cardboard and containing the captions supplied by the photographer, into the major categories, which included, for example: the Land, Cities and Towns, Homes, Transportation, Medicine and Health. Within a category such as Transportation there might be subclasses (e.g. Horses, Automobiles, Garages, Road repairs, Trucks).[21] For any individual print found in the file, the user could find the lot number on the back and thereby trace the image back to the original context of its making, in the microfilm version.

As Alan Trachtenberg points out, Vanderbilt's scheme was meant to generate meaning. Photographs were conceptions as well as facts, and images should, as Trachtenberg writes, "be endlessly recombined into new relations to generate new ideas, new cognitions, new senses of the world."[22] The maker of the file should allow for the retrieval of an individual image, but the file's greater purpose, Vanderbilt wrote, was "to provide for recombination and reuse....Certainly the provision for location of pictures on call is not to be neglected, but more important is the scattering of pictures in the pathways of search, where they may be found unexpected as fresh inspirations."[23] Vanderbilt could not foresee the digital age that was coming in

the decades after he wrote about the making of the FSA-OWI file, but by the late 1990s, digitization of the FSA images was well underway. Any user in the world with Internet access may now go to the Library of Congress's Prints and Photographs page and search the FSA-OWI file, making possible a variety of pathways and discoveries that Vanderbilt could only dream of: Tires; Migrant workers; City stores; Church. These words will yield the expected results, assuming the words themselves are part of the bibliographic documentation that the Library of Congress has matched with the image, including the original captions for the images, which are the main source of searchable "content" and were transferred to the online catalogue.[24]

If, however, the word is not on the bibliographic page, the image will not turn up, regardless of what's in it. Try the word "happy": with the exception of a farmer who declares that he likes the "happy and hard-working" Negro pickers he hired from the FSA, most of the uses of the word "happy" are in connection with the war: airplanes make "happy" landings, soldiers hang out at "Happy Tavern," a soldier is "happy" to be pushing supplies to the Russian war front, and so on. "Sad" got three hits. "Frightened" got one – and it was the Nazis who were frightened. (These are from the war years, obviously.) Americans, Roosevelt said, had nothing to fear but fear itself. "Fear" yields eleven results, with several of them relating to the "Four Freedoms" (FDR's 1941 goals for the US, one of which was freedom from fear), and others relating vaguely to momentary emotions, but not to the underlying trauma of the Depression itself. In short, even the digitized file is limited by the descriptive language used by the photographers who were supplying captions for Stryker's growing archive and will not allow users to discover the more nuanced representations of everyday life that are contained in so many of the images themselves. "Dignity" is a word that is used countless times in describing the work of Dorothea Lange, for example, but there is no return of images for the word in the FSA file, and it would take another project on the scale of the FSA itself to tag the images in the file with the language of emotions.[25]

The archive in the years since its origin
What is the meaning of the FSA archive? No single answer can possibly suffice, but we have had more than a few attempts to create meaning out it, the first ones being contemporaneous with the formation of the archive itself and continuing to the present day.[26] Poet Archibald MacLeish was intrigued by the FSA photographs and began by looking for images to illustrate a text he was planning; but the FSA file was so powerful that he ended by reversing the expected relationship between text and image: *Land of the Free*, he wrote in the Notes, "is the opposite of a book of poems illustrated by photographs. It is a book of photographs illustrated by a poem."[27] MacLeish's careful sequencing of the images tells the main story, with his own poetic text printed on facing pages under a blue line that represents a "sound track" on a film strip and shaping the meaning of the narrative. For MacLeish, writing in 1937 in the depths of the Depression, the meaning of the file was a story of bewilderment, disillusionment, and at the end some hope that out of the confusion of the times may come the will to demand a better life from a government that should serve the people's needs.

MacLeish's story was given greater specificity in what was perhaps the first work by an FSA photographer to have a major impact on the national audience, Dorothea Lange and Paul Schuster Taylor's *An American Exodus*, which defined the core narrative of the FSA years. Harsh climate conditions combined with poor crop planning produced unprecedented farm failures, which led to banks foreclosing on farm properties, allowing the major agricultural companies to take over with their more efficient machines. This forced farmers who had lived for generations in the Dust Bowl region to leave their homesteads and take to the road. Their exodus, in search of work in the fertile California valleys, was the story Lange and Taylor told through pictures, text, and quotations. In turn, their iconic Dust Bowl images and stalwart farmers on the road became symbols of an era, to be fictionalized in John Steinbeck's contemporaneous *The Grapes of Wrath* (1939).[28] For both Lange and Steinbeck, the FSA camps, housing migrant workers, were models of government assistance, but Lange and Taylor concluded *An American Exodus* with the labor unrest in the West that was dividing migrant workers and the big farm owners.

Others used the FSA file to tell quite different stories. Sherwood Anderson's *Home Town* (1940), for example,

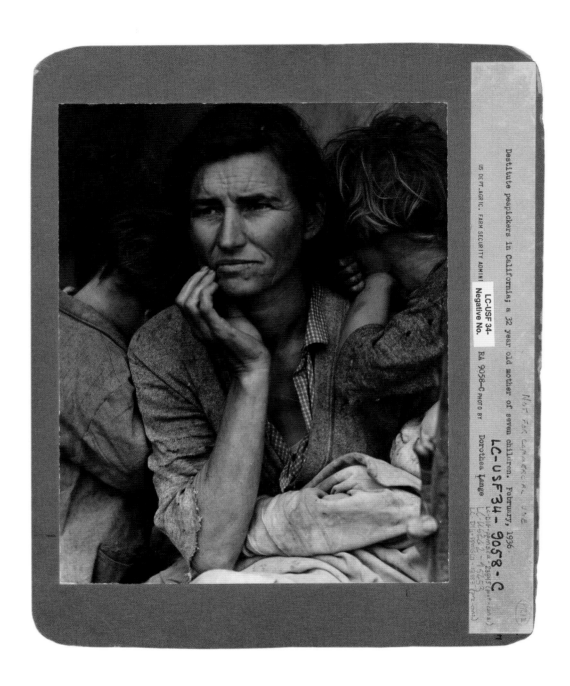

Dorothea Lange's iconic "Migrant Mother," here seen as it was filed in the FSA archives, mounted on stiff cardboard, with the caption typed on the side label. The thumb on the lower right was later eliminated from the image by Lange when she retouched the photo. Nipomo, California, 1936.

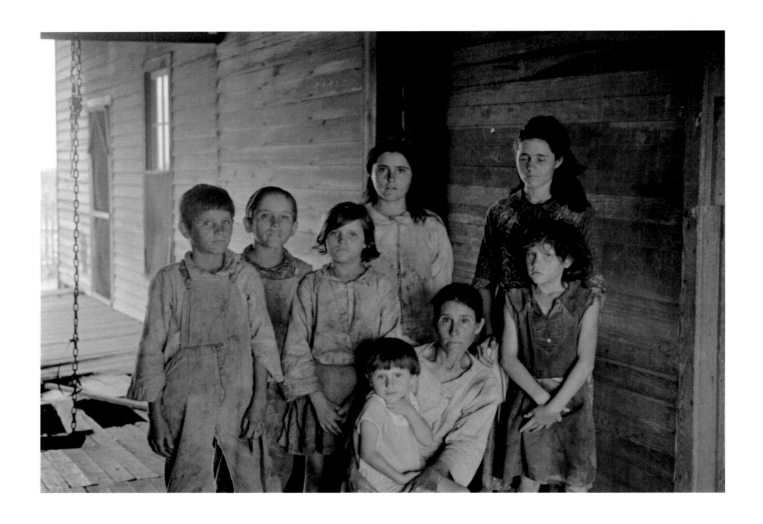

A group portrait by Walker Evans of one of the Alabama tenant farmer families who are the subject of Evans and James Agee's *Let Us Now Praise Famous Men* (1941). Evans used a large-format camera for these more formal portraits, thus assuring a detailed image. Hale County, Alabama, 1936.

depicts a society in which the small town forms a central emotional tie for the American, and in which the machine "has brought the land and the people of the land closer to the towns." Edwin Rosskam, who assisted Stryker in managing the file, selected the images for Anderson's book, which drew upon the many images of small towns that FSA photographers were requested by Stryker to take. Rosskam's sense of the FSA archive, already in 1940, is a mixture of expectation and retrospection: "It can be said without exaggeration that, neatly mounted on gray caption cards in Washington, our time on the land is already becoming history…. In rows of filing cabinets they wait for today's planner and tomorrow's historian."[29] But Rosskam's FSA file told a very different story when he edited the pictures for yet another photographic book, Richard Wright's 12 *Million Black Voices: A Folk History of the Negro in the United States.*[30] Here the narrative – and the corresponding illustrations – follows the migration of the African American from the Southern to the Northern states in the early twentieth century, emphasizing the Chicago and Midwestern region that had been Wright's own path of migration. His text is directly woven into the picture layout on several occasions, punctuating a narrative that is otherwise a folk history of the move from rural to urban America and the adjustment of the African American to the machine and modern civilization.

One more work from the 1930s must be acknowledged, and it has been perhaps the most important one to keep alive the legacy of the FSA, from the mid-twentieth century to our own time – James Agee and Walker Evans's *Let Us Now Praise Famous Men.* Agee was commissioned by *Fortune* magazine to do a story on Southern sharecroppers in 1936, and he took with him, during that summer, photographer Walker Evans, on loan from the FSA. Evans was a relatively short-term member of the Stryker group, but the images he produced were a model for the younger photographers, and the photographs he took in Alabama in connection with the Agee project became iconic representations of 1930s America in the decades following the Depression. Evans and Agee both eschewed the New Deal narrative that was so prevalent in 1930s documentary (the common man, crushed by the failing economy of the Depression,

is brought back to life through the help of enlightened government programs); instead, they depicted the most downtrodden of Alabama tenant farmers with a dignity and beauty that created a profound and puzzling response, dividing the viewer's feelings between pity and homage.

Agee's text, the most brilliant prose of the decade on the subject, carried the reader deeper into the lives of the poor than one could imagine and in the process posed the dilemma of all documentary forms more acutely than anyone before or since: by what right do we observe and objectify the lives of others? *Let Us Now Praise Famous Men*, hardly noticed when it came out in wartime America, was never quite forgotten either, and Agee went on to write *A Death in the Family*, which came out in 1957, two years after Agee's death at the age of 46. When the novel won the Pulitzer Prize in 1958, fresh attention was focused on Agee's work, and in 1960 Houghton Mifflin brought out a new edition of *Let Us Now Praise Famous Men* (with a preface by Walker Evans). The work has not been out of print since then, with paperback editions in the 1960s becoming a vade mecum for Northern Civil Rights workers going to the South during the mid-1960s.

Given the monumentality of the FSA archive, which we may view as an accident of history, the years of the Great Depression in the United States seem destined to endure in the national memory as a trauma we can return to again and again, from different angles, in an effort to understand it. And given the sheer size of the archive, we are dealing with a mountain of images that can be carved into any number of visions of the period. Surely the first major response to the archive, following the 1960 re-publication of *Let Us Now Praise Famous Men*, was Steichen's "The Bitter Years" exhibition, and it is worth looking at the way Steichen presented it to the public.

Steichen's initial response to the FSA work, in the 1938 exhibition that inspired his *U.S. Camera* essay and the selection of images accompanying it, imposed its own narrative on the imagery, and one that carried over, we might say, into the creation of "The Bitter Years." Alan Trachtenberg describes Steichen's vision best when he says that the implied audience for these pictures are not among the afflicted who are pictured:

the crisis is felt only among the "lower orders," that is, the uneducated, chronically poor blacks and whites, the drifting migrant families, whom we can look "down" on in an act of self-ennoblement. The story we hear is a "pastoral," a story in which the lowly "shepherd" characters – the ignorant, dirty, and hungry but wise and just country folk – instruct us in dignity, humility, sorrow, transcendence, or whatever we clean urban people (perhaps just beginning to feel the crunch ourselves) might wish to hear from such imagined characters.[31]

Interestingly, if we accept this "pastoral" reading, then Steichen was in effect erasing the New Deal narrative of the period itself, which looked at the role of government as essential to our national salvation. Instead, Steichen's response to the FSA work emphasizes the merits of those pictured, especially the rural poor, who survived the Depression by the force of their character and who provide a model for the American middle class.

We can look at The Bitter Years as autobiography – the final statement of a life in photography that was giving the last word to the social-documentary and mass-communication function of the medium – but we can also look at the book as an attempt to intervene in the national history of the United States. In that sense, we may view it as the exemplary act of an artist and a patriot, a return to history in order to provide a foundation for the future. As Steichen wrote in the brief introduction to his book The Bitter Years in 1962, "I believe it is good at this time to be reminded of those 'Bitter Years' and to bring them into the consciousness of a new generation which has problems of its own, but is largely unaware of the endurance and fortitude that made the emergence from the Great Depression one of America's victorious hours."[32] We can argue about what finally brought the US out of the Great Depression – Keynesian economic intervention in the free market or simply the robust response to World War II – but even so we can pay tribute to the virtues of the Depression generation.

But in 1962, when "The Bitter Years" opened, what problems did this new generation have that Steichen's 1930s exhibition was addressing? The Cold War? The

atomic bomb? These were surely in the background, but they were not the daily thoughts of most Americans, who in 1962 had already left the post-war nightmare of the McCarthy years behind, years when the merest association with the Communist Party was enough to earn blacklisting and ostracism. Indeed, if the FSA archive represented anything in the early 1960s, it must be a decidedly anachronistic vision of America, a vision of the Depression that was far from the dreams of suburbia, of Levittown houses, of finned automobiles, of Elvis Presley, Chubby Checkers, and the twist, of frozen food and TV dinners, of electric typewriters, portable radios, of television – Ed Sullivan, Milton Berle, and American Bandstand; far indeed from the utopian dreams of Disneyland. What could the Depression mean to this younger generation?

Meanwhile, for the parents of this generation – those who had grown up during the Depression or lived their mature lives in an economy that was perched on the edge of catastrophe – the years of the 1930s represented in the Steichen exhibit would have been like returning to the scene of a disaster, reliving the terrible scenes of deprivation and suffering that had challenged the will to survive and sent people to breadlines, to migrant worker camps, to scavenge for coal in slag heaps and for food in garbage dumps, with millions on the roads and rails traveling to nowhere. No wonder this was not the most popular exhibition in MoMA's history.

If Steichen was offering "The Bitter Years" as a lesson plan for a generation who for the most part didn't know what degrees of fortitude would be required of them, he had another motive in mind as well: "It is also my hope," he writes in the same introduction, that the FSA exhibition "may lead the Federal Government to establish and sponsor a permanent photographic organization for the continuing record of every phase and activity of the United States and its people. This idea might be in line with that of The National Council on the Arts and Government, which has included photography in its list of the arts." Here, I would argue, is the central rationale behind Steichen's last MoMA exhibition – to offer, as his final legacy, a model for the kind of photographic program he could envision for the US at this time, a massive documentary effort that would rival, if not surpass, the work of Stryker and the FSA in the 1930s, yet essentially along the same lines

that Stryker had also evolved as the ultimate purpose of the FSA project: to record photographically the entirety of American culture for the American people. Steichen attaches his idea to the optimism and ambition of the moment, for it was in the early 1960s that the US government was indeed in the business of founding what would become the National Endowment for the Arts (NEA) and the National Endowment for the Humanities (NEH), both created by Acts of Congress in 1965. (Steichen refers to the germinating committee, active in 1962, that would soon lead to these institutions – the National Council on the Arts and Government.)

The NEA and the NEH have sustained for nearly fifty years their crucial roles in fostering the intellectual and artistic cultures of the US, but neither agency would articulate a national mission that would approach anything like Steichen's dream of a continual documentary undertaking. Instead, they have functioned as grant-giving agencies, responding to applicants from the arts and humanities who have applied for support in their individual projects. One might look at the totality of NEA and NEH support

and see a collective body of work that touches on myriad aspects of American culture, both in terms of production and study, but not the systematic documentary program that Steichen hoped to see. All of which reminds us how unique was the body of work and the totality of achievement wrought by Stryker and his photographers during their years of operation, from 1935 to 1943.[33]

Ten years after "The Bitter Years," Stryker formulated his own retrospective view of the period, in his collection of FSA work, *In This Proud Land*.[34] To Stryker the collection must be considered as a whole to be appreciated, and what he sees in the whole is "an unusual continuity to it all. Mostly, there's rural America in it. It's the farms and the little towns and the highways in between." And what distinguishes the archive file is "an attitude toward people," a respect for the common man that is, after all, the hallmark of 1930s culture.[35] Stryker's images offer a cross section of America, geographically considered, but his pages are consistently peopled with the "folk," the shepherds, as Trachtenberg might call them, and his caption for the last two images makes the final statement in terms

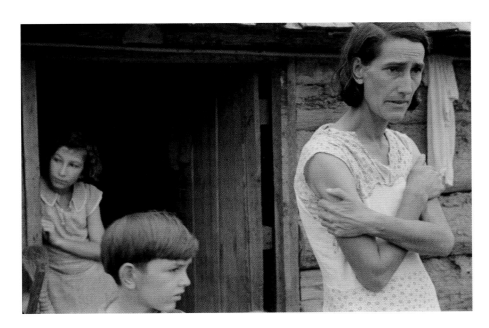 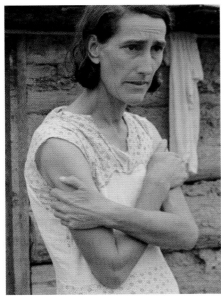

The family of a Resettlement Administration client. Steichen used this photograph by Ben Shahn in "The Family of Man" (reproduced on a full page in the book) and again in "The Bitter Years"; in both cases he cropped the original (above left) to focus on the image of the woman. Boone County, Arkansas, 1935.

that are consistent with Steichen: "Dignity versus despair.... I believe that dignity wins out."[36]

Stryker may have created the FSA file, but his vision doesn't possess it entirely and in perpetuity, and in the years since *In This Proud Land*, a number of other collections have appeared, mining the files in ways both predictable and unpredictable. While Stryker (and Steichen) emphasized the collective nature of the FSA enterprise, creating narratives of photographs rather than of photographers, several volumes appearing after them have shifted toward an emphasis on individual photographers. With each volume, we are often discovering images not published before, and this adds to a sense of the infinite wealth within that FSA mountain. Thus the early collection by Hank O'Neal, *A Vision Shared*, allows the photographers to choose their own most representative images.[37] *FSA: The American Vision* likewise allows each photographer a separate narrative and emphasizes the coherence of their individual projects rather than the coherence of the entire FSA.[38] A similar structure is used in *The Likes of Us*, where the photographer is primary.[39] Michael Lesy returns to an overall view of the FSA in his collection, *Long Time Coming*, and though there are many rural images we get for the first time in Lesy's collection a sense of the strong urban dimension of the archive.[40] And because we inevitably have been conditioned to think of the Depression in black and white, it is shocking to see, coming to our full senses, that it actually took place in a world of color: Paul Hendrickson's *Bound for Glory: America in Color, 1939–1943*, mines this dimension of the file, presenting a fraction of the nearly two thousand images taken in color by the FSA photographers in the last four years of the project.[41]

These are all works that take the totality of the archive as their subject. Meanwhile, scores of books have appeared in the last twenty years that have mined the FSA file for more narrowly specific topics, the two most common approaches being work by individual photographers and work that highlights a particular state. Thus Esther Bubley, Jack Delano, Walker Evans, Dorothea Lange, Russell Lee, Arthur Rothstein, Ben Shahn, John Vachon, and Marion Post Wolcott have all received full treatment, and many of these are also the subject of a uniform series begun in 2008 by the Library of Congress, called *Fields of Vision*, which features

fifty photographs by each photographer. In addition, there is no shortage of books collecting FSA work featuring life in individual states, thus reaffirming the political divisions that had been set aside by Vanderbilt's regional classification system: Colorado, Florida, Illinois (three on Illinois, including Chicago), Indiana, Iowa, Kansas, Kentucky, Louisiana, Maine, Michigan, Minnesota, Mississippi, Missouri, Montana, New Mexico (four on this state), Ohio, Pennsylvania, South Carolina, Texas, Utah, Vermont, and Virginia. The works featuring individual photographers allow us to recapture the individual vision that was all too readily subsumed under the ethos of a project whose "collective" nature was one of its proudest boasts. Moving from the collective to the individual, we can begin to appreciate the idiosyncratic strengths brought to the file by the singular visions of these photographers. Viewing the pictures by state provides yet another perspective on the file, one in which we can look through the individual images at regional and local characteristics that break the indistinct totality of "America" into pieces which make more sense when seen as local places that shared local problems.

One more work remains to be mentioned, and it stands alone as an exploration of one of the remaining mysteries of the FSA archive – the fact that Stryker, while gathering the images that were to go into the Washington files, was at the same time winnowing the harvest of images, setting aside those that were, in his eyes, weak or otherwise destined for oblivion. What is remarkable is not so much that he was selectively editing the archive as he was creating it, but the way he chose to do so: for images he wished to discard, he would punch a single hole in the negative, thus rendering it unusable. (Prints of these "killed" images thus appear with what looks like a bullet hole, often in or near the center.) Stryker took this responsibility on himself, initially, though given the photographers' dismay and resistance, he ceased the practice in 1939. Was he simply eliminating technically poor images, or near duplicates (photographers often took several images of the same subject, bracketing the exposure)? Was he killing images that were compositionally inferior? Or ones that ridiculed their subjects? Or ones that might be subjected to criticism by outsiders? Or was he "disciplining" his photographers, showing

them who was boss, asserting his control over the picture file? All of these possibilities might make sense, but they are not upheld by the record of killed images, which is incomprehensible in its inconsistency. And they don't explain the brutal and irreversible mutilation of the images. We have known about Stryker's habit for years, and browsers in the online FSA file may have come upon some of these images from time to time. William E. Jones has devoted a book to the subject, called *"Killed": Rejected Images of the Farm Security Administration.*[42]

Jones takes as his premise the license we all enjoy now, with online access to the FSA files, to pick and choose among the pictures, creating any narrative we might like. Treating the archive not as a "memorial or a temple with dogma for us to obey, but a site for reinvention," Jones began his research in the FSA archive looking for documentation of queer Americans during the 1930s, and he discovered a few images that are suggestive in that regard and which he reproduces in *Killed*. Interestingly, these images were not destroyed. But his interest in the killed images grew, and he assembled the resulting volume as itself a deliberate act of "perversion": "I use the word perversion in the sense of putting the collection to improper use, or distorting its original intentions. I contend that perverting this important compendium of documentary photography is desirable, even necessary. Its photographs have become so encrusted with conventional pieties that we can hardly see them any longer."[43] Unless the photographer developed his or her own negatives (as did Dorothea Lange), the Washington office exercised central authority over photographers such as Walker Evans, Theodor Jung, Carl Mydans, Arthur Rothstein, Ben Shahn, John Vachon, Marion Post Wolcott – all of whose killed images are in that volume, arranged by photographer. Yet even these canceled images are available in the online archives and thus remain a part of the FSA story, and have even inspired an intriguing esthetic appropriation by artist Dimitra Ermeidou, who arranges the killed images into striking multiples, giving them new life in a work called *The Stryker Bullet Series.*[44]

The FSA archive can be seen from our own perspective now as the quintessential gift that keeps giving. Produced originally to show the US the effects of the Great Depression and to connect the role of government with the needs of the people, it soon took on a life of its own as the most nearly complete photographic record of a time and place that has ever been produced. That it is now online and searchable makes it, for the digital twenty-first century, a resource whose possibilities for narrative and understanding we will never exhaust. The social-documentary style that Stryker evolved in the practice of the FSA group is also a model for contemporary photography, in insisting that the eye behind the lens be informed and aware of the larger story that stands behind the individual picture.

Documentary since "The Bitter Years" has taken many different paths, of which we might distinguish three principal ones: one toward an over-intellectualized self-conscious theorizing of documentary itself (e.g. Martha Rosler, Allan Sekula); a second type that uses documentary as a kind of self-expression (e.g. Nan Goldin, Danny Lyon); and a third that features sensationalistic imagery which exploits the shock value of the visual (e.g. Diane Arbus, Mary Ellen Mark). The FSA was neither self-conscious nor personal nor sensationalistic, but occupied a middle ground, bearing witness to the times in the most detailed of ways, filled with curiosity and care, edged at times with wit and humor. The archive remains a resource of infinite value and inspiration, picturing a time and place that is long gone but that remains a part of us through these images.

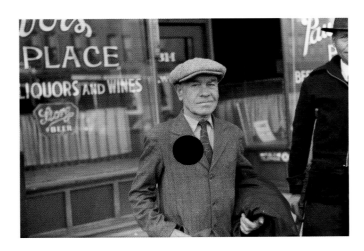

John Vachon's 1938 image, with a hole punched near the center of the negative, is an example of one of the photographs "killed" by Stryker. Surrounding images in the same lot indicate that it is a portrait of "Tommy Murphy and Ed Kay, traveling companions, Omaha, Nebraska."

THE CHÂTEAU D'EAU: A WATER TOWER AS CULTURAL RESERVOIR

Antoinette Lorang

Top: View from the blast furnace toward the city center with the water tower in the background, 1956.

Above: The Dudelange steel mill was modernized in 1928–31, when three new blast furnaces were brought into operation. The water tower was built at the same time.

The new home of "The Bitter Years" exhibition is the Château d'Eau, a disused water tower at the Dudelange steelworks, a relic of the steelmaking history of a town that was known at its industrial peak as the "forge of the south." A symbolic structure, the water tower plays an important role as a landmark for the town. Following sensitive renovation and appropriate refurbishment, it is now one of the most interesting sites of Luxembourg's industrial heritage.

Setting a cultural example

The conversion of industrial buildings into museums or cultural sites is now quite commonplace. The transformation of the abattoirs of La Villette in Paris into the Cité des Sciences, or the creation of Tate Modern in London from a former power station, are just two of the most famous examples of a practice that began in the 1980s. The restructuring of industry, particularly in the fields of ore and coalmining, iron and steelmaking, has left behind large complexes of buildings, often situated on the outskirts of towns. While a sizeable number of these sites have been demolished, parts of their infrastructure still survive, sometimes due to a deliberate conservation policy, sometimes merely by chance.

In the Grand Duchy of Luxembourg, awareness of the country's industrial heritage dates back to the time of the great steel-industry crisis of the 1970s. It was this loss that stimulated a desire to conserve and redevelop, in a period in which changes were taking place with increasing speed. The first industrial museum in the country was the Iron Ore Mining Museum in Rumelange, which opened in 1973; others would follow. A quite different example of the redeployment of an industrial building occurred some fifteen years later, when a young people's collective succeeded in

turning a former abattoir in Esch-sur-Alzette into a cultural center. Since then, further buildings have been converted for cultural use, including a water-storage tank in Differdange that recently reopened as the H2O Gallery, and the Massenoire building close to the Belval blast furnaces, which now houses the documentation center for the Cité des Sciences university project, currently under construction on what was once industrial wasteland.

It is therefore not surprising to find the internationally renowned photographic collection "The Bitter Years," which is conserved by the Centre National de l'Audiovisuel in Dudelange, installed in the water tower of a former steelworks. Nor should it be. In particular, the unusual nature of the exhibition spaces justifies this choice, as well as the thematic links between the exhibited works and the history of the site. Worker migrations of the kind depicted in "The Bitter Years" have been associated with the town of Dudelange for more than a century. The establishment of the steelworks led to the arrival of many immigrant workers who settled in the neighborhoods that sprang up around the mill, particularly the Schmelz and Little Italy districts. The story of immigration is still ongoing today, at these locations close to the water tower.

A country shaped by steel

The water tower of the Dudelange steelworks was built in 1928, at a time when the plant was undergoing major changes. More than forty years had passed since the steelworks had been put into service. It was the first integrated steel mill in the country, meaning that it had its own blast furnaces, steelmaking facilities, and rolling mills, capable of creating finished steel products. Throughout the twentieth century, Dudelange ranked among the largest steel-production sites in Luxembourg, alongside others at Esch-sur-Alzette, Schifflange, Rodange, and Differdange.

Before discussing the Dudelange works in more detail, it is important to look at the steel industry in Luxembourg and its unprecedented growth. From a small and poor agrarian society at the start of the nineteenth century, Luxembourg rose to sixth place in the world ranks of iron production by the start of World War I. The economic expansion of Luxembourg resulted from several factors. These included the rediscovery of deposits of iron ore in the south in around 1840; the country's decision to join the German customs union known as the Zollverein in 1842, and the availability of foreign investment capital, particularly from Germany, which allowed for the construction of large factories; and, last but not least, the building of a railway from 1859 onwards.

The iron-ore deposits in the south of the country had lain forgotten for several centuries. The deposits were part of the iron-bearing rock layers of the Paris basin, a small part of which extends into southern Luxembourg and is known as the "mining basin." The rediscovery of the iron ore known as "minette," because of its low iron content, gave rise to a new era for the steel industry in Luxembourg. Membership of the Zollverein opened up a huge market for the sale and distribution of goods and the supply of coal. Lastly, the arrival of railways brought Luxembourg's geographic isolation to an end.

In the 1860s and 1870s, the Luxembourg steel industry underwent a veritable boom, leading to the full-scale exploitation of the ore deposits and the construction of large modern steel mills in the mining basin. At first the minette ore was mostly intended for export, but the Luxembourg government and business interests involved soon realized that on-site production would be of greater benefit to the local economy and they put stricter regulations in place regarding the granting of mining concessions.

However, the production of iron alone did not fulfill the huge demands of the market, and there was a rise in the number of integrated mills, which included blast furnaces, steelmaking and rolling facilities, in order to manufacture finished or semi-finished products. Luxembourg's major problem was the fact that the minette ore had a high phosphorus content and so did not lend itself well to traditional steelmaking processes. It was not until the invention of the Thomas-Gilchrist process, patented in 1877 by British inventors Sidney Gilchrist Thomas and Percy Carlyle Gilchrist, that it became possible to turn low-grade ore into high-quality steel. The Thomas-Gilchrist process revolutionized the Luxembourg steel industry by allowing steel to be produced from minette, and Dudelange was the place where this revolution began.

Dudelange: the first center of Luxembourg steel

The company known as the Société en Commandite des Forges d'Eich Metz et Cie soon became aware that the Thomas-Gilchrist process was a great opportunity for the Luxembourg steel industry. Just a few weeks after the process was patented, the firm acquired a license to use it. This led to the formation of the Société Anonyme des Hauts Fourneaux et Forges de Dudelange and to the construction of the steelworks. This was an early culmination of a policy pursued for many years by Auguste Metz, the entrepreneur who founded the company Metz & Cie in 1838 and soon acquired land in the mining basin, including at Dudelange.

In the 1890s, steel production in Luxembourg entered a crucial phase. New integrated steelworks that incorporated the agglomeration of raw material, blast furnaces, steelmaking, and rolling mills were built in the mining basin, and among these was the Differdange works, opened in 1896, which achieved a world renown that still survives today for its production of "Grey beams," a type of steel girder named after its inventor, American engineer Henry Grey. At Esch-sur-Alzette, two integrated mills were built at the turn of the century, the old ironworks belonging to Metz & Cie was modernized, and a new mill was built at Belval between 1909 and 1912; steel piles – one of its branded products – are still manufactured today in the same location.

The need for business consolidation led to the merger in 1911 of Hauts Fourneaux et Forges de Dudelange with Mines du Luxembourg and Forges de Sarrebruck, and with the Forges d'Eich. ARBED (Aciéries Réunies de Burbach-Eich-Dudelange, or the United Steelworks of Burbach, Eich, and Dudelange), became one of the largest steel companies in the world and synonymous with the steel industry in Luxembourg. Émile Mayrisch, director of the Dudelange mill and a towering figure in the Luxembourg steel industry, became the general director of the new company. The firm owned twenty-one blast furnaces and two steelmaking facilities, with an output of 824,500 tonnes of steel in 1912.

ARBED remained based in Dudelange until 1922, when it opened a prestigious new headquarters in one of the most desirable districts of the city of Luxembourg, the Plateau Bourbon. This classical-style building with its symbolic ornaments and courtyard provided a more suitable setting for an international steel company than the old Dudelange site.

An overview of the Dudelange mill

The founders of the Société Anonyme des Hauts Fourneaux et Forges de Dudelange included factory owner Jean-Norbert Metz, Belgian politician Victor Tesch, and Comte René-Auguste-Anatole de Bertier, owner of the Dudelange land.[1] At their first meeting, the new company's board of administrators gave their approval to contracts with the engineer R. M. Daelen of Düsseldorf for the design of the steelworks and with the Victor Tassin company for the delivery of bricks. It was decided that construction work should begin immediately. The first stone was laid in November 1882. Curiously, however, planning permission to build the mill was not requested until June 17, 1883, and it was granted on November 10 of that year.

The site included four blast furnaces, steelmaking facilities, a rolling mill, an engineering workshop, and a foundry, as well as open-cast and drift mines. Each blast furnace had a hearth diameter of 3.5 meters and an average output of around 150 tonnes of iron per day. The steelworks was located at Breitwies, on pasture land crossed by a stream and a canal. The site totaled 22 hectares.

Some difficulties delayed the opening of the steelworks. At the start, Dudelange had no rail links and the state of the roads left much to be desired, meaning that the transport of raw materials for the construction of the mill was very difficult. Eventually, on July 14 and 30, 1885, the first blast furnaces were fired up. Following delays in the construction of the casthouses, the first Thomas converter was put into operation on April 15, 1886; the third blast furnace went into service on 1 December of the same year and the fourth in 1889. Two additional blast furnaces were opened in 1893 and 1899 respectively. Among other products, the Dudelange works made ingots, blooms, slabs, billets, merchant bars, beams, rails, and sleepers. In 1906, major modernization work began on the mill, which continued for several years.

In the 1920s, the Dudelange mill was adapted to meet the changing demands of the market, with the

construction of the Greisendall sheet-metal works and new blast furnaces, the older ones no longer being competitive. To increase production, all the blast furnaces were replaced by three new American-style units with a 6-meter hearth and a daily output of 450–500 tonnes. Unlike the old blast furnaces, which were loaded by carts pushed by hand, the new blast furnaces were fed by means of an electric hoist that carried the skips (small wagons) up and down an inclined track. These three new blast furnaces were put into service in 1929, 1930, and 1931. Although the furnaces had formerly employed around 500 workers, 70 percent of whom were Italians, the new installations only needed a workforce of around 160. A fourth blast furnace with a 7.2-meter hearth and a daily output of 750 tonnes was opened in 1962.

The crisis in the steel industry that began in the 1970s, prompted by the oil crisis, led to the gradual closure of the former industrial sites in the mining basin. Moreover, the excavation of minette was no longer profitable. In 1981, the last iron-ore mine in Luxembourg closed; after that date, all iron ore was imported. In 1997, the last blast furnace in Luxembourg closed, at Esch-Belval. Three mini-mills using electric arc furnaces were opened at Belval, Differdange, and Schifflange. The Luxembourg steel industry had to face increasingly stiff competition, particularly from "coastal" steel, produced on sites with access to sea transport. A merger of international firms led to the formation of the Arcelor group in 2002, which became ArcelorMittal in 2007.

It was within this context of redevelopment that the last working blast furnace at Dudelange, the steelmaking facility, and the hot rolling mill finally closed at the end of 1984. Two years later, dynamite was used to bring down the towers of the four blast furnaces. The only remaining traces of the old steel mill were a few scattered buildings and the water tower. The skyline of Dudelange changed completely. The slag heap disappeared from the urban landscape. A large area of indeterminate land was the result. The town of Dudelange seized the opportunity and began redevelopment. A new residential district and a supermarket were built on the industrial wasteland close to Dudelange's center and town hall. A new urban life was beginning to take hold.

The difficult living conditions for immigrants

The mining of iron in southern Luxembourg had created a huge demographic shift, owing to the mass influx of workers from poorer regions of the country and from abroad. Local labor soon proved insufficient to operate the new mills and excavate the ore. In around 1890, the first wave of immigration reached a peak. On the eve of World War I, the workforce of the Luxembourg steel industry was 60 percent foreign.

This demographic growth overturned the rural world of the mining basin and its villages. The statistics are striking. From a population of 2,250 in 1870, the year before the opening of the first steel mill, the town of Esch-sur-Alzette grew to a total of more than 21,000 residents in 1913. In Dudelange, the population had expanded from 1,600 in 1882 to 10,800 by 1910, when the workforce of the steelworks stabilized. Facilities to welcome these new workers were completely lacking. There was a severe accommodation shortage, so miners and millworkers were obliged to live in harsh conditions in the working-class districts that sprang up around the mills, including the Schmelz district in Dudelange. Heavy immigration from Italy led to the growth of the "Little Italy" district near the Dudelange works, which resembled an Italian village on a hillside with its cramped houses, alleyways, steps, and passages that swiftly formed an urban fabric.[2] This district became a symbol of Italian immigration and its history is preserved through the work of the CDMH (Centre de Documentation sur les Migrations Humaines), now installed in the railway station that once served the steelworks. In 2007, when Dudelange celebrated the centenary of achieving city status, the CDMH and the CLAE (Comité de Liaison des Associations d'Étrangers) held a photography exhibition called "Retour de Babel" ("Return to Babel"), retracing the routes traveled by foreign workers. It is no surprise that its organizers chose to stage the exhibition in a large hall that had survived the dismantling of the steelworks.

Nonetheless, most Italians have long since left "Little Italy" to live elsewhere, in "better" areas. Other nationalities have taken their place in the neighborhood, which has become a place of passage for people with a similar wish to escape from harsh conditions and seek out a better life.

The water tower and pumping station: high capacity, high potential

Water plays a key role in the workings of a steel plant.[3] It is essential for cooling the blast furnaces, and is also used for gas purification; gas from the blast furnaces was recycled to power machines such as blowers and turbines. Water is also required to produce granulated slag, a by-product of iron making. Large water tanks are therefore part of the standard installations at a steel mill. In order to use the water from the settling or cooling tanks, fed by springs, rainwater, and the local stream, a means of pumping it to wherever it was needed was required. The brick building situated at the foot of the water tower was the Dudelange mill's first pumping station. The pumphouse was in operation until 1929, when a new one was built, and the old building became a warehouse. It is a typical example of the industrial architecture of the nineteenth century, featuring a brick facade with large arched windows, topped by a row of smaller twin windows. The facade is punctuated by vertical divisions and modest decoration in the form of a frieze, bearing witness to a concern for architectural esthetics displayed by many industrial buildings of the period. The pumphouse was a small building among other larger constructions in the same style, built in the late nineteenth century. On old photographs of the steelworks several similar brick buildings can be seen, including the power station with its tower and carefully articulated facades.

The water tower, on the other hand, is typical of industrial buildings from the 1920s; its architecture is unpretentious and functional, but nonetheless striking for its compact and restrained design that retains a certain elegance. The Dudelange steelworks had two water towers of this type, built in the same era. The first of them, now converted into an exhibition space, had a single water tank and was used to cool the blast furnaces; the second, now demolished, served the rolling mill and also contained a second tank with drinking water.

The water tower is a concrete construction with a total height of 56.1 meters. The surrounding land is marshy because of the stream known as the Diddelenger Bach, which runs through it and fed the water tanks at the steelworks, so the structure was built on piles 15 to 17 meters deep. The tower consists of a cylindrical water tank supported by an open structure made up of eight pillars with horizontal reinforcements. The tank had a usable volume of 1,000 cubic meters. At its top is a roof lantern that allowed air inside. During World War II, a surveillance post was installed at the top. The tower could be accessed via a staircase that spiraled up between the pillars and up to the roof lantern through a cylindrical opening in the center of the reservoir.

The water tower was used to regulate and store the water required for cooling and blast-furnace operations. Water could be pumped into the blast furnaces and rolling mills at a rate of 9,000–10,000 cubic meters per hour. The purpose of the settling tank was to clean the water of any suspended matter from consumer use. After passing through the settling tanks, the filtered water was pumped to the blast furnaces. The water tower was directly connected to the feed pipe. With its functional height of 52 meters, the tower served as a reserve in case the pumps broke down, and it regulated the water pressure within the system (an open circuit). When the tank was full, the pumps were stopped, and any overflow was run off into the settling tanks. In total there were two settling tanks for the blast furnaces and two settling tanks for the rolling mill; one of the blast-furnace tanks is still in situ.

Today the water tower, strikingly renovated by the architect Claudine Kaell, houses two exhibition spaces devoted to the collection "The Bitter Years", one of which is located in the reservoir, some 40 meters up. A new elevator inside an exposed concrete cage and a staircase provide access to the tank and a viewing platform. The former pumphouse, connected to the water tower at ground-floor level, houses the reception area and a space devoted to contemporary photography.

A landmark in the cultural landscape

It was not by chance that the Dudelange water tower featured on the cover of a book published in 2007 by the town of Dudelange on the occasion of its 100th anniversary.[4] The photograph, taken by Marc Lazzarini, shows a young skateboarder taking to the skies alongside the water tower, a symbolic image

bringing together the past and the future of this former industrial town.

The water tower marks the urban landscape and became a popular subject for photographers and artists as the years went by. Following the closure of the steelworks in the 1980s and the demolition of most of its buildings, the water tower has become a symbol of Dudelange's past and of an industrial age that ended all too quickly. Since that time, the town has invested in economic redevelopment and also pursued a very active cultural policy. Through its art galleries, musical and other public events, it has managed to attract a regular audience of art and culture lovers. In addition, the creation of the CNA (Centre National de l'Audiovisuel) in Dudelange has contributed to this boom. The construction of a new building to house both the CNA and the Opderschmelz Cultural Center marks the beginning of a new phase of urban development that aims to revive the former industrial wasteland around the Dudelange mill, between the Schmelz district and "Little Italy." Under the auspices of Luxembourg's Fund for Housing, this should become a desirable area in which the water tower will occupy a well-deserved place as a photography center of international stature.

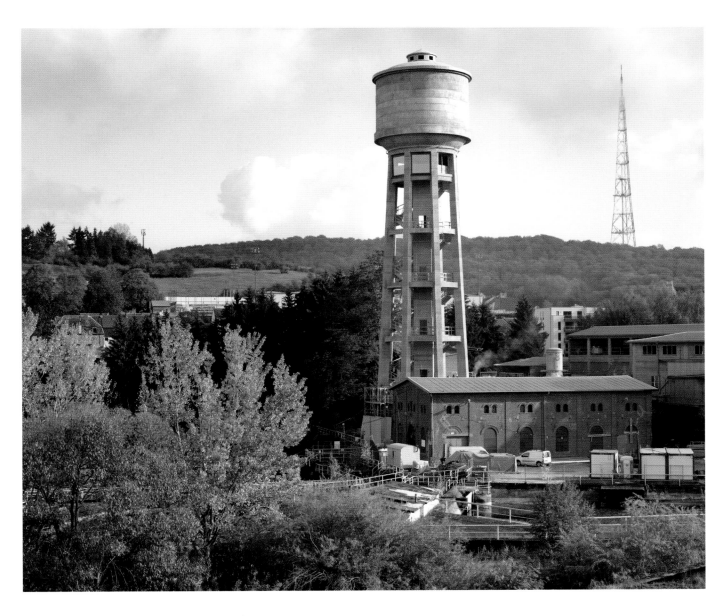

The water tower and the former pumping station
at the foot of the tower, 2012.

This exhibition, saluting one of the proudest collective achievements in the history of photography, is dedicated to

Roy E. Stryker

who organized and directed the Photographic Unit of the Farm Security Administration and to his photographers

Paul Carter

John Collier, Jr

Jack Delano

Walker Evans

Theo Jung

Dorothea Lange

Russell Lee

Carl Mydans

Arthur Rothstein

Ben Shahn

John Vachon

Marion Post Wolcott

EDWARD STEICHEN

THE PLATES

"I BELIEVE THAT IT IS GOOD AT THIS TIME TO BE REMINDED
OF 'THE BITTER YEARS' AND TO BRING THEM INTO THE
CONSCIOUSNESS OF A NEW GENERATION WHICH HAS PROBLEMS
OF ITS OWN, BUT IS LARGELY UNAWARE OF THE ENDURANCE
AND FORTITUDE THAT MADE THE EMERGENCE FROM THE GREAT
DEPRESSION ONE OF AMERICA'S VICTORIOUS HOURS. IT IS ALSO
MY HOPE THAT THE EXHIBITION OF AN INCISIVE FRAGMENT OF
A VAST UNDERTAKING MAY LEAD THE FEDERAL GOVERNMENT
TO ESTABLISH AND SPONSOR A PERMANENT PHOTOGRAPHIC
ORGANIZATION FOR THE CONTINUING RECORD OF EVERY PHASE
AND ACTIVITY OF THE UNITED STATES AND ITS PEOPLE."

EDWARD STEICHEN

Pennsylvania coal miner. Undated.

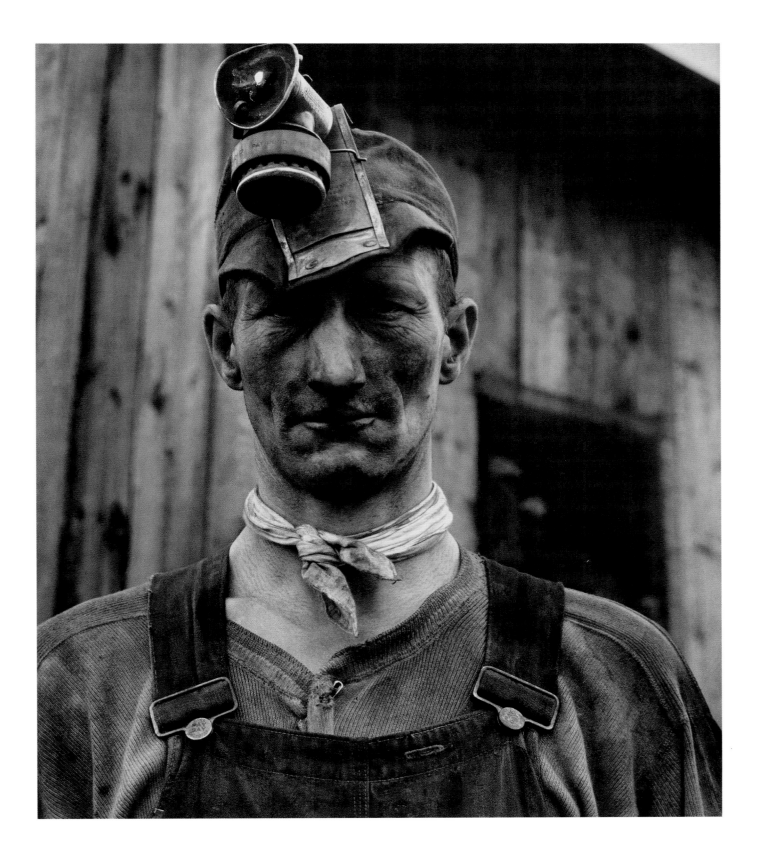

"IT WAS CLEAR TO THOSE OF US WHO HAD RESPONSIBILITY FOR THE RELIEF OF DISTRESS AMONG FARMERS DURING THE GREAT DEPRESSION AND DURING THE FOLLOWING YEARS OF DROUGHT, THAT WE WERE PASSING THROUGH AN EXPERIENCE OF AMERICAN LIFE THAT WAS UNIQUE.

AT LEAST WE HOPED IT WOULD BE UNIQUE; AND WE INTENDED NOT ONLY TO BRING THE RESOURCES OF GOVERNMENT TO THE ASSISTANCE OF THOSE WHO WERE DISTRESSED OR STARVED OUT BUT TO MAKE CERTAIN THAT NEVER AGAIN SHOULD AMERICANS BE EXPOSED TO SUCH CRUELTIES.

IT SEEMED IMPORTANT TO RECORD THE INCREDIBLE EVENTS OF THOSE YEARS; AND THE BEST WAY WAS TO PHOTOGRAPH THEM. ROY STRYKER WAS ASKED TO ORGANIZE THE WORK AND THE SUPERB JOB HE AND HIS COLLABORATORS DID SPEAKS FOR ITSELF. IT IS NOT ONLY A TECHNICAL TRIUMPH BUT A RECORD OF NEGLECT AND A WARNING.

IT CAN NEVER HAPPEN AGAIN TO SO MANY IN THE SAME WAYS – PARTLY BECAUSE WE HAVE THESE REMINDERS OF WHAT HAPPENED WHEN WE TURNED OUR BACKS ON FELLOW CITIZENS AND ALLOWED THEM TO BE RAVAGED."

REXFORD GUY TUGWELL

Carl Mydans

Interior of a wood shack built upon a Ford truck
chassis, housing a father, mother, and seven
children. This view shows the mother and two
of her children. They were found on Route 70,
between Camden and Bruceton, Tennessee, near
the Tennessee River. March, 1936.

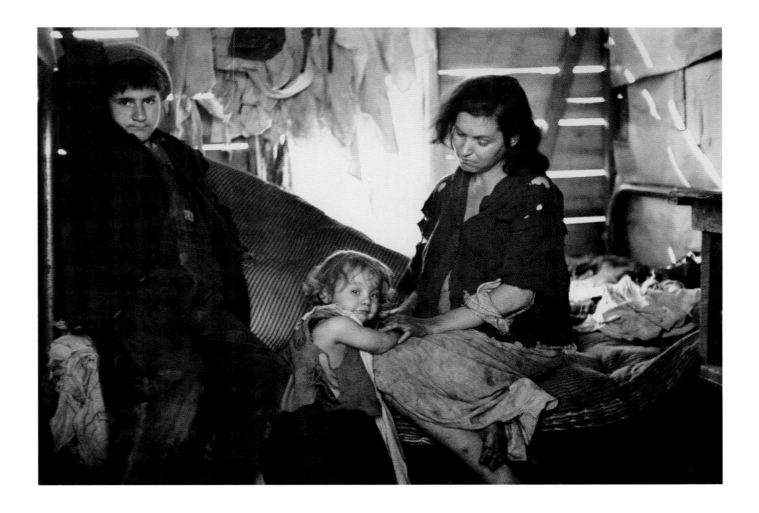

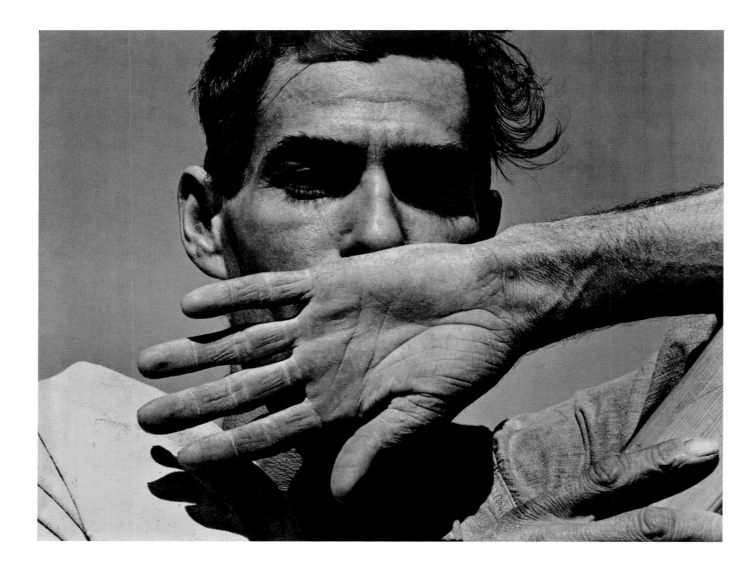

Dorothea Lange

He has picked cotton all day and stands at the
edge of the field and the cotton wagon.
Eloy, Arizona. November, 1940.

"IN 1935, MIDWAY DURING THE GREAT DEPRESSION, THE RURAL RESETTLEMENT ADMINISTRATION WAS CREATED WITHIN THE DEPARTMENT OF AGRICULTURE, TO ALLEVIATE THE PLIGHT OF AMERICA'S FARM POPULATION, AND PRESIDENT ROOSEVELT APPOINTED REXFORD GUY TUGWELL (THE UNDER SECRETARY OF AGRICULTURE) AS ITS ADMINISTRATOR. TUGWELL'S ADVOCACY OF THE DISSEMINATION OF INFORMATION BY VISUAL MEANS LED HIM TO DESIGNATE ROY E. STRYKER, HIS LONG TIME COLLEAGUE ON THE ECONOMICS FACULTY OF COLUMBIA UNIVERSITY, AS HEAD OF THE NEWLY CREATED HISTORICAL SECTION (THE PHOTOGRAPHIC UNIT) OF THE DIVISION OF INFORMATION OF THE RESETTLEMENT ADMINISTRATION, WHICH IN 1937 BECAME THE FARM SECURITY ADMINISTRATION. THOUGH NOT HIMSELF A PHOTOGRAPHER, STRYKER POSSESSED THE INTRICATE SKILLS REQUIRED TO DIRECT THE MEN AND WOMEN WHO WERE TO MAKE IN THE NEIGHBORHOOD OF 270,000 PHOTOGRAPHS OF THE LAND AND THE VILLAGES AND THE TOWNS AND THE PEOPLE IN THE EIGHT YEARS BEFORE THE PROGRAM BECAME PART OF THE OFFICE OF WAR INFORMATION. THE NEGATIVES ARE PRESERVED IN THE LIBRARY OF CONGRESS, TO SERVE AS RECORD AND PURPOSEFUL REMINDER, WHILE APPROXIMATELY 200,000 PRINTS ARE ON FILE IN THE PICTURE COLLECTION OF THE NEW YORK PUBLIC LIBRARY."

GRACE M. MAYER

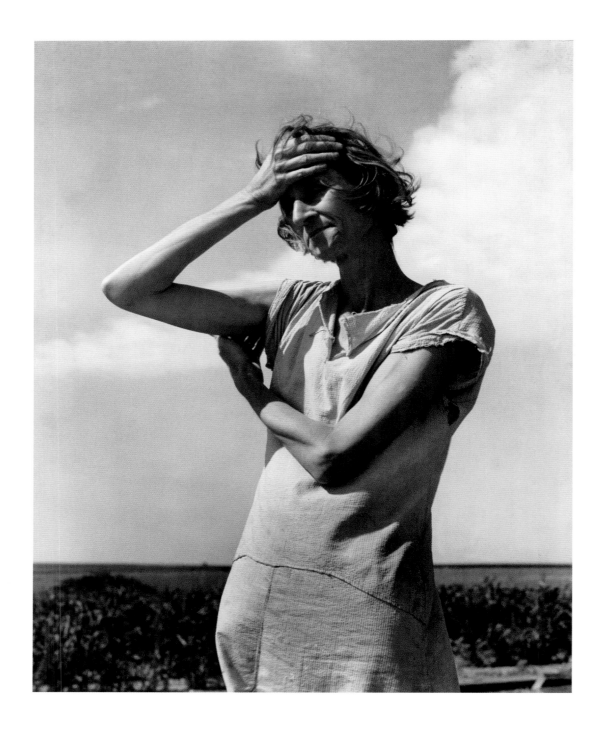

Dorothea Lange

The wife of a migratory laborer with three children. "If you die, you're dead – that's all." Near Childress, Texas Panhandle, June, 1938.

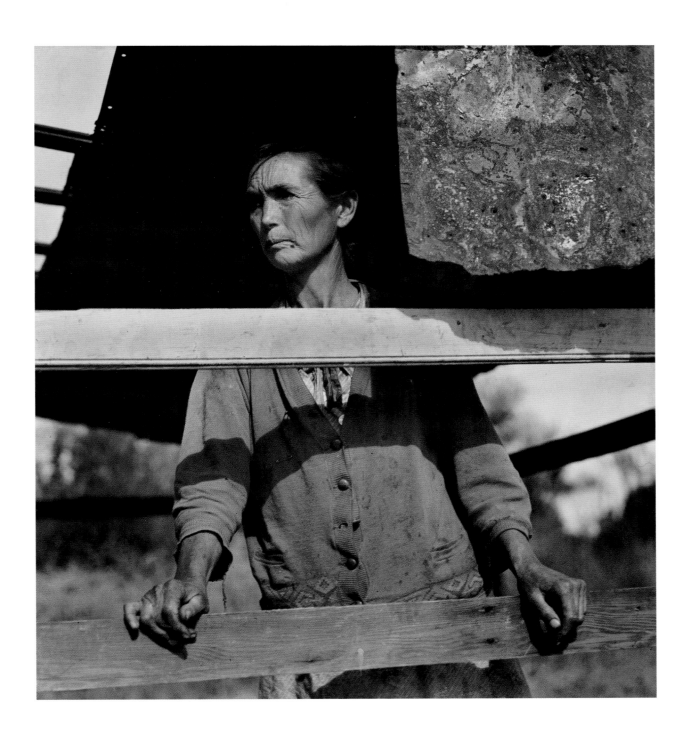

Dorothea Lange

Dispossessed Arkansas farmers (wife only).
These people are resettling themselves on the
dump outside Bakersfield, California. 1935.

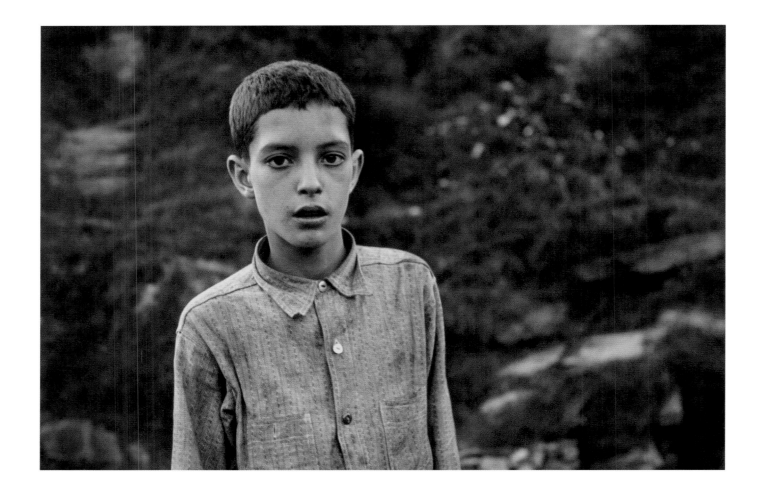

Ben Shahn
Coal miner's child, Omar, West Virginia.
October, 1935.

Marion Post Wolcott

A coal miner's child taking home kerosene
for lamps; company houses; coal tipple in
the background, Pursglove, Scotts Run, West
Virginia. September, 1938.

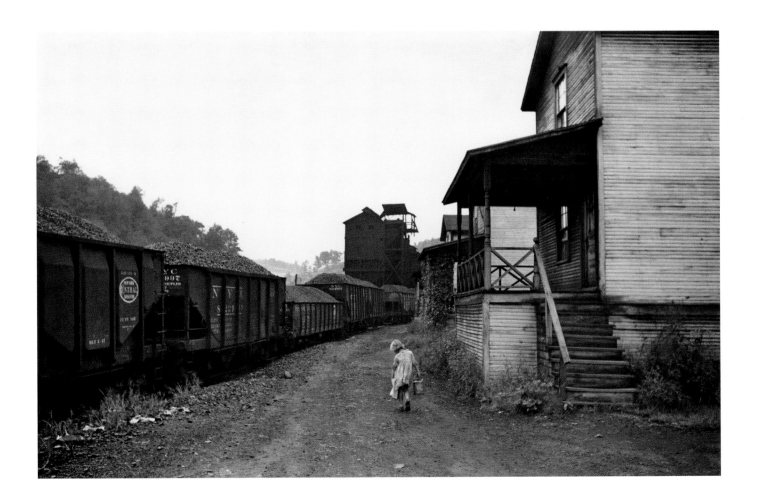

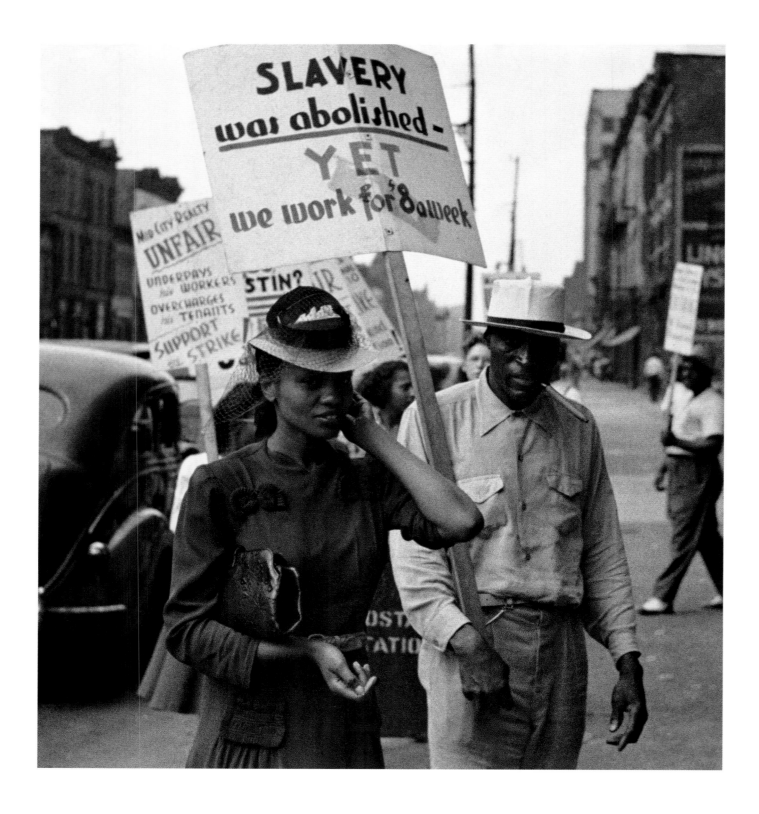

"1941 – STILL UNFINISHED BUSINESS IN 1962.

SOME SAY WE MUST NOT MOVE TOO FAST."

EDWARD STEICHEN

John Vachon
Picket line at Mid-City Realty Company,
South Chicago, Illinois. July, 1941.

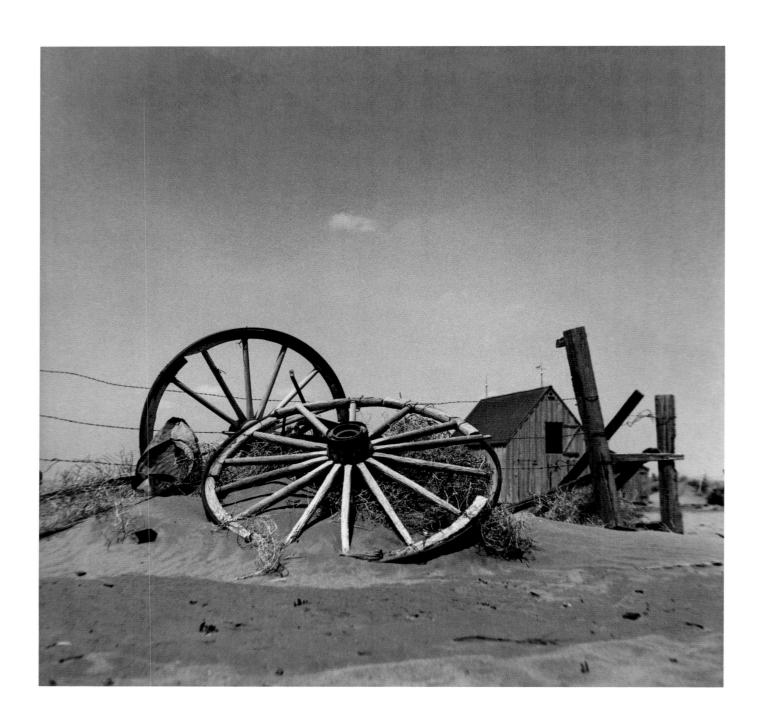

Arthur Rothstein

An abandoned farm, Cimarron County,
Oklahoma. April, 1936.

Arthur Rothstein

Dry and parched earth in the Bad Lands
of South Dakota. May, 1936.

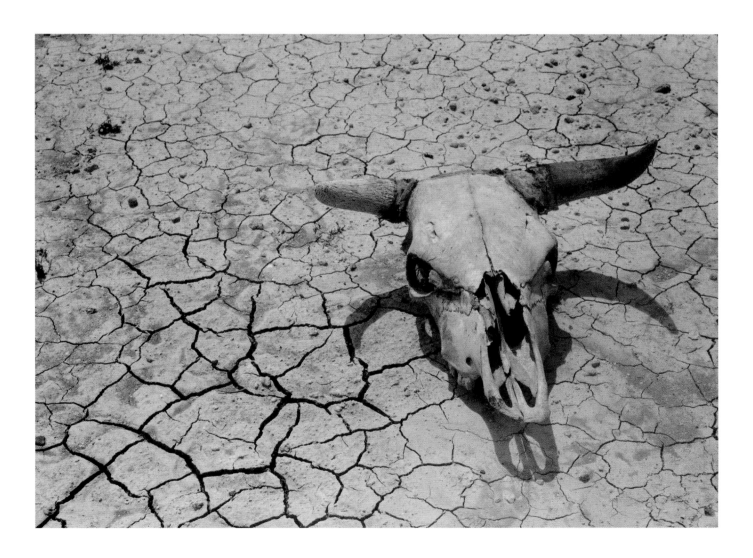

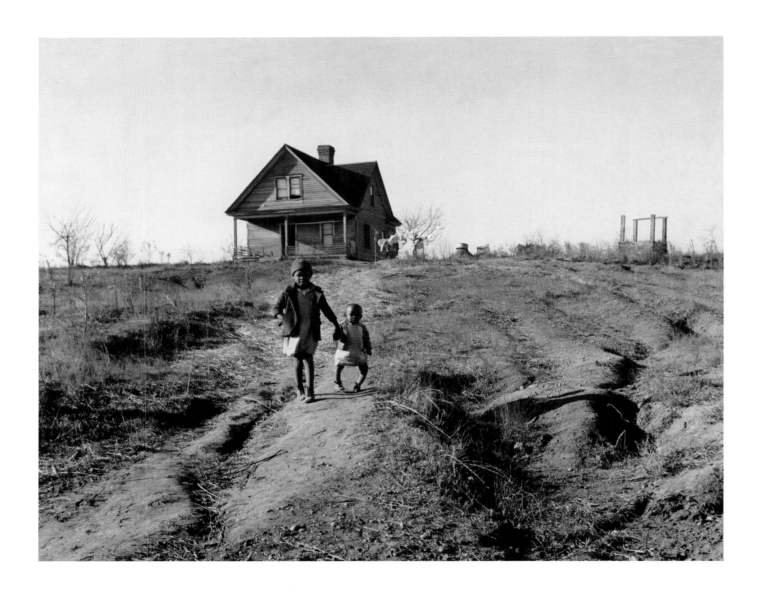

Marion Post Wolcott
Negro children and an old home on badly
eroded land near Wadesboro, North Carolina.
December, 1938.

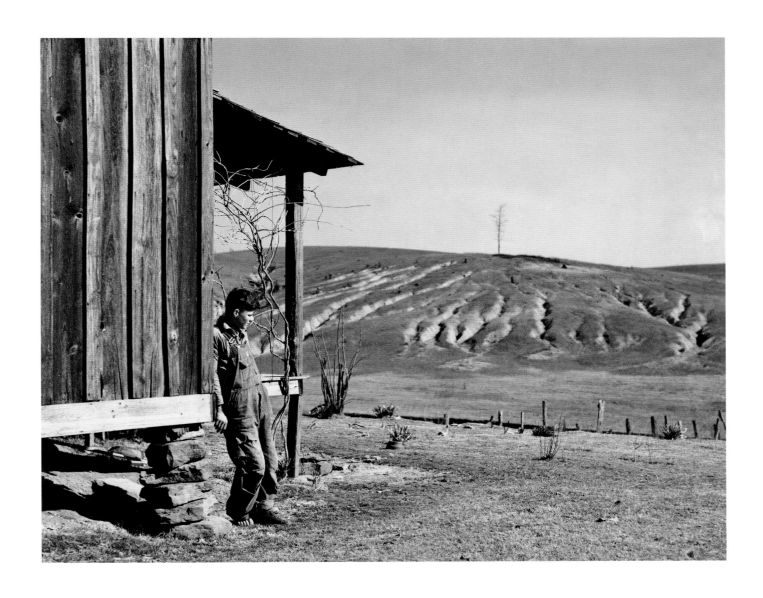

Arthur Rothstein
Eroded land, tenant's farm, Walker County,
Alabama. February, 1937.

Arthur Rothstein
Corn withered by the heat and chewed by
grasshoppers, Terry, Montana. July, 1936.

Jack Delano
Mrs. Mary Willis, widow, who with two children
runs a rented farm near Woodville, Greene
County, Georgia. June, 1941.

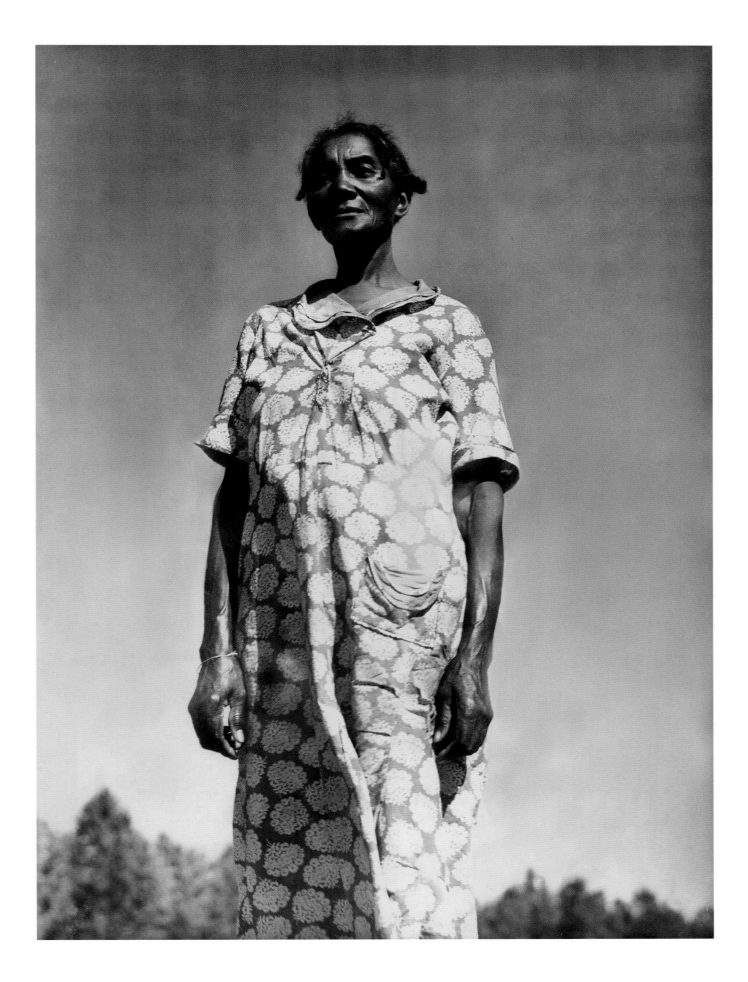

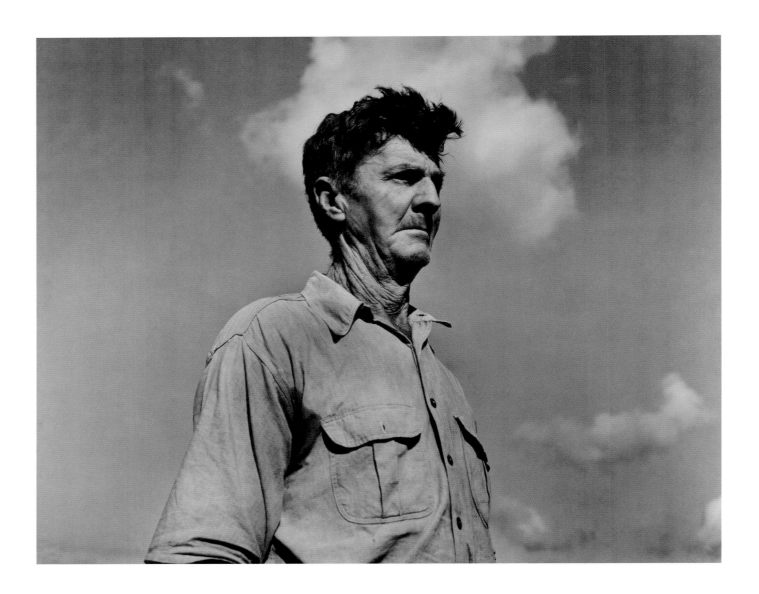

Dorothea Lange
Industrialized agriculture: from Texas farmer
to migratory worker in Kern County, California.
November, 1938.

"THE PEOPLE IS A MONOLITH,

A MOVER, A DIRT FARMER,

A DESPERATE HOPER.

THE PRIZE LIAR COMES SAYING, 'I KNOW HOW, LISTEN TO ME
AND I'LL BRING YOU THROUGH.'

THE GUESSER COMES SAYING, 'THE WAY IS LONG AND HARD
AND MAYBE WHAT I OFFER WILL WORK OUT.'

THE PEOPLE CHOOSE AND THE PEOPLE'S CHOICE MORE OFTEN
THAN NOT IS ONE MORE WASHOUT.

YET THE STRONG MAN, THE PRICELESS ONE WHO WANTS
NOTHING FOR HIMSELF AND HAS HIS ROOTS AMONG HIS PEOPLE,

COMES OFTEN ENOUGH FOR THE PEOPLE TO KNOW HIM AND
TO WIN THROUGH INTO GAINS BEYOND LATER LOSING,

COMES OFTEN ENOUGH SO THE PEOPLE CAN LOOK BACK
AND SAY, 'WE HAVE COME FAR AND WILL GO FARTHER YET.'

THE PEOPLE IS A TRUNK OF PATIENCE, A MONOLITH."

CARL SANDBURG

Dorothea Lange
Dust storm. It was conditions of this sort which forced many farmers to abandon the area (New Mexico). April, 1935.

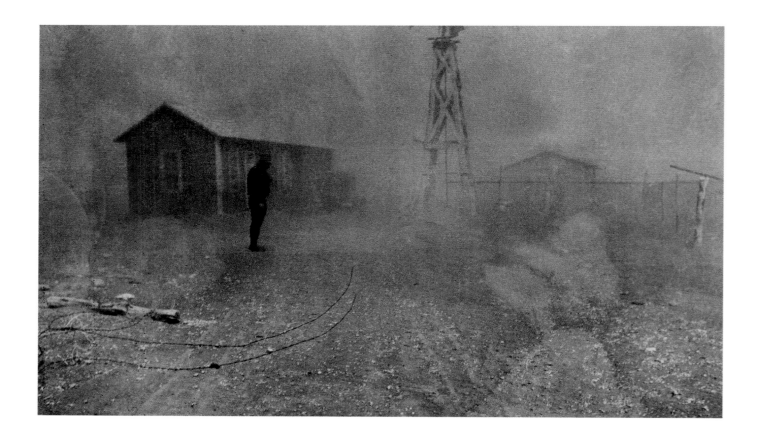

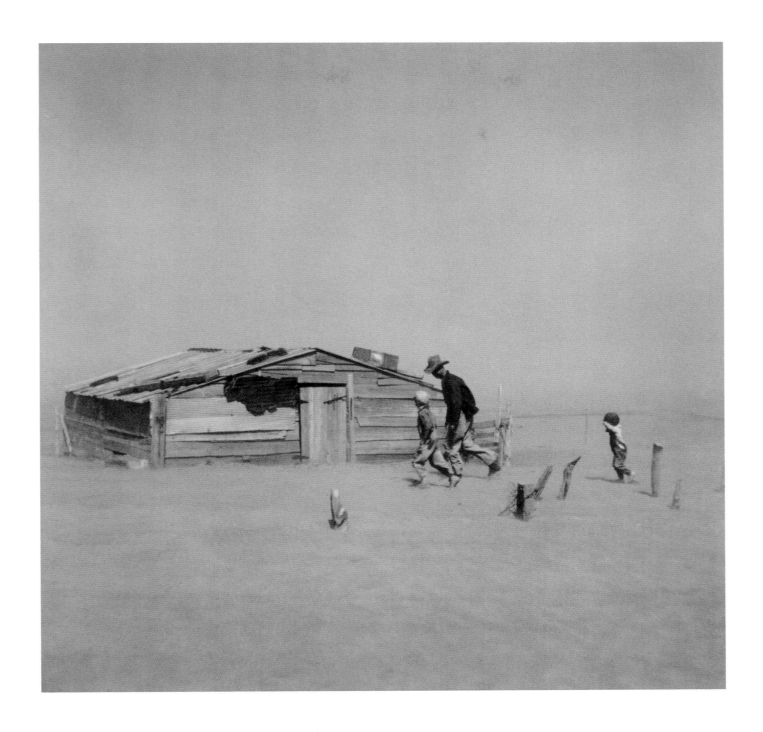

Arthur Rothstein
Farmer and sons walking in the face of a dust
storm, Cimarron County, Oklahoma. April, 1936.

"I SEE ONE-THIRD OF A NATION ILL-HOUSED,
ILL-CLAD, ILL-NOURISHED."

FRANKLIN DELANO ROOSEVELT
Second Inaugural Address, March 20, 1937.

Ben Shahn
Arkansas squatter's home. October, 1935.

Russell Lee
Child looking out of the window of a tent home
near Sallisaw, Sequoyah County, Oklahoma.
June, 1939.

Ben Shahn
Children of a destitute Ozark mountaineer,
Arkansas. October, 1935.

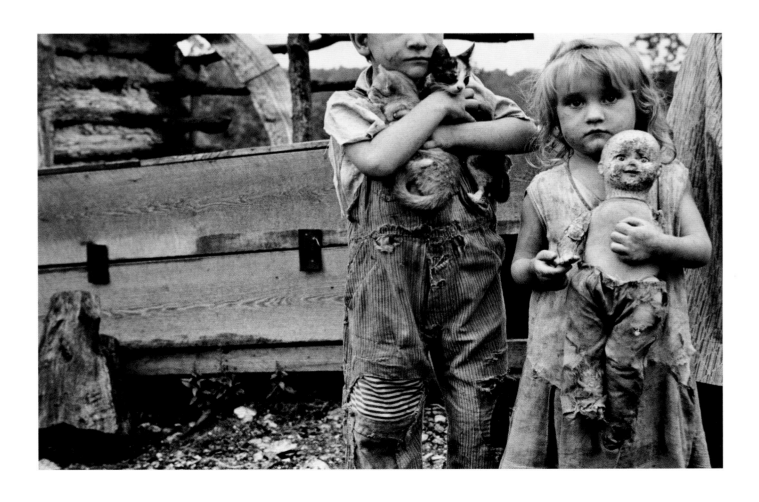

Dorothea Lange
Missouri woman (detail). *c.* 1938.

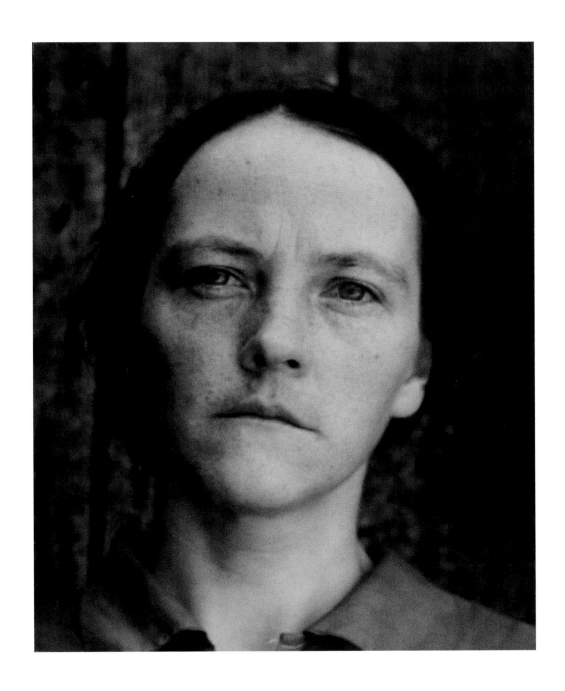

"CHRISTMAS DINNER: POTATOES, CABBAGE, AND PIE."

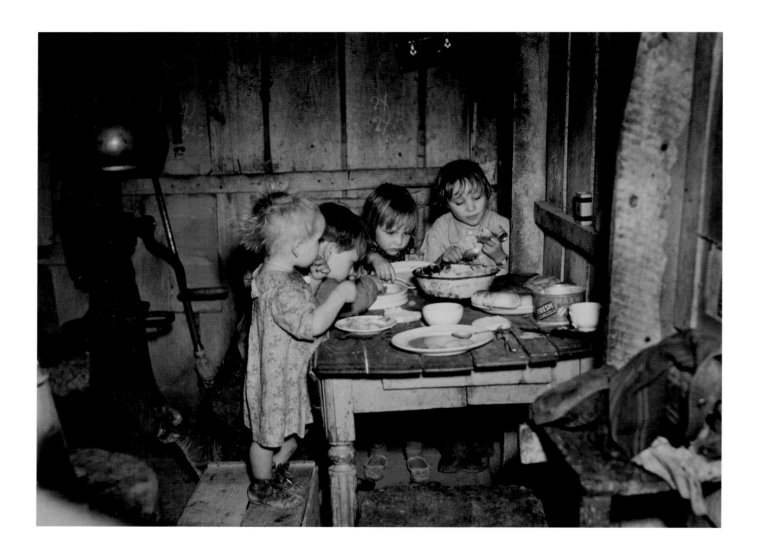

Russell Lee

Christmas dinner in the home of Earl Pauley, near Smithfield, Iowa. Dinner consisted of potatoes, cabbage, and pie. These children were motherless and their father prepared the dinner. December, 1936.

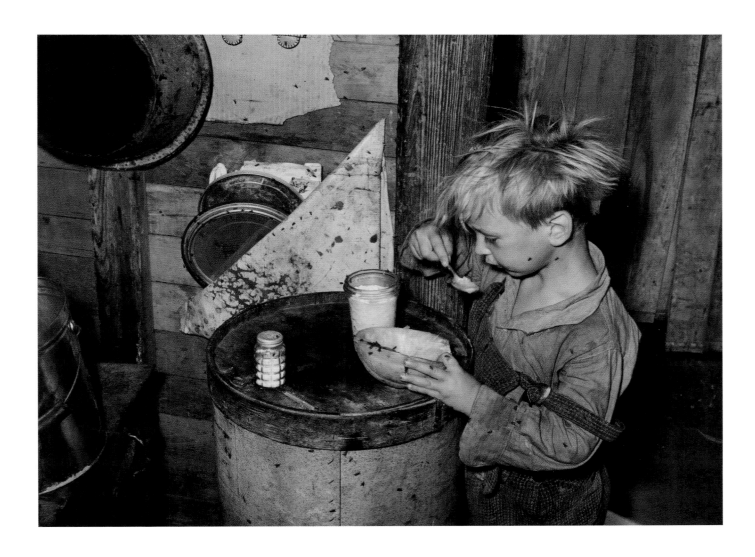

Russell Lee
A child in May's Avenue camp, Oklahoma, eating an
overripe cantaloupe found in the market. July, 1939.

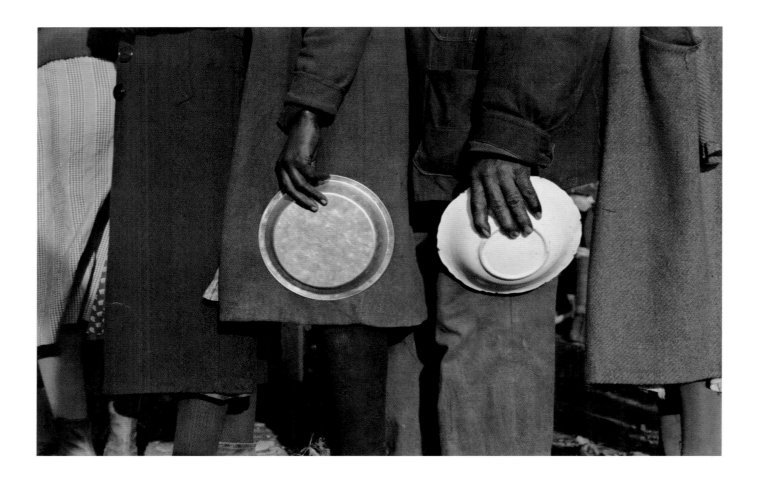

Walker Evans
Negroes in the line-up for food at mealtime
in the camp for flood refugees, Forrest City,
Arkansas. February, 1937.

Marion Post Wolcott
Old negro, near Camden, Alabama. May, 1939.

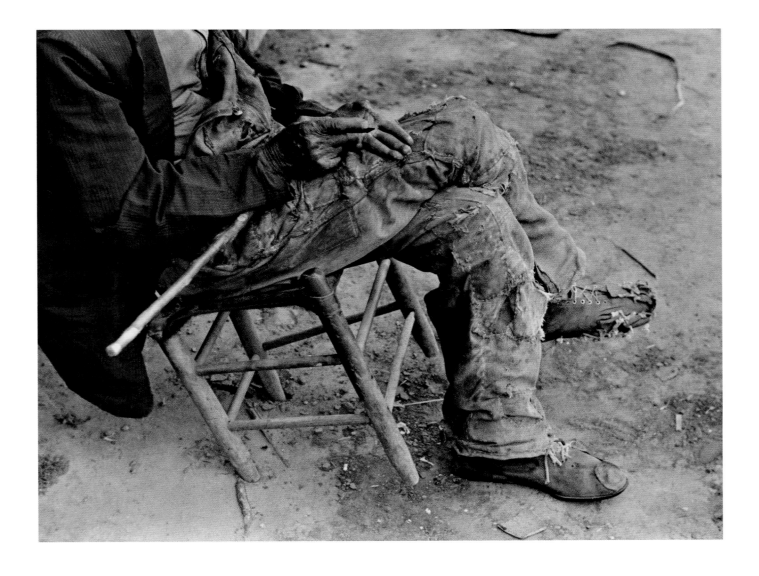

Dorothea Lange

Sharecropper family near Hazlehurst, Georgia.
July, 1937.

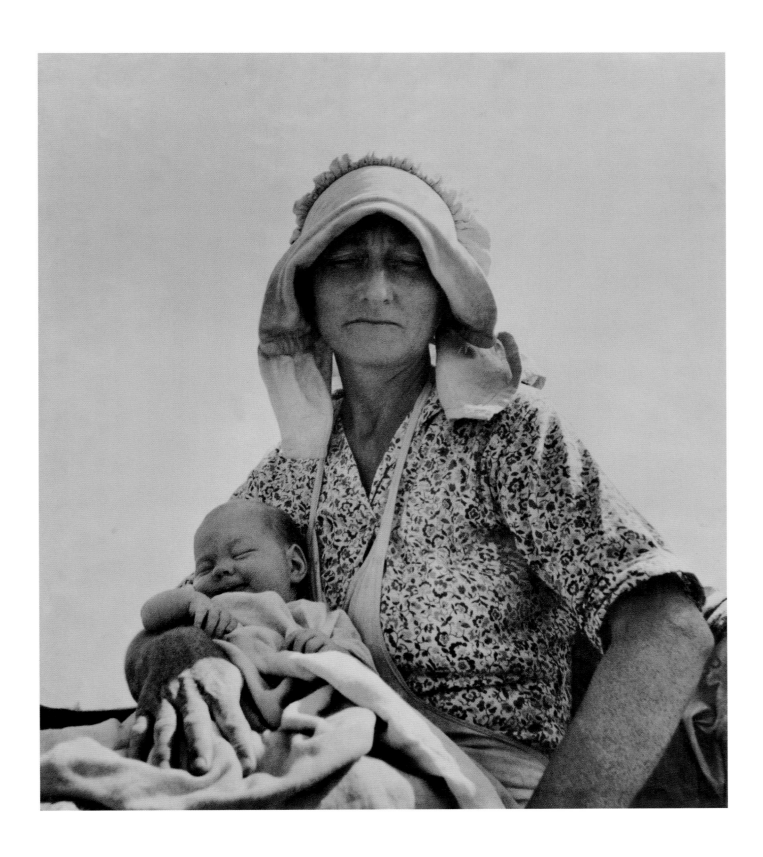

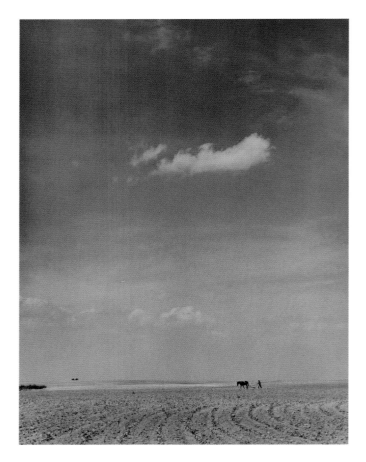

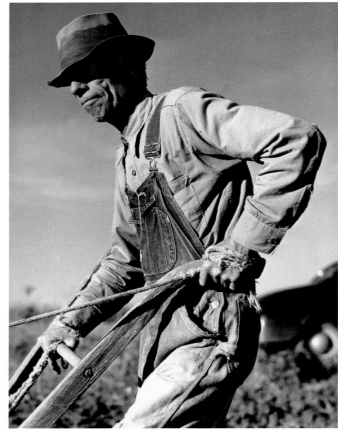

Jack Delano

Plowing a field of cotton, Greene County, Georgia. June, 1941.

Jack Delano

Mr. W. H. Holmes, a renter on the Wray place, plowing sweet potatoes, Greene County, Georgia. November, 1941.

Dorothea Lange
Young cotton picker, migrant camp, Kern
County, California. November, 1936.

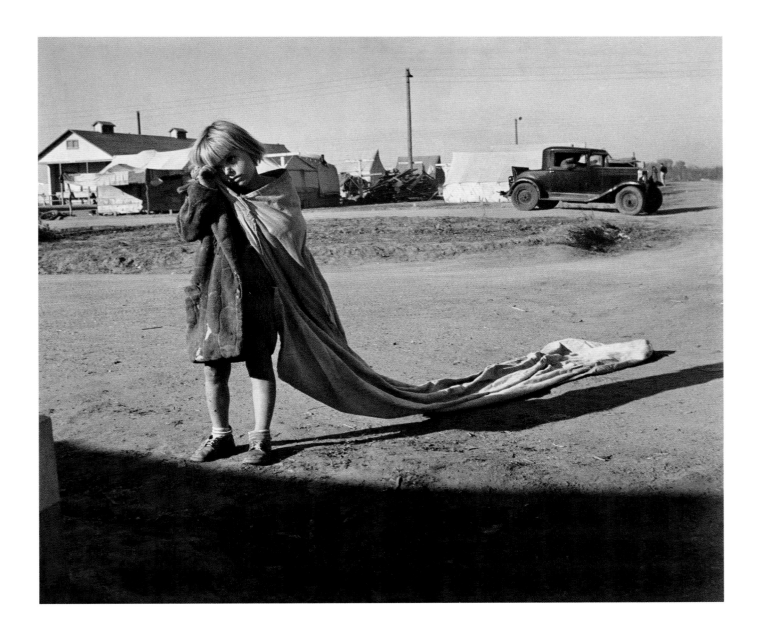

Dorothea Lange

These cotton hoers work from 6 a.m. to 7 p.m.
for $1. The use of machinery in cotton production
is increasing. It is displacing labor and dislodging
tenants. Day laborers for seasonal peaks of hoeing
and picking are drawn back from the nearer
towns in trucks. Mississippi Delta plantation,
near Clarksdale, Mississippi. June 1937.

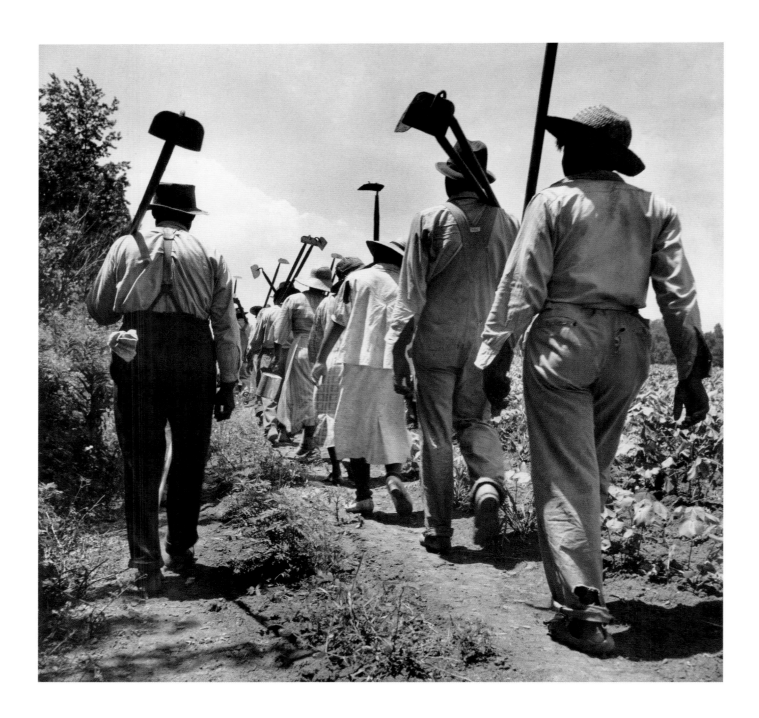

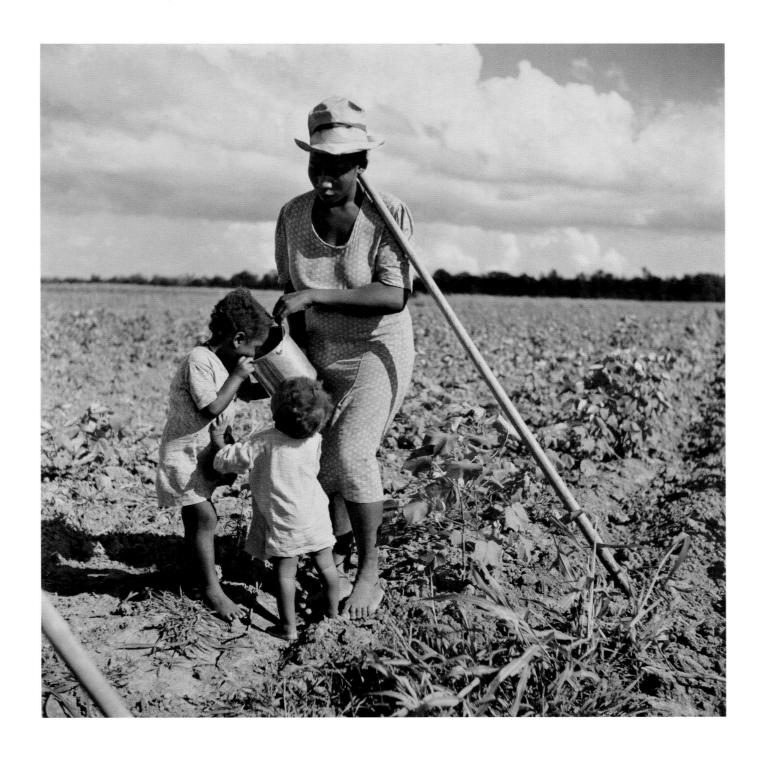

Marion Post Wolcott

A member of the Allen Plantation Cooperative
Association and her children taking a rest from
hoeing cotton, near Natchitoches, Louisiana.
July, 1940.

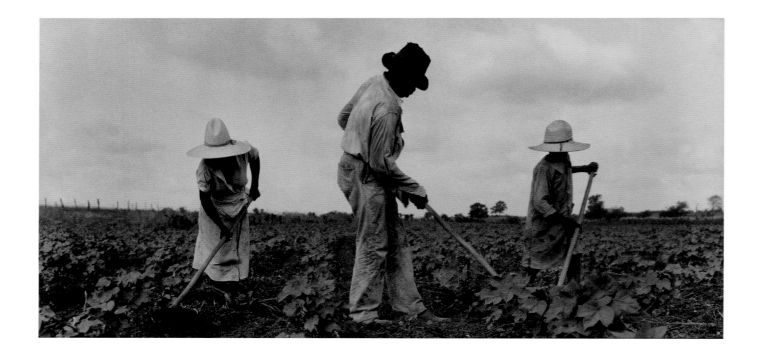

Dorothea Lange
Hoe culture in the South, near Eutaw, Alabama.
July, 1936.

Dorothea Lange

Hoe culture: Alabama tenant farmer near
Anniston. June, 1936.

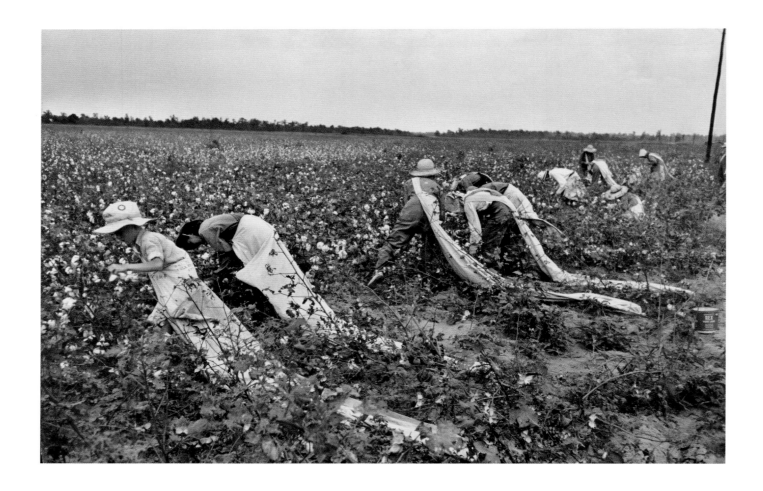

Russell Lee
Picking cotton: members of Lake Dick
Cooperative Association working together.
September, 1938.

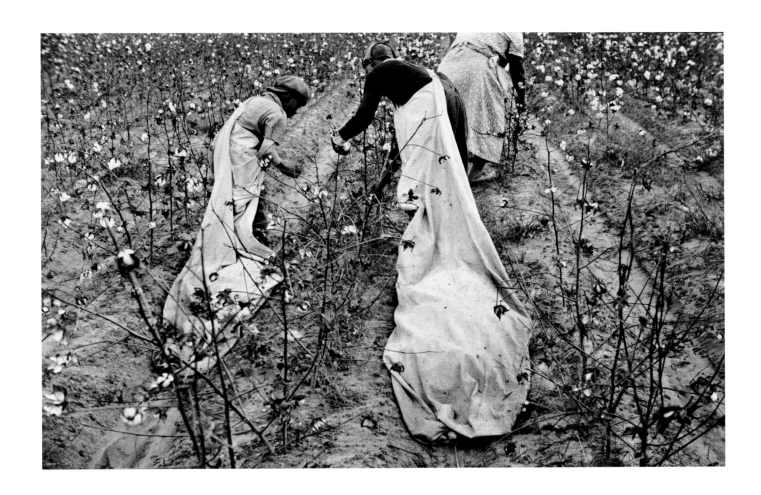

Ben Shahn
Cotton pickers, Pulaski County, Arkansas.
October, 1935.

Dorothea Lange

Migratory field worker picking cotton in San Joaquin Valley, California. These pickers are being paid 75 cents per 100 pounds of picked cotton. Strikers organizing under the CIO Union are demanding $1. A good male picker, in good cotton under favorable weather conditions, can pick about 200 pounds in a day's work. November, 1938.

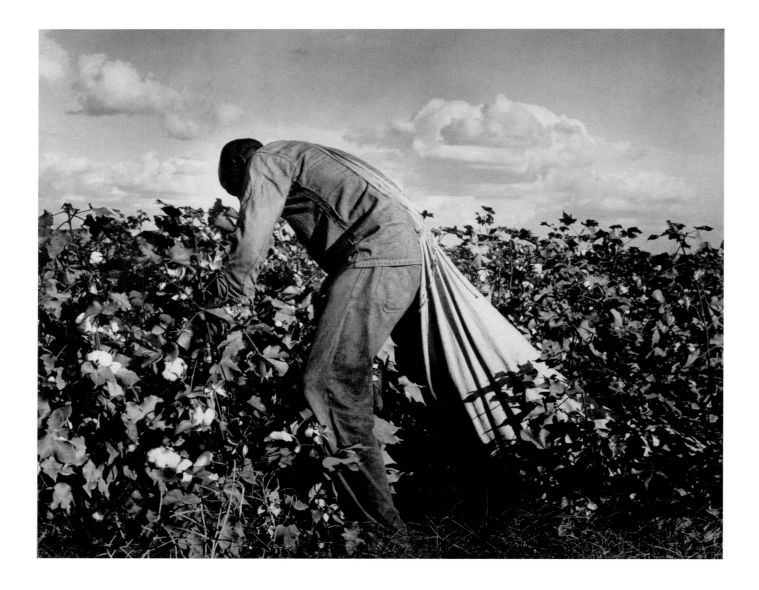

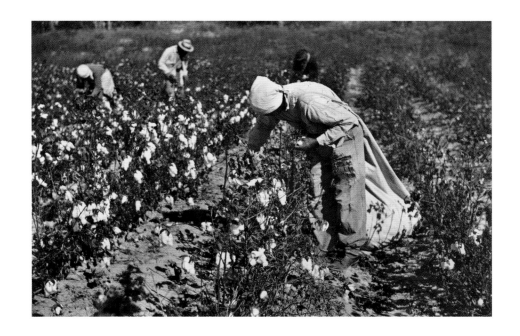

Marion Post Wolcott

Picking cotton on a plantation outside Clarksdale,
Mississippi Delta, Mississippi. October, 1939.

Marion Post Wolcott

J. A. Johnson's youngest son picking cotton,
Route 3, Statesville, North Carolina. October, 1939.

Dorothea Lange
Plantation owner, Mississippi Delta, near
Clarksdale, Mississippi. June, 1936.

Ben Shahn

Cotton pickers, Pulaski County, Arkansas.
October, 1935.

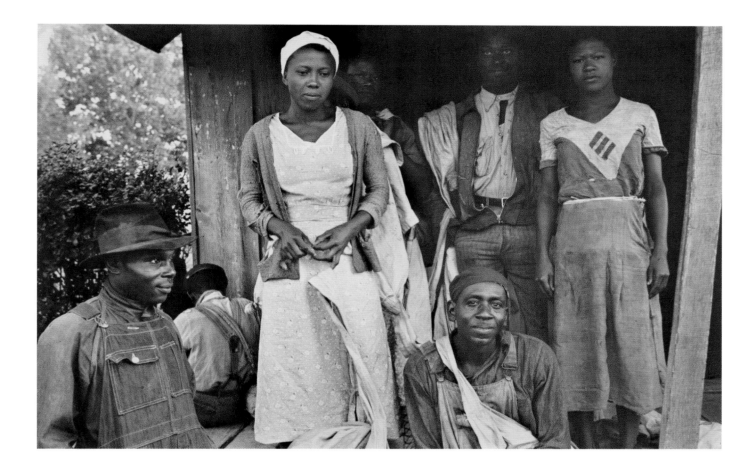

"TO THOSE OF WHOM THE RECORD IS MADE.

IN GRATEFULNESS AND IN LOVE."

Dedication in *Let Us Now Praise Famous Men*

BY JAMES AGEE AND WALKER EVANS

Walker Evans

A corner of the kitchen in Floyd Burroughs's
cabin, Hale County, Alabama. 1935 or 1936.

Walker Evans

The home of Bud Fields, Alabama
sharecropper, Hale County. 1935 or 1936.

Walker Evans

A corner of the kitchen in Bud Fields's home,
Hale County, Alabama. 1935 or 1936.

Walker Evans

Bud Fields and his family at home, Alabama.
1935 or 1936.

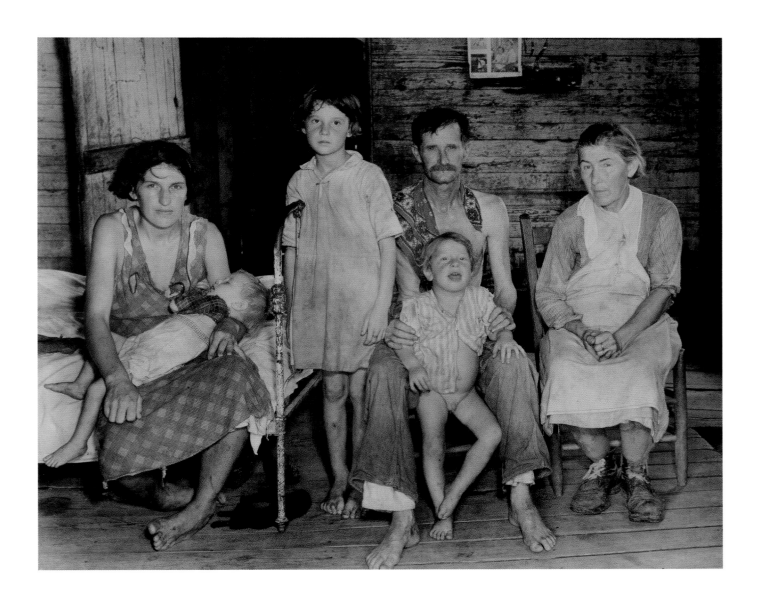

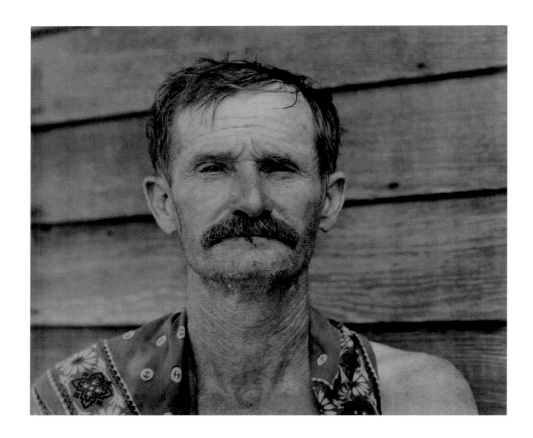

Walker Evans

Bud Fields, cotton sharecropper, Alabama.
1935 or 1936.

Walker Evans

Landowner in Moundville, Alabama. August, 1936.

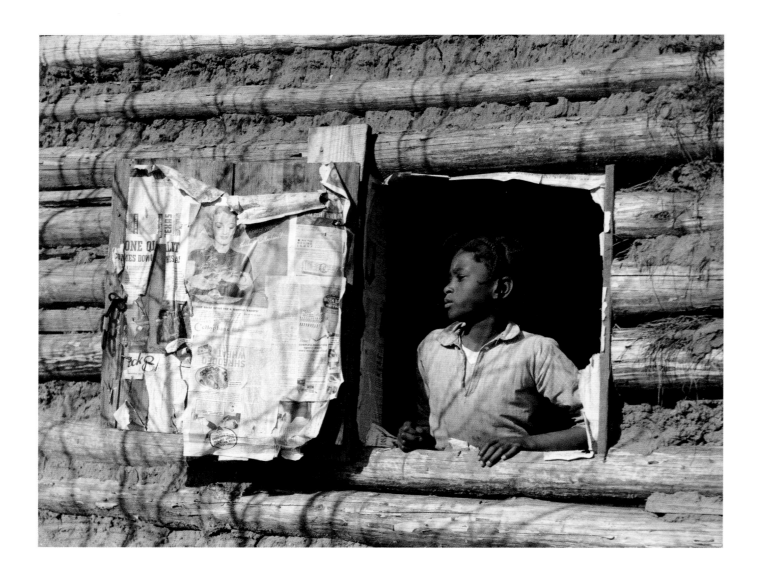

Arthur Rothstein

Girl at Gee's Bend, Alabama. April, 1937.

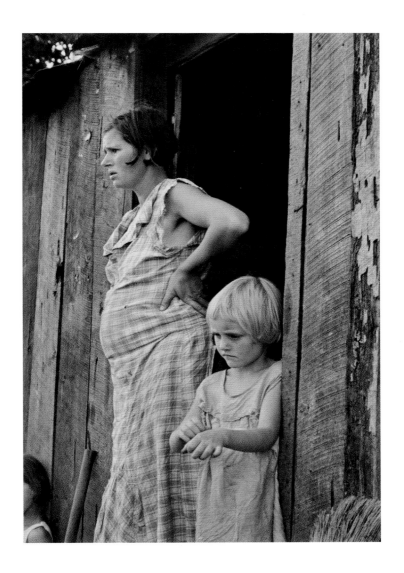

Arthur Rothstein

The wife and child of a sharecropper,
Washington County, Arkansas. August, 1935.

Dorothea Lange

Home of a white tenant farmer family,
Newport, Oklahoma. June, 1937.

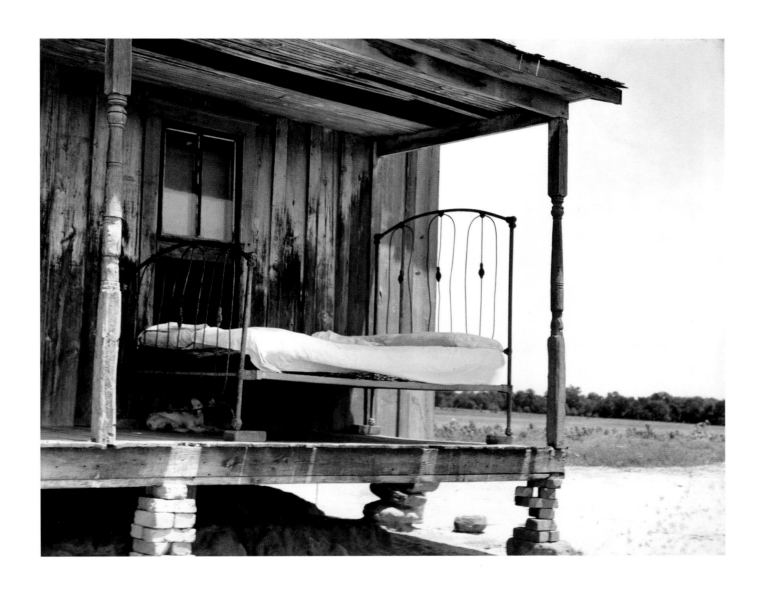

Walker Evans

Kitchen wall in Bud Fields's house, Hale
County, Alabama. 1935 or 1936.

Walker Evans

Negro cabin, Hale County, Alabama. 1935 or 1936.

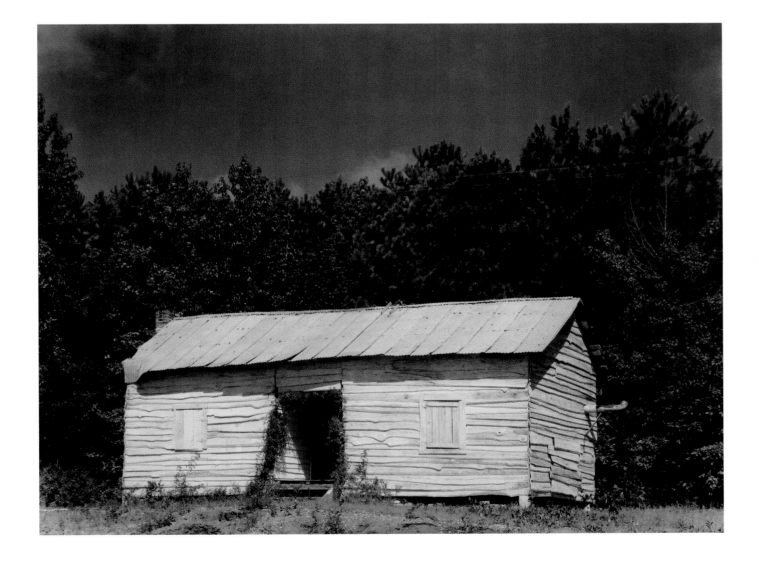

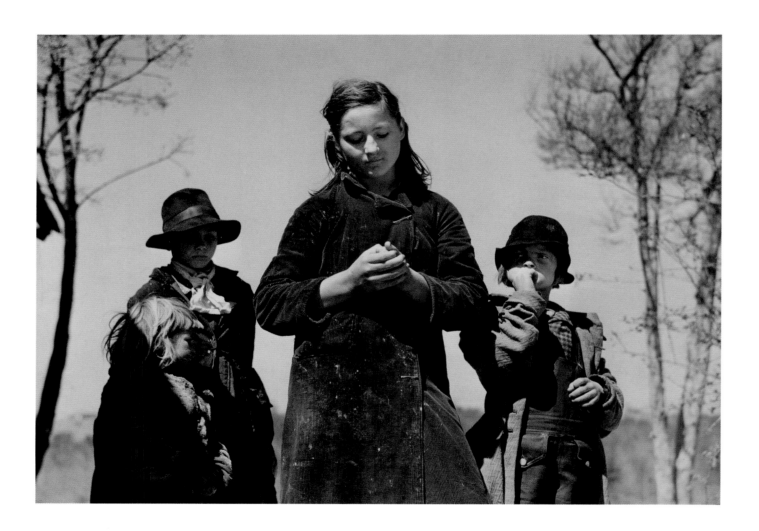

Jack Delano

Children of a "squatter" family who were
preparing to move out of the Spartanburg army
camp area, near Whitestone, South Carolina
region. March, 1941.

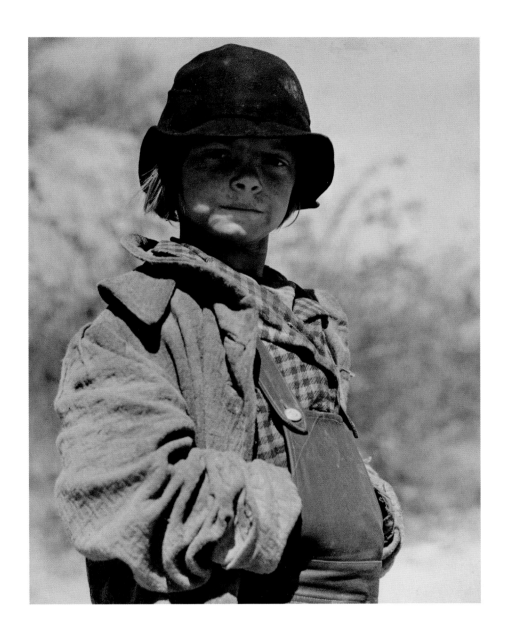

Jack Delano

One of the children of a "squatter" family that
had to move out of the Camp Croft area near
Whitestone, South Carolina region. March, 1941.

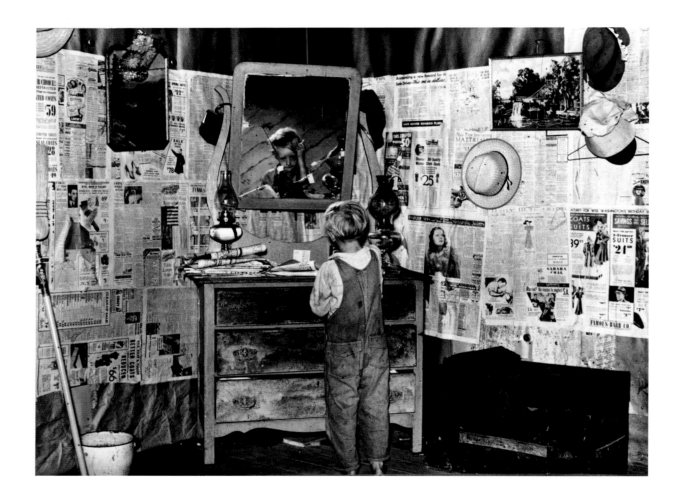

Russell Lee

Son of a sharecropper combing his hair in the bedroom of a shack, southeast Missouri farms. May, 1938.

Ben Shahn

Children of the Fortuna family (strawberry pickers), Hammond, Louisiana. October, 1935.

Russell Lee

Family squatting on FSA property, Caruthersville, Missouri. August, 1938.

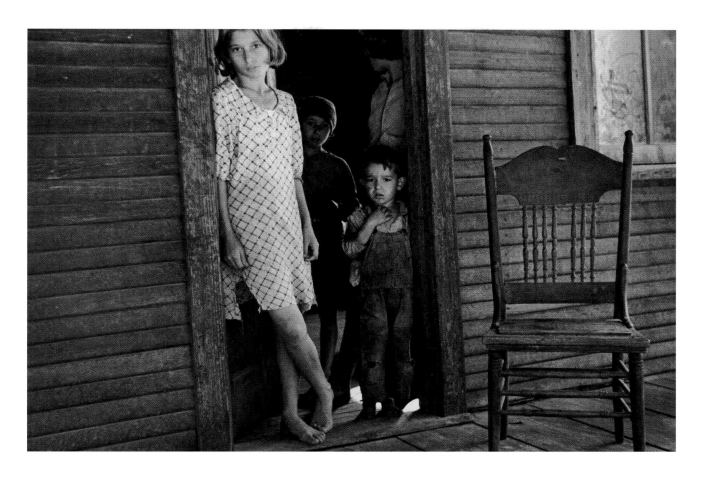

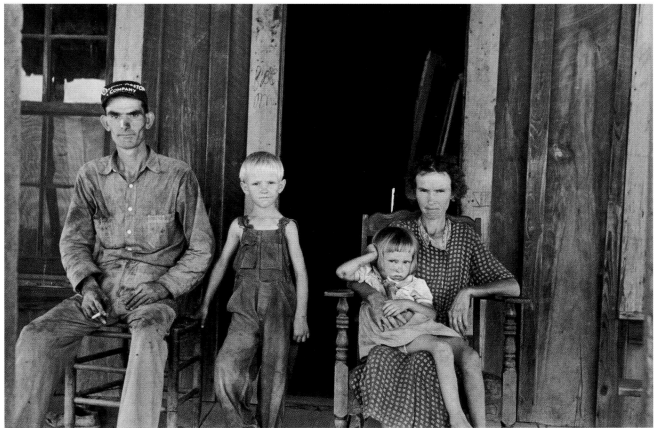

Ben Shahn

Family of a Resettlement Administration client,
Boone County, Arkansas. October, 1935.

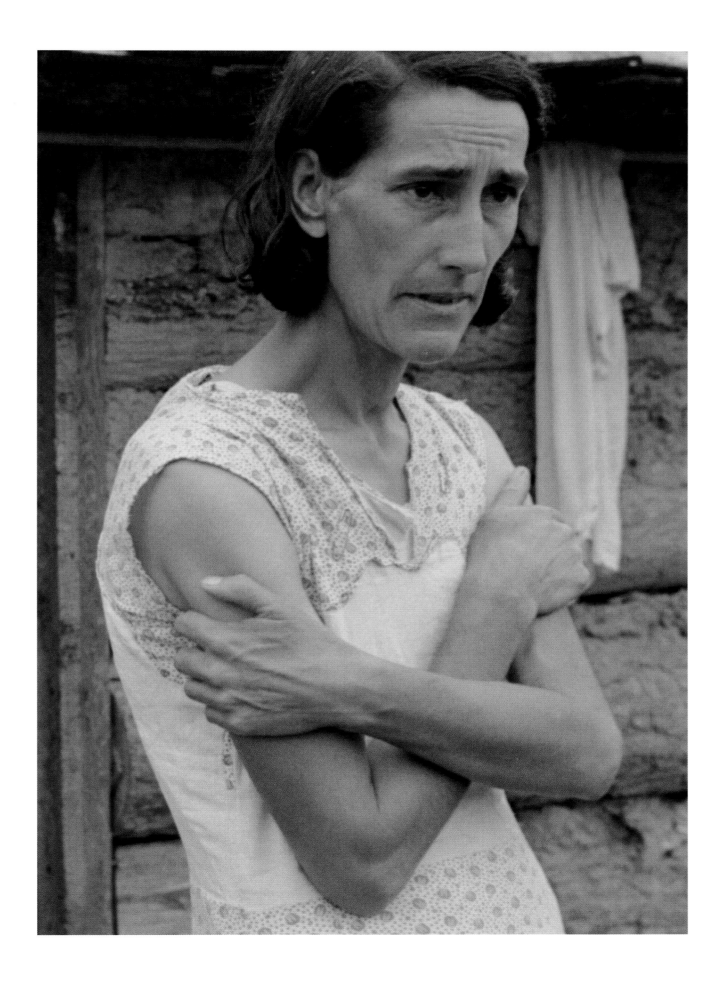

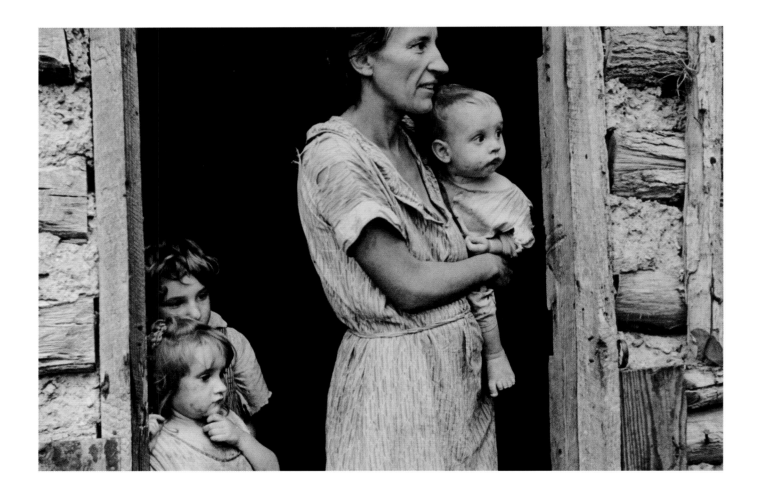

Ben Shahn

The wife and children of a sharecropper.
October, 1935.

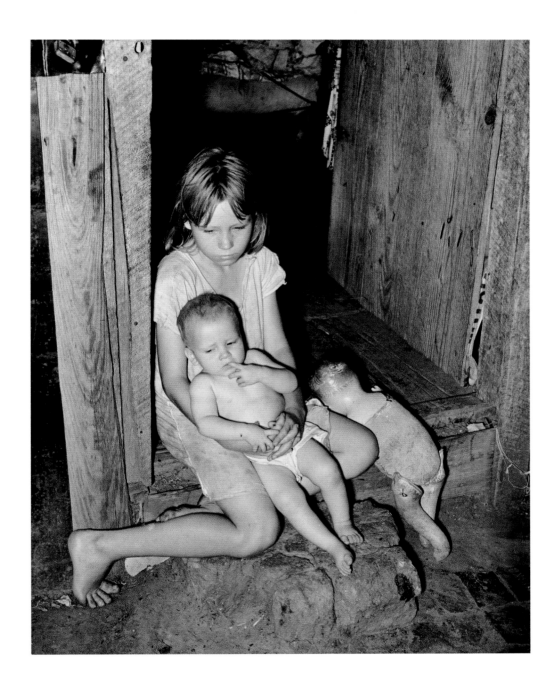

Russell Lee

The children of an agricultural day laborer
in the doorway of a home near Tullahassee,
Wagoner County, Oklahoma. June, 1939.

Walker Evans

"Squinchy" asleep. Child of Floyd Burroughs,
Alabama sharecropper. 1935 or 1936.

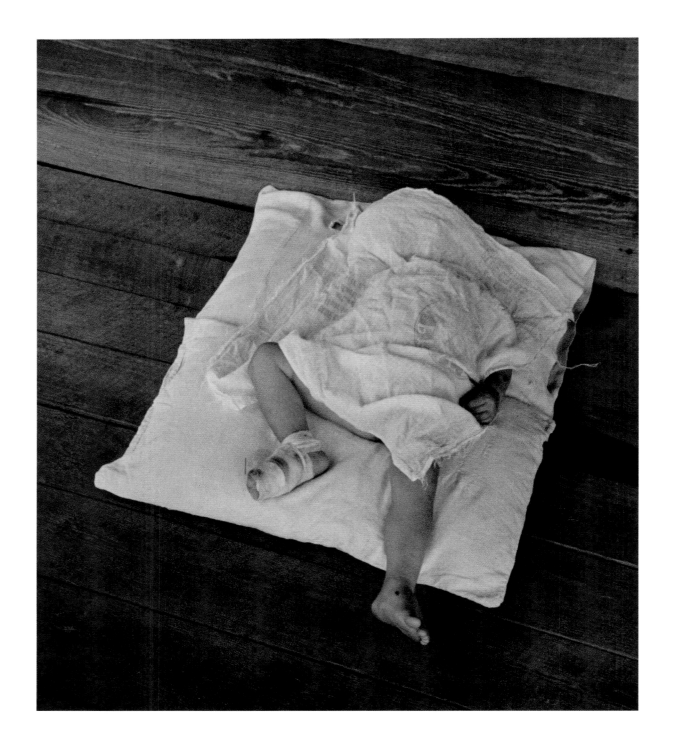

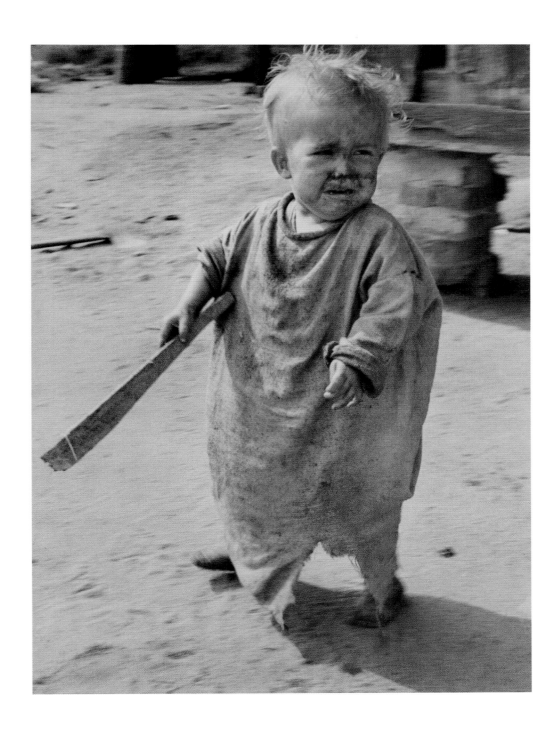

Arthur Rothstein

The child of a North Carolina sharecropper. He
has two strikes on him already. September, 1935.

Russell Lee

Children looking out of the window of a shack
home, community camp, Oklahoma City,
Oklahoma. July, 1939.

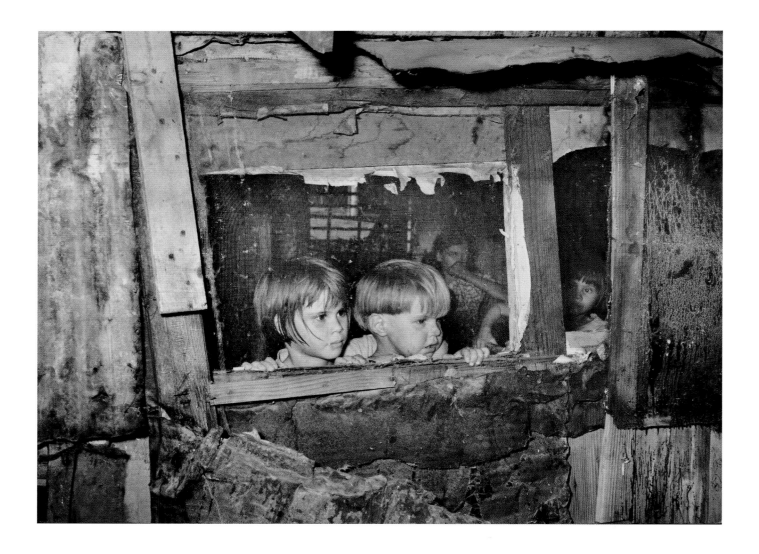

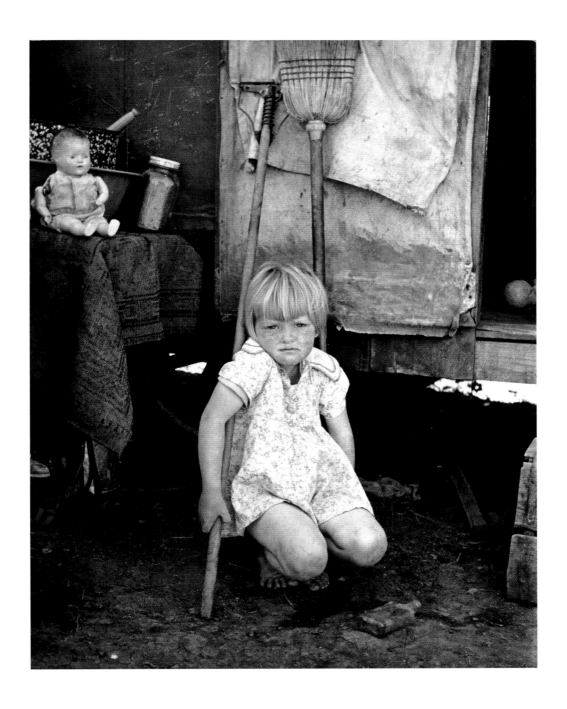

Russell Lee

The child of a white migrant worker in front
of a trailer home, Weslaco, Texas. January, 1939.

"WE TRUST IN THE LORD

AND DON'T EXPECT MUCH."

Jack Delano

Mrs. Lemuel Smith preparing the afternoon meal
on her farm in Carroll County, Georgia. April, 1941.

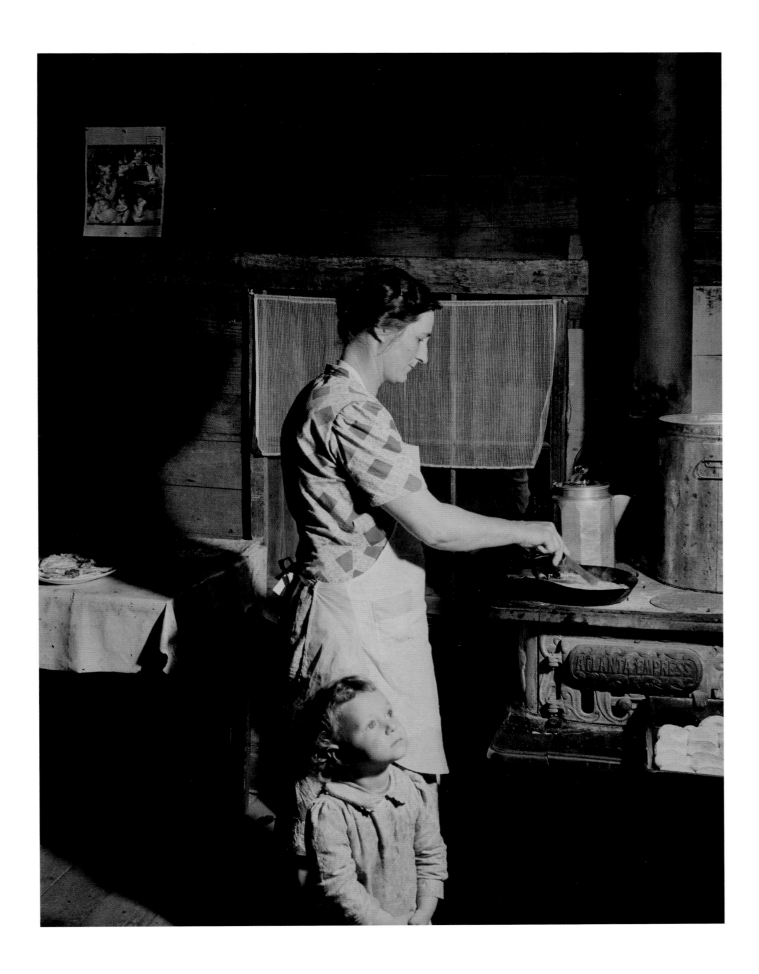

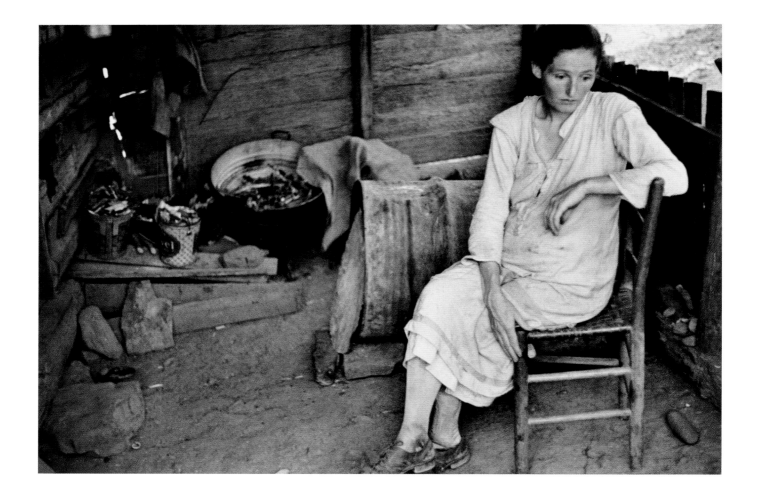

Ben Shahn

Destitute tenant farmer's family, Ozark
Mountains, Arkansas. October, 1935.

Walker Evans

Sharecropper's child, Alabama. 1935 or 1936.

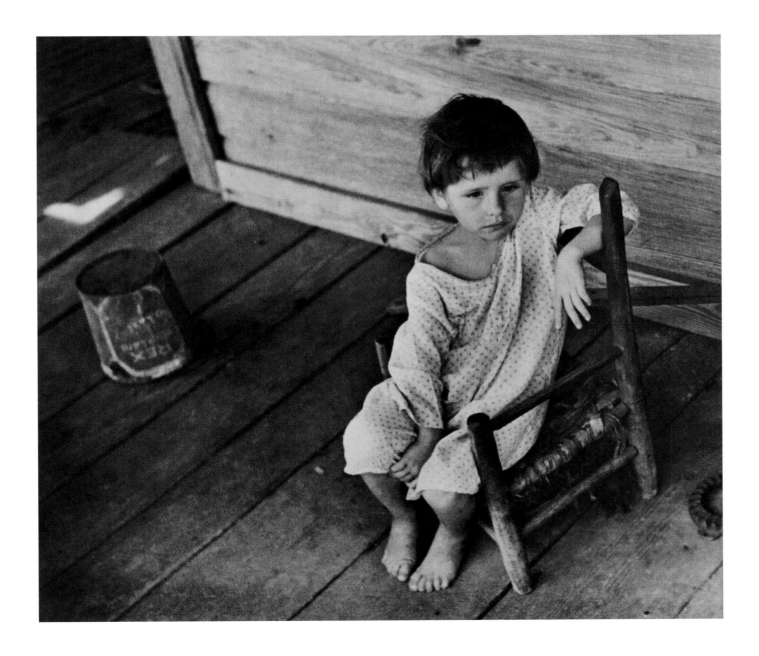

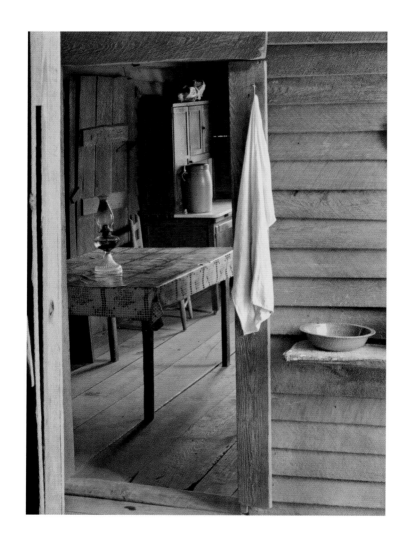

Walker Evans

Washstand in the dog run and kitchen of Floyd
Burroughs's cabin, Hale County, Alabama. 1935
or 1936.

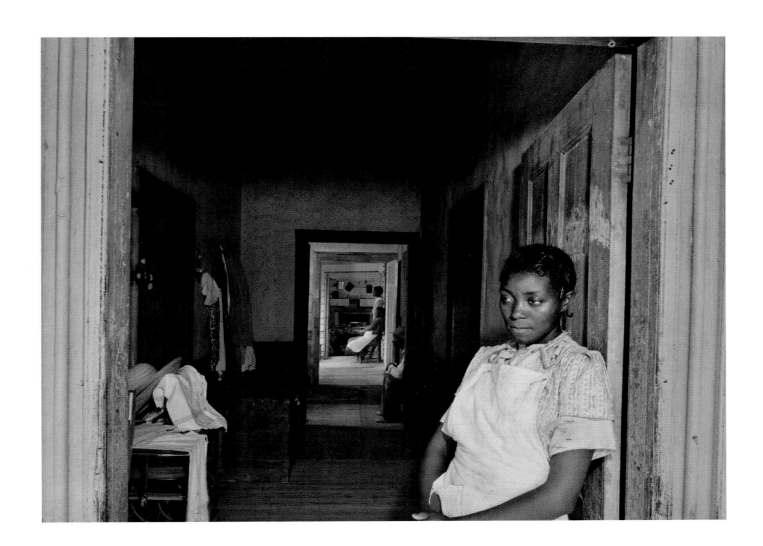

Jack Delano
Interior of a rural house, Greene County, Georgia.
June, 1941.

Russell Lee
Baby in front of a dresser in John Baker's farm home, Divide County, North Dakota. November, 1937.

Theodor Jung
The interior of a home of a prospective client, Brown County, Indiana. October, 1938.

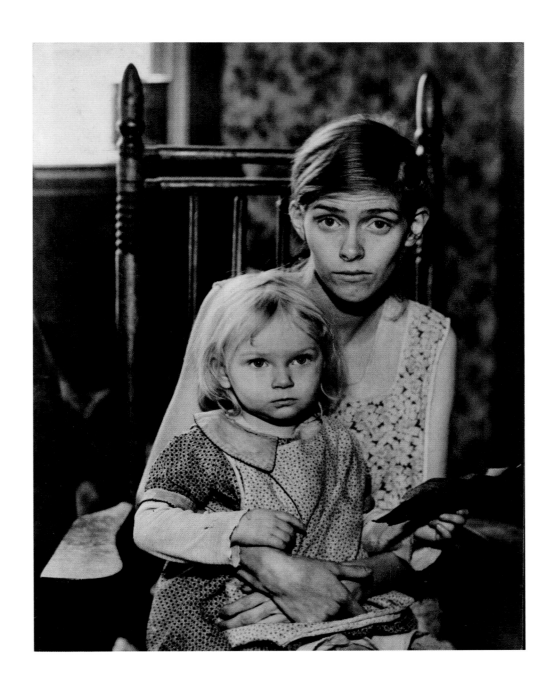

Paul Carter
Tubercular mother and child, New York City.
April, 1936.

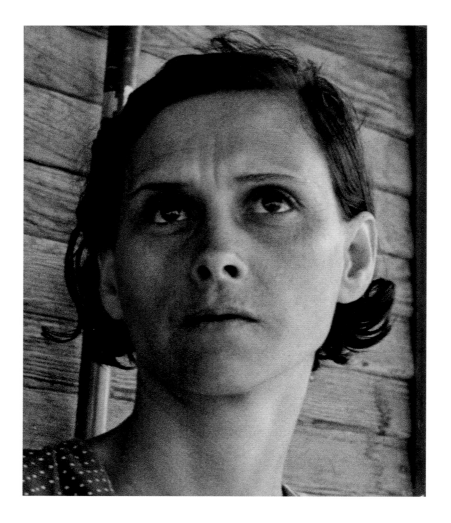

Dorothea Lange
Woman on relief, Memphis, Texas. June, 1937.

Dorothea Lange
12-year-old son of a cotton sharecropper near
Cleveland, Mississippi. June, 1937.

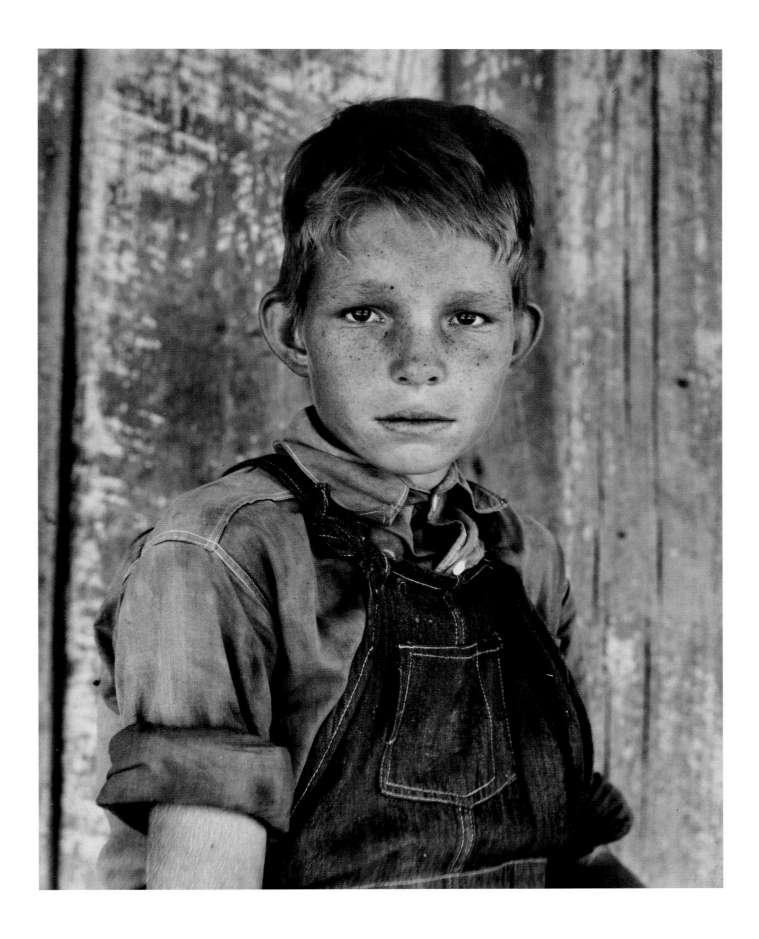

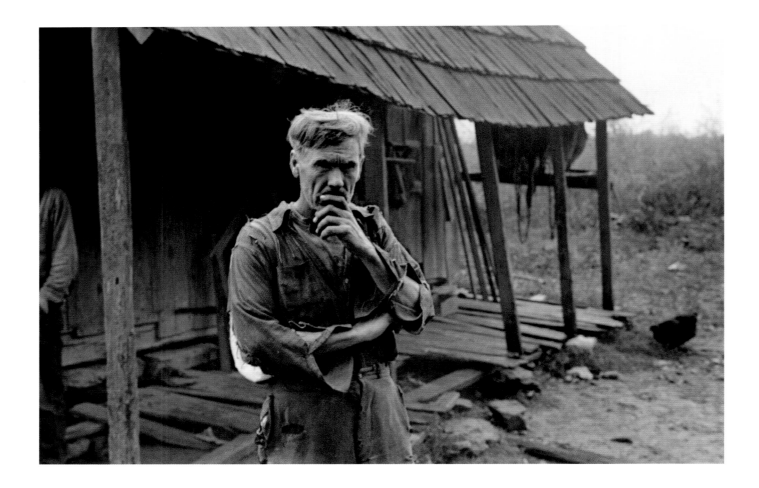

Ben Shahn

Sam Nichols, tenant farmer, Boone County,
Arkansas. October, 1935.

Russell Lee

FSA client, former sharecropper, southeast
Missouri farms. 1938.

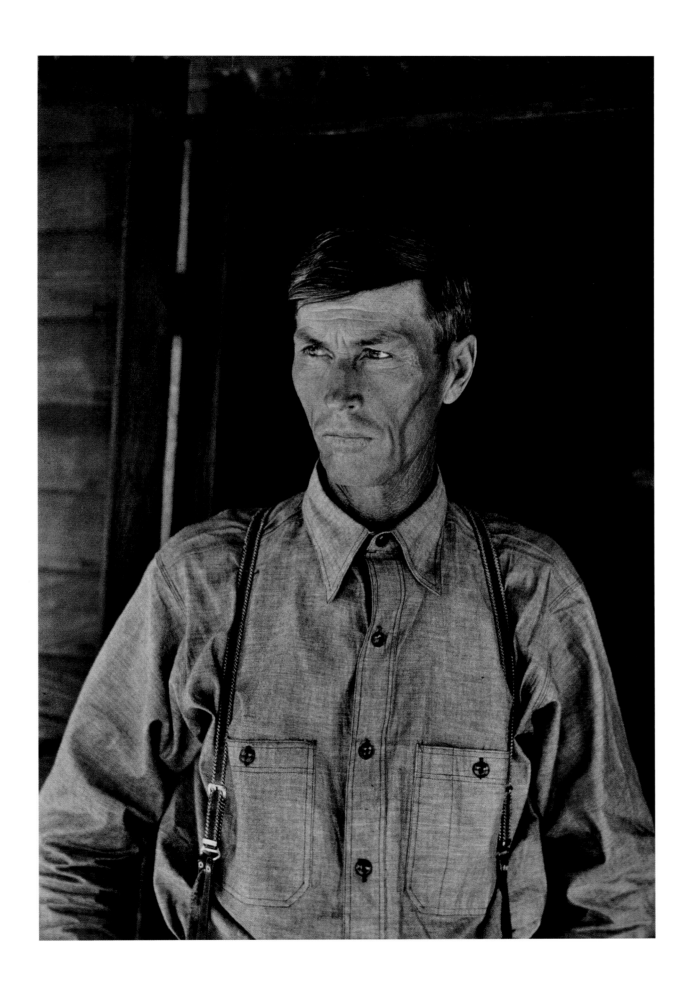

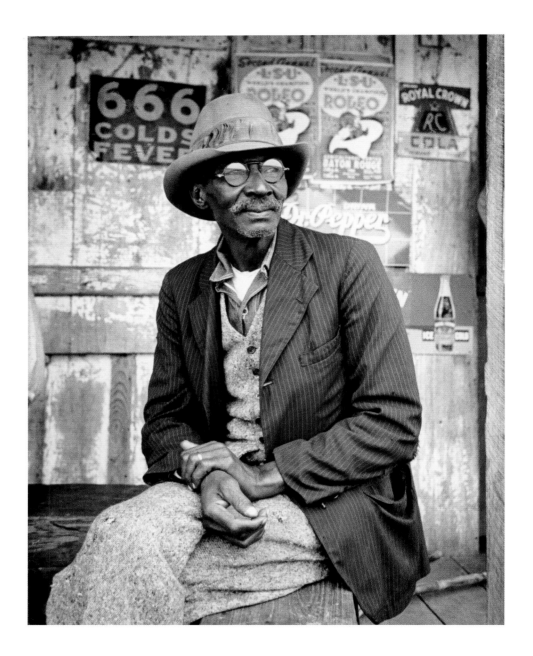

Russell Lee

Negro on the porch of a general store, Louisiana.
October, 1938.

Arthur Rothstein

Inhabitants of Gee's Bend, Alabama. April, 1937.

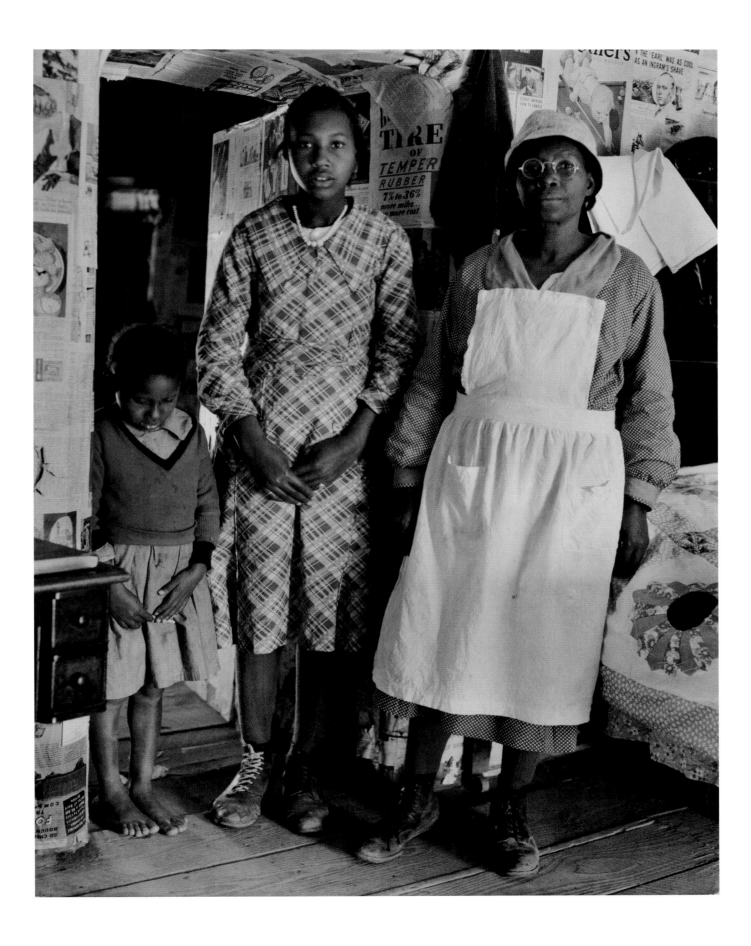

"A HUMAN BEING HAS A RIGHT TO STAND

LIKE A TREE HAS A RIGHT TO STAND."

John Vachon
An Ozark mountain farmer and family, Missouri.
May, 1940.

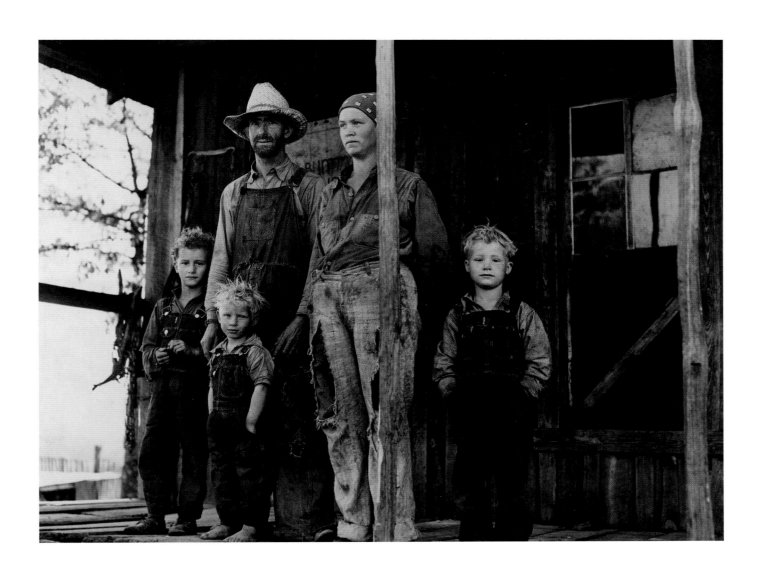

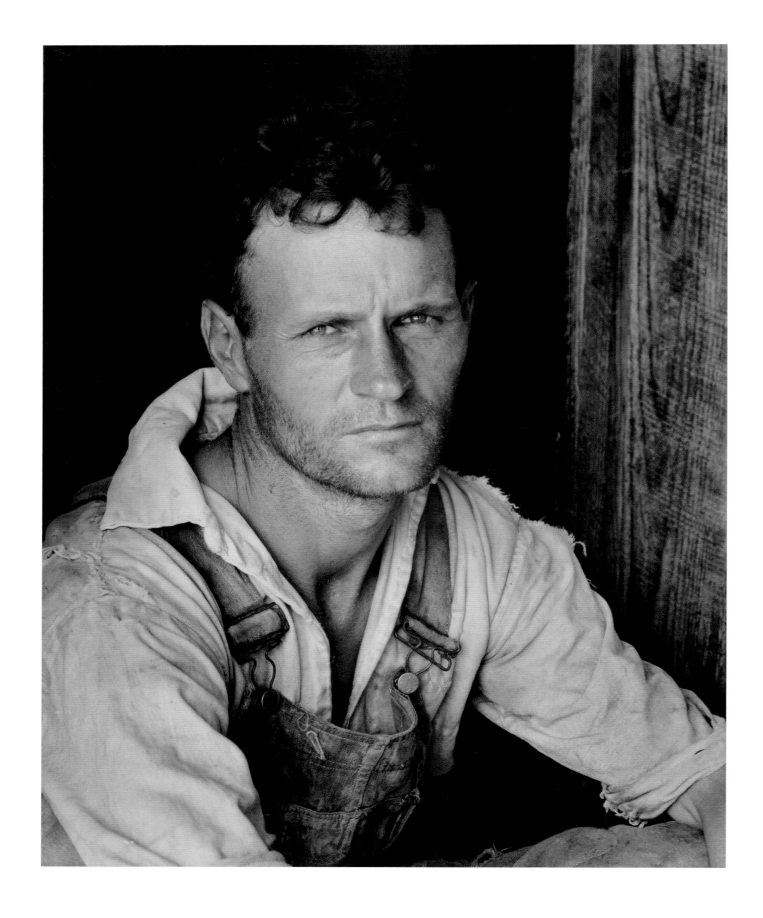

Walker Evans

Floyd Burroughs, cotton sharecropper,
Hale County, Alabama. 1935 or 1936.

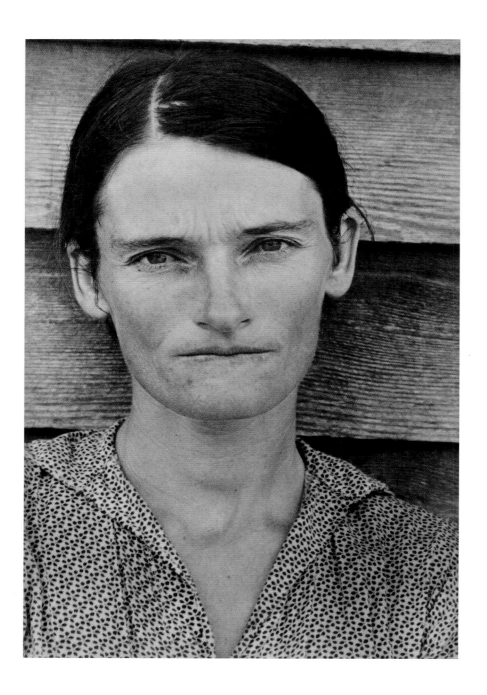

Walker Evans

Alabama cotton tenant farmer wife.
1935 or 1936.

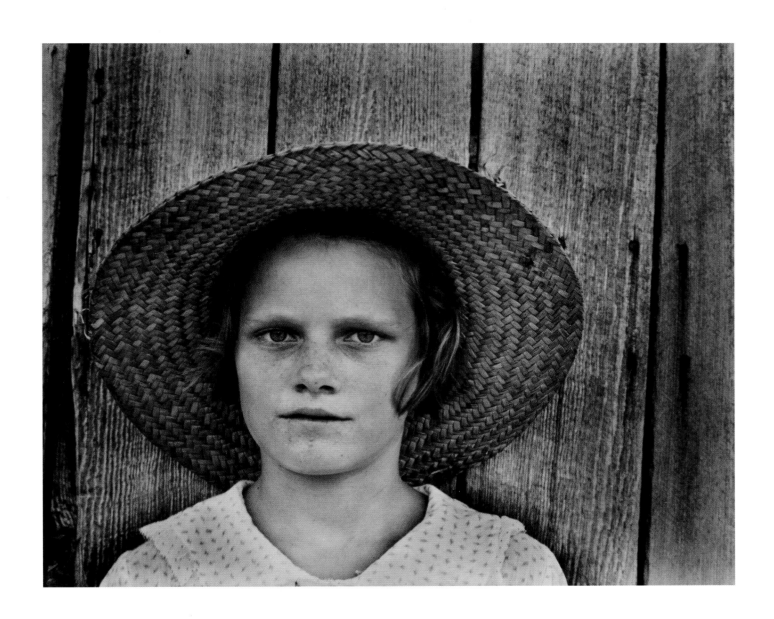

Walker Evans

Lucille Burroughs, the daughter of a cotton cropper, Hale County, Alabama. 1935 or 1936.

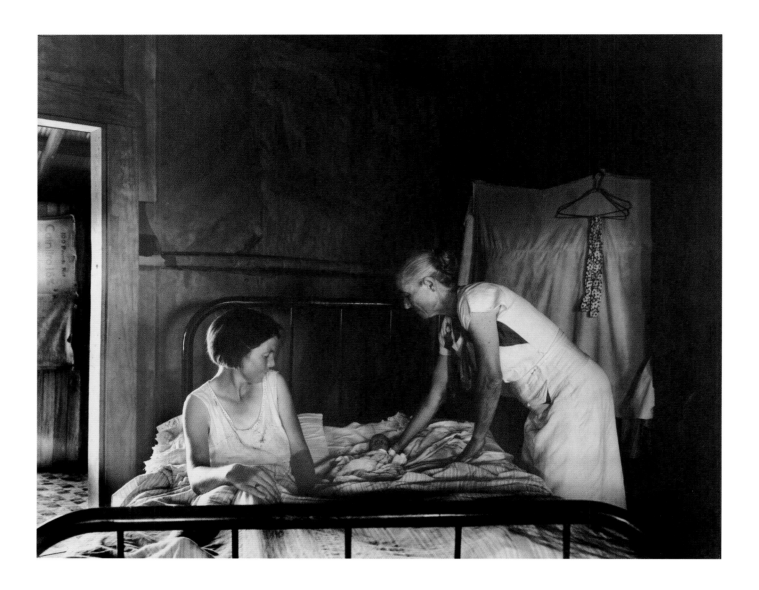

Dorothea Lange
The grandmother, mother, and new-born
baby of a sharecropper family near Cleveland,
Mississippi. June, 1937.

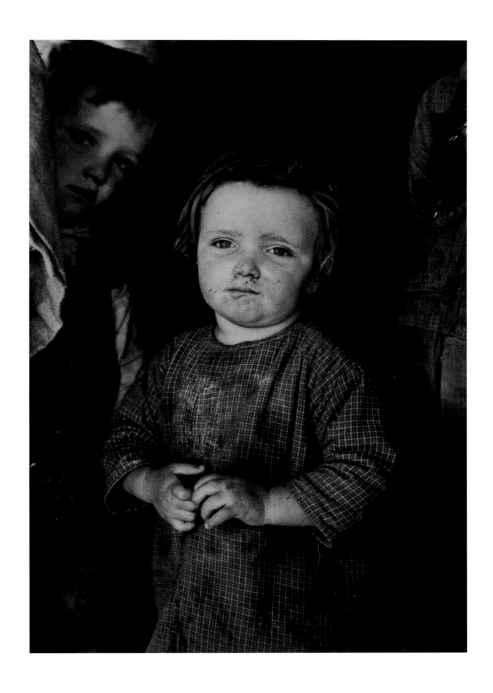

Carl Mydans
The baby girl of a family living on Natchez Trace
Project, near Lexington, Tennessee. March, 1936.

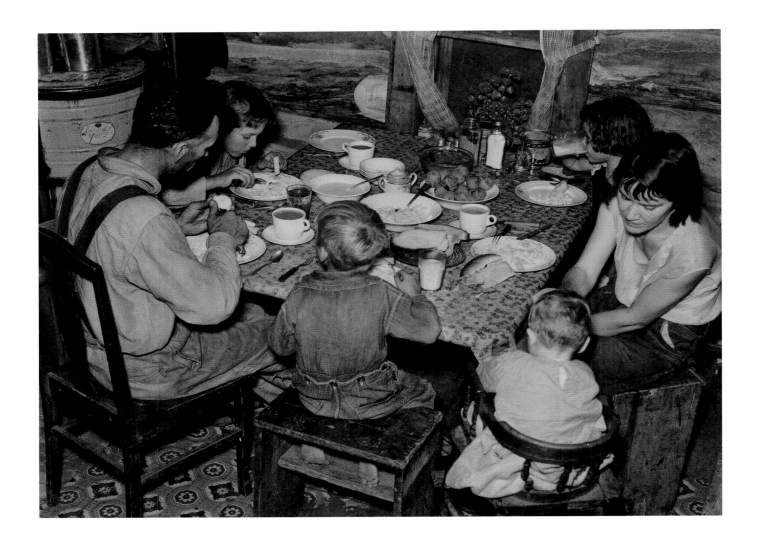

Russell Lee
The William Horavitch family eating dinner,
Williams County, North Dakota (drought area).
September, 1937.

"A PIECE OF MEAT IN THE HOUSE

WOULD LIKE TO SCARE THESE

CHILDREN OF MINE TO DEATH."

Russell Lee
The daughter of a migrant auto-wrecker doing
her lessons on the bed in a tent home, Corpus
Christi, Texas. February, 1939.

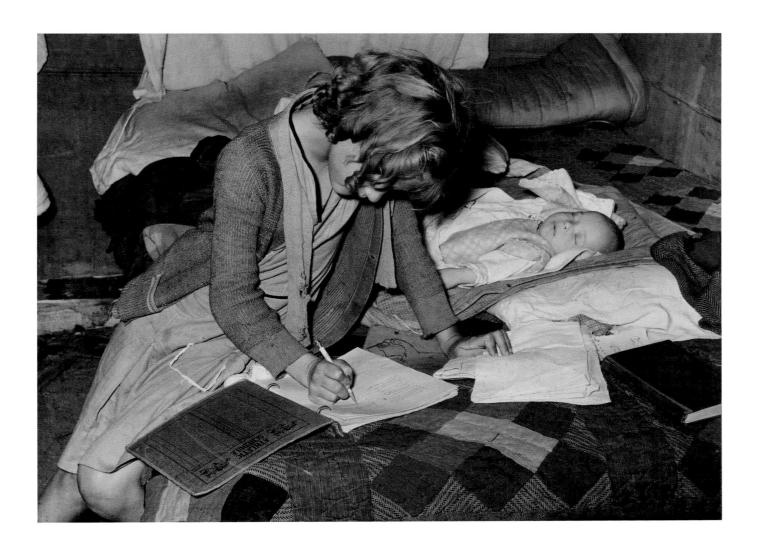

Ben Shahn
Roadside advertising along Route 40,
central Ohio. Summer, 1938.

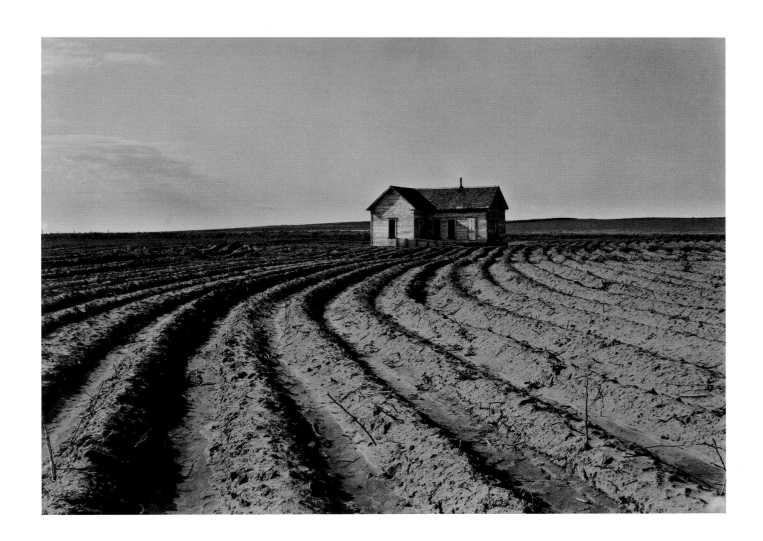

Dorothea Lange
Power farming displaces tenants from the land
in the western dry cotton area, Texas Panhandle.
June, 1938.

"BURNED OUT, BLOWED OUT,

EAT OUT, TRACTORED OUT."

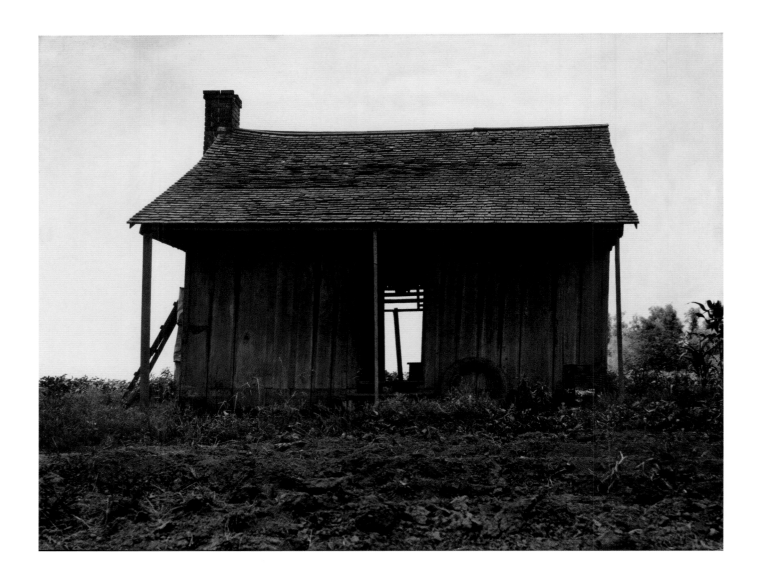

Dorothea Lange
Abandoned tenant house on a mechanized
plantation of the Mississippi Delta. June, 1937.

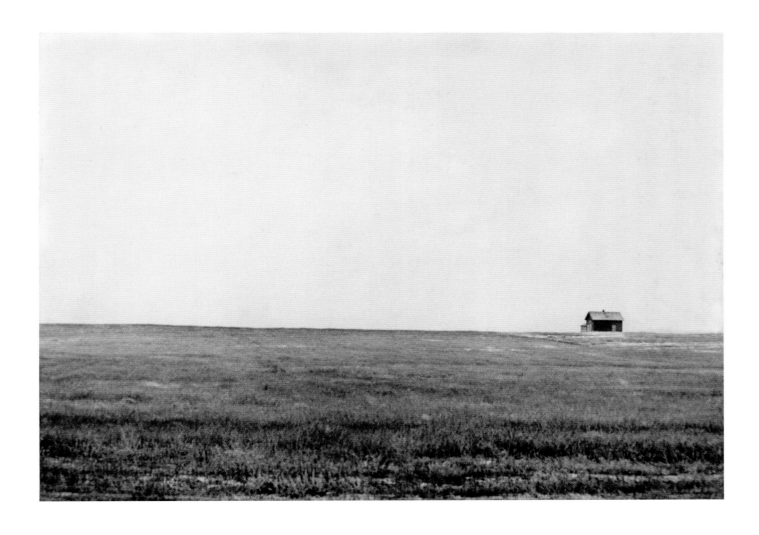

John Vachon

Dewey County, South Dakota. February, 1942.

"THAT PLACE HAS MADE A LIVING

FOR A FAMILY EVER SINCE THE LAND WAS BROKE."

Dorothea Lange
County postmaster, Carey, Childress County,
Texas. A small Texas town in an area being
depopulated by tractor farming. June, 1938.

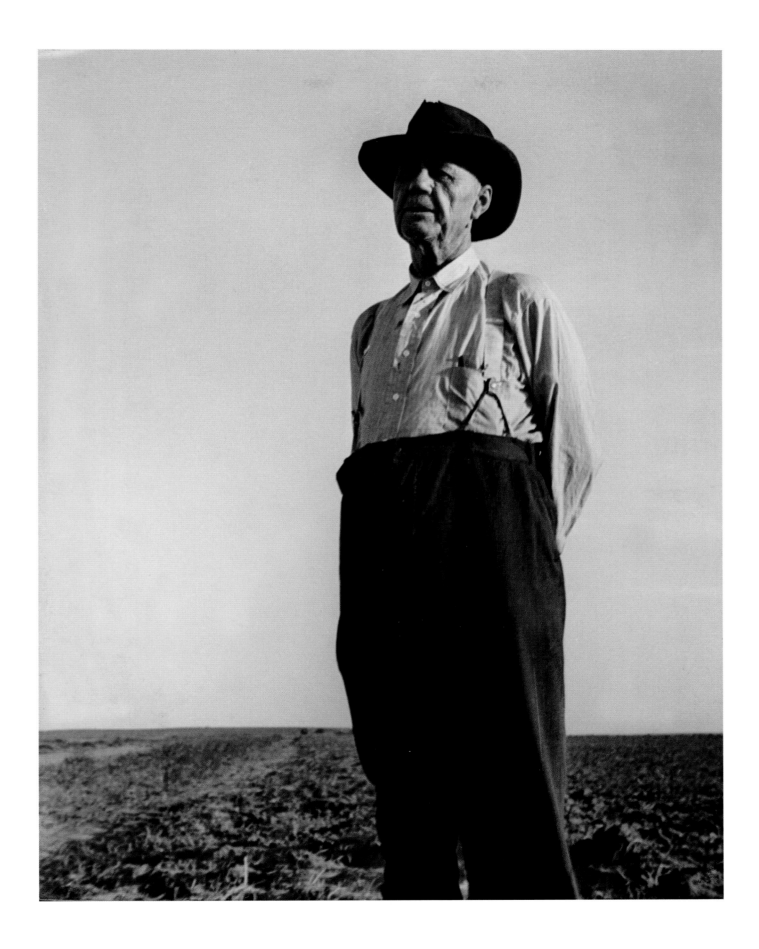

John Vachon
Furniture of evicted sharecroppers on the Dibble
Plantation, Arkansas. January, 1936.

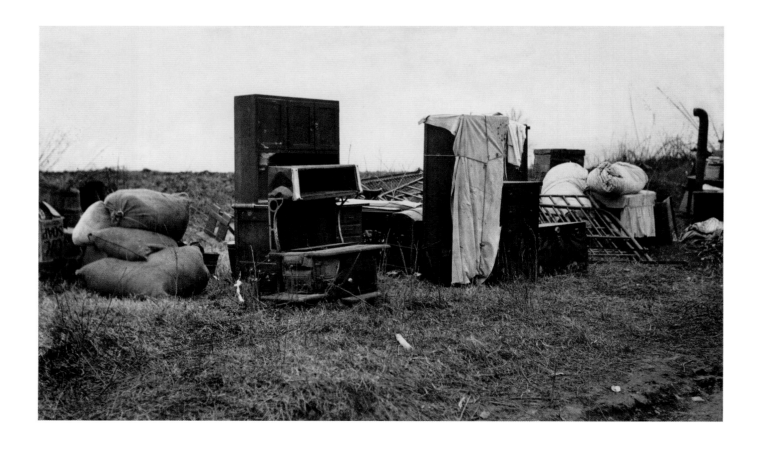

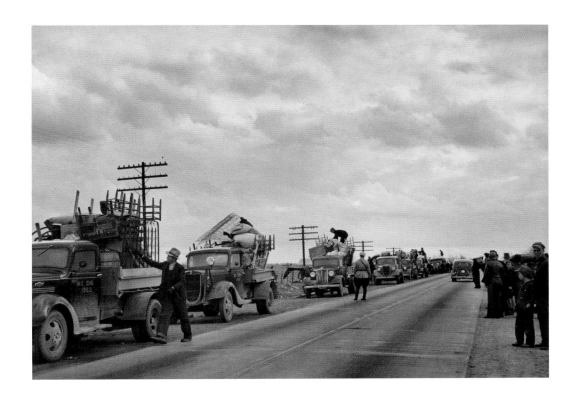

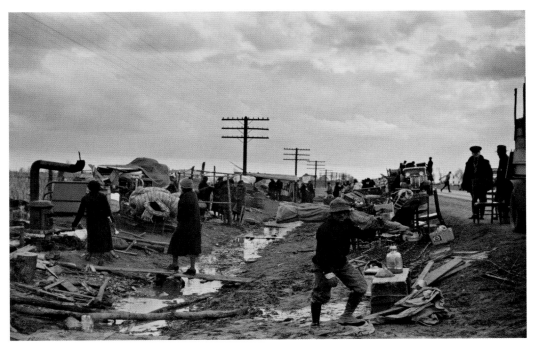

Arthur Rothstein
(Top and above) State highway officials moving
sharecroppers away from the roadside to an area
between the levee and the Mississippi River, New
Madrid County, Missouri. June, 1939.

Dorothea Lange
Route 99 near Tracy, California. A Missouri
family of five, seven months from the drought
area. They worked in a California sawmill at 40
cents an hour until it closed. Went to the cotton
fields at the end of the harvest, made $5 a week
"just scrappin' along; we're not tramps; we hold
ourselves to be white folks. We was forced out;
we couldn't stay there." A common story. Broke,
hungry, sick, car trouble. February, 1937.

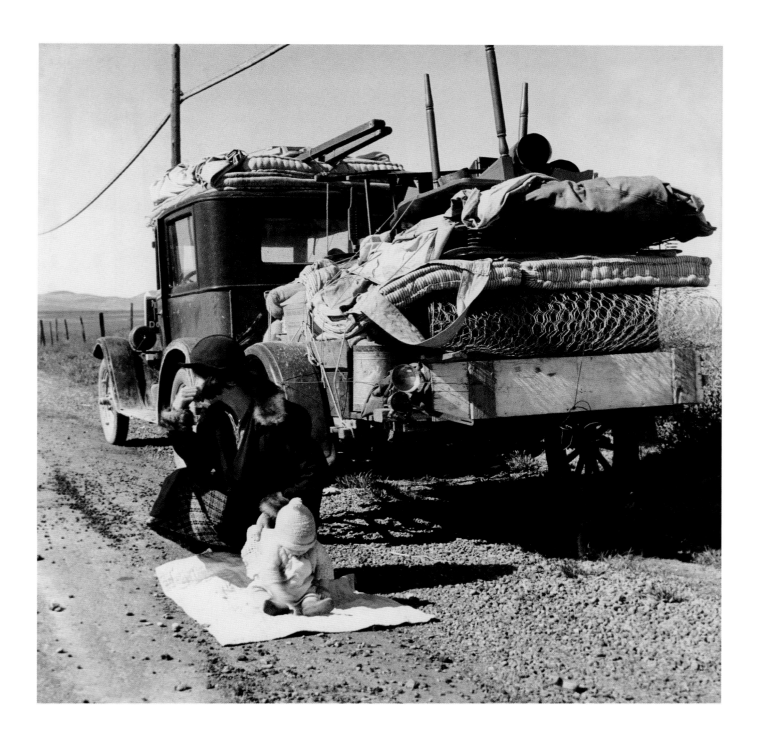

Dorothea Lange
A baby from Mississippi parked in a truck at
the FSA camp, Merrill, Oregon. October, 1939.

Dorothea Lange
One migrant family hauls the broken down
car of the other to the pea fields at Nipomo,
Route 101, California. February, 1936.

Dorothea Lange
The car of drought refugees on the edge of
a carrot field in the Coachella Valley, California.
Spring, 1937.

Arthur Rothstein
A tenant farmer moving his household goods
to a new farm, Hamilton County, Tennessee.
1937.

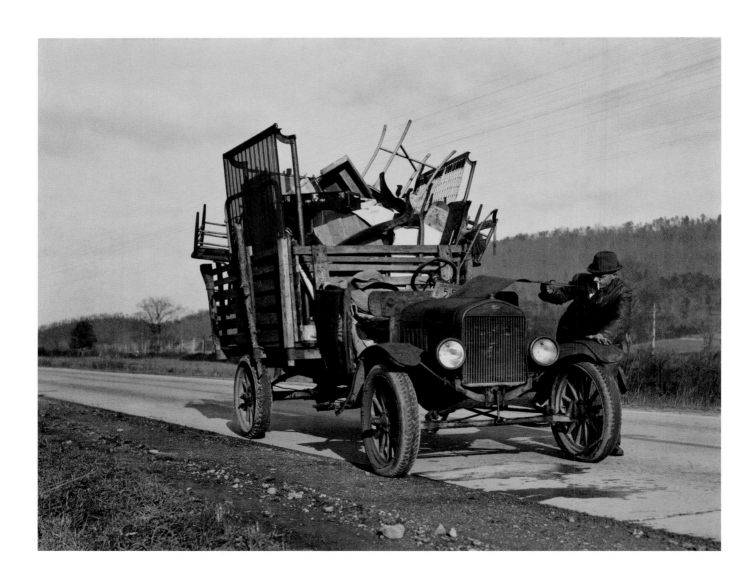

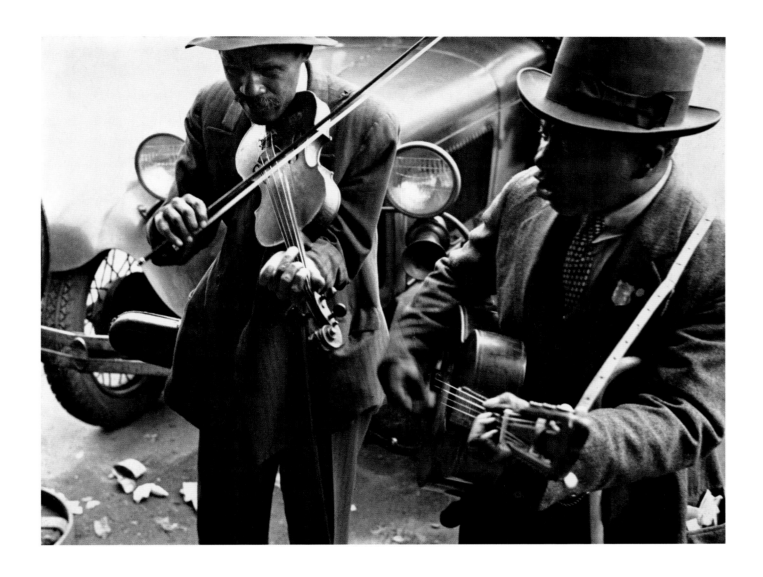

Ben Shahn
Street musicians in Memphis, Tennessee. 1935.

"WE JUST MAKE ENOUGH FOR BEANS,

AND WHEN WE HAVE TO BUY GAS

IT COMES OUT OF THE BEANS."

Arthur Rothstein
Sign, Birmingham, Alabama. February, 1937.

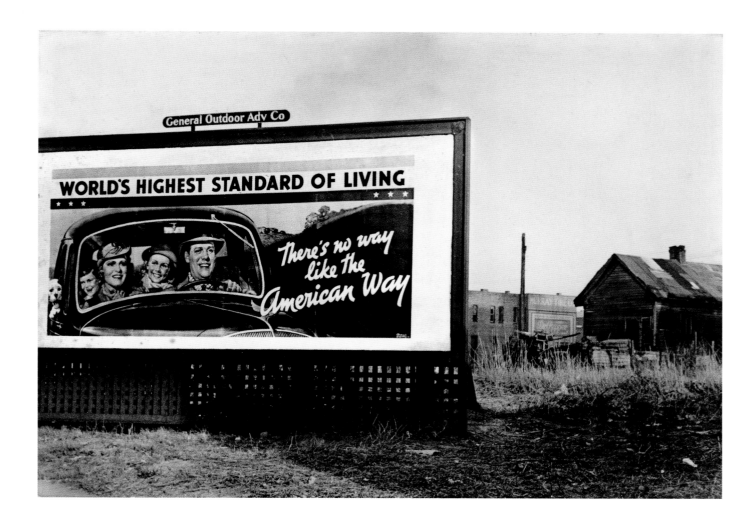

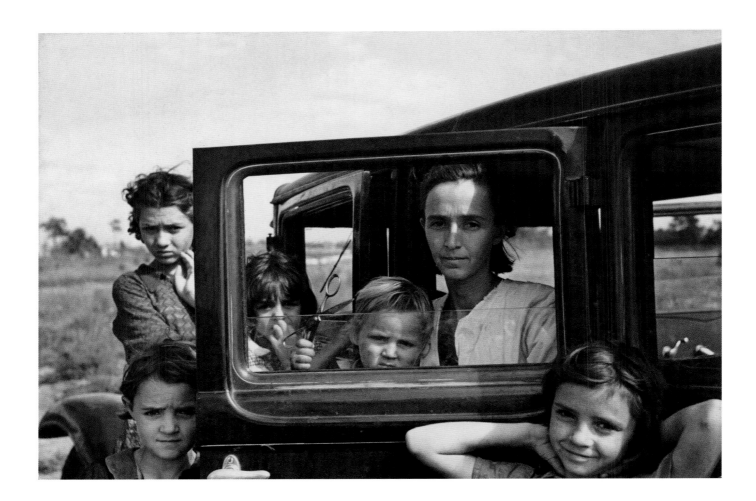

Arthur Rothstein
The family of a migratory fruit worker from
Tennessee now camped in a field near the
packing house at Winterhaven, Florida.
January, 1937.

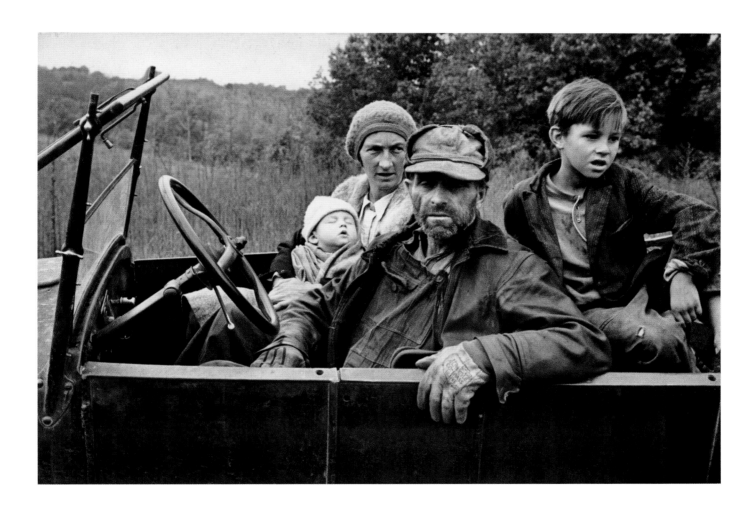

Ben Shahn
Destitute Ozark family, Arkansas. October, 1935.

Dorothea Lange

A family between Dallas and Austin, Texas.
The people left their home and connections
in South Texas and hope to reach the
Arkansas Delta for work in the cotton fields.
Penniless people. No food and three gallons
of gas in the tank. The father is trying to
repair a tire. Three children. Father says,
"It's tough but life's tough anyway you take
it." August, 1936.

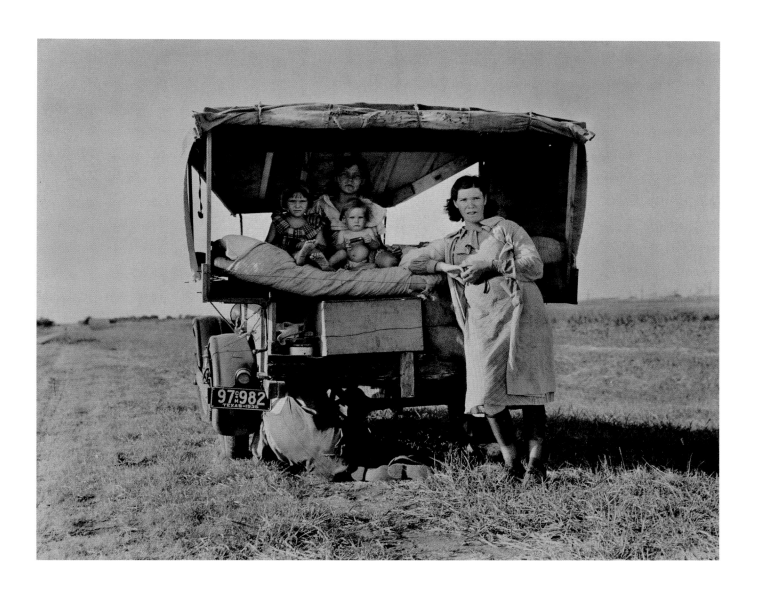

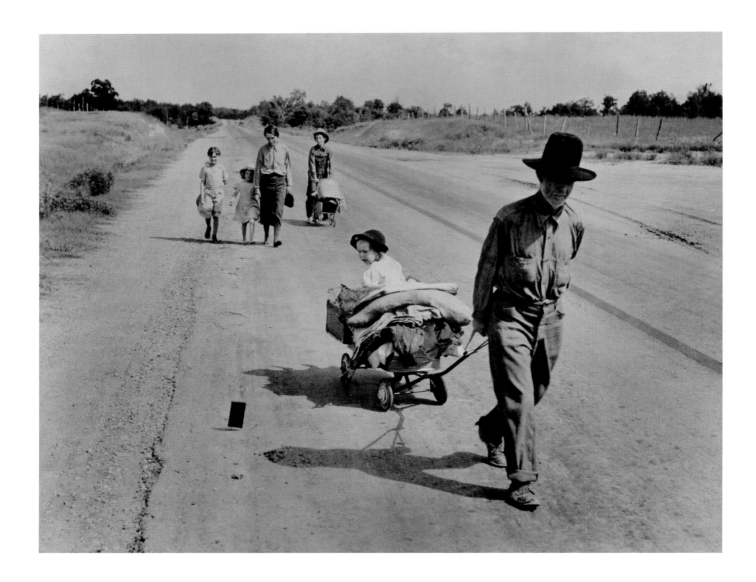

Dorothea Lange

A family walking on the highway with five children, Pittsburg County, Oklahoma. They started from Idabel, Oklahoma, bound for Krebs, Oklahoma. In 1936, the father farmed on thirds and fourths at Eagletown, McCurtain County, Oklahoma. He was taken sick with pneumonia and lost the farm. He was unable to get work on Works Progress Administration and was refused county relief in county of fifteen years' residence because of temporary residence in another county after his illness. June, 1938.

"NO, I DIDN'T SELL OUT BACK THERE. I <u>GIVE</u> OUT."

"YESSIR WE'RE STARVED, STALLED AND STRANDED."

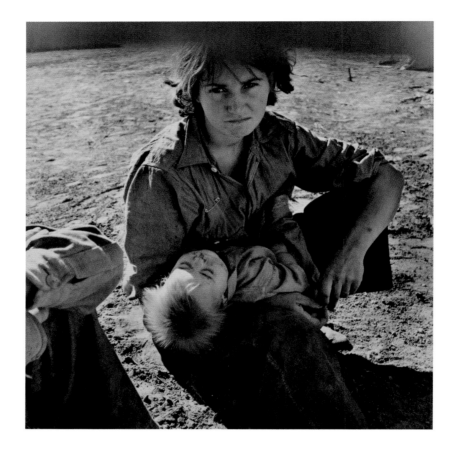

Dorothea Lange
A young Oklahoma mother, age 18, penniless,
stranded in California. Imperial Valley. March, 1937.

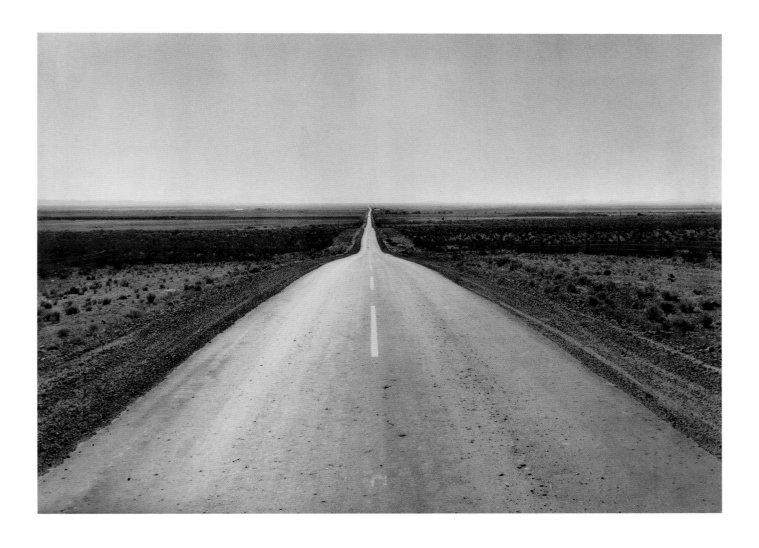

Dorothea Lange
Route 54, north of El Paso, Texas. One of the
westward routes of the migrants. June, 1938.

Dorothea Lange
Flood refugee family near Memphis, Texas. These
people, with all their belongings, are bound for
the lower Rio Grande Valley, where they hope to
pick cotton. They come from Arkansas. May, 1937.

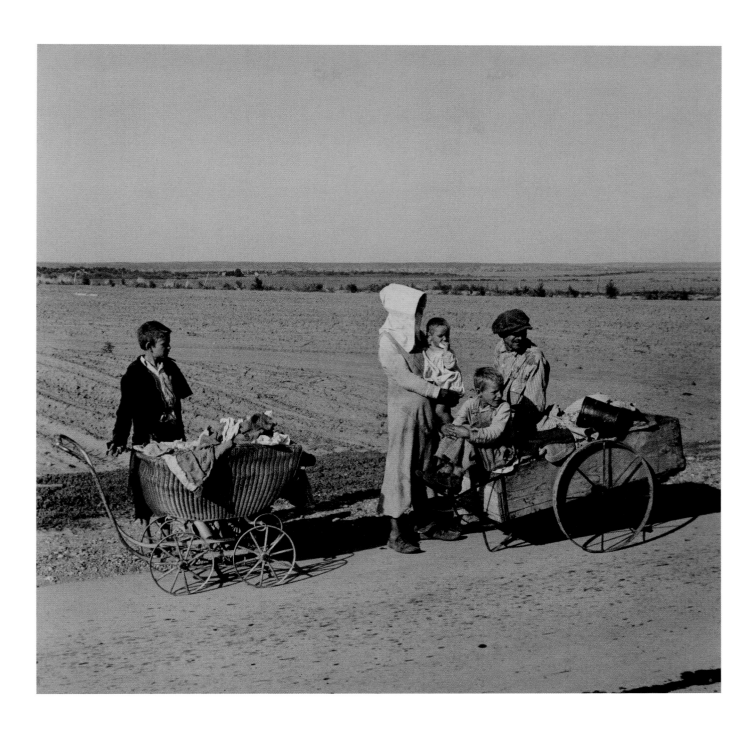

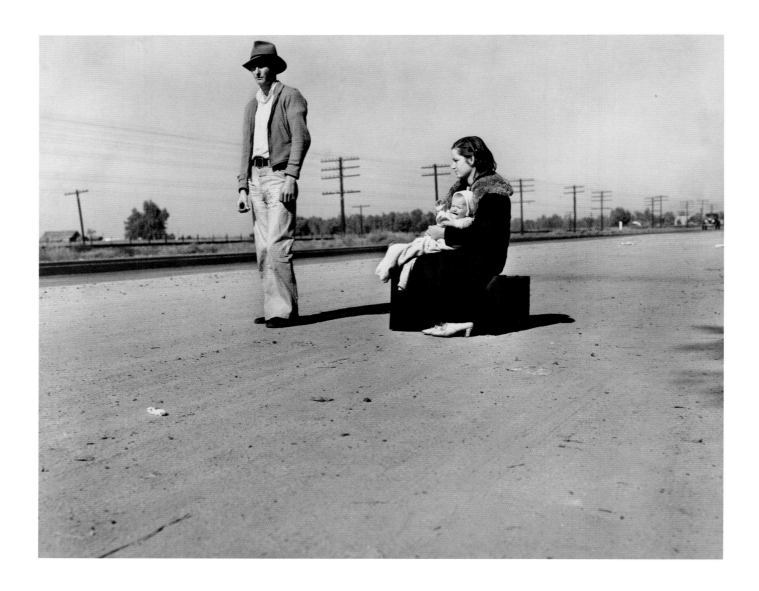

Dorothea Lange

A young family, penniless, hitch-hiking on U.S. Highway 99, California. The father, 24, and the mother, 17, came from West Salem, North Carolina, early in 1935. Their baby was born in the Imperial Valley, California, where they were working as field laborers. November, 1936.

Dorothea Lange

A hitch-hiking family waiting along the highway
in Macon, Georgia. The father repairs sewing
machines, lawn mowers, etc. He is leaving
Macon, where a license is required for such work
($25), and heading back to Alabama. July, 1937.

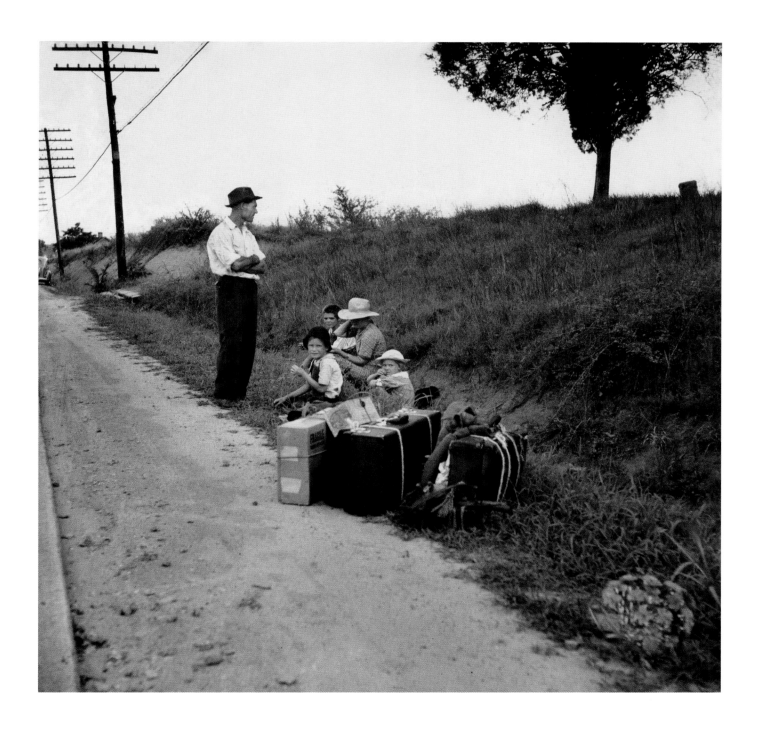

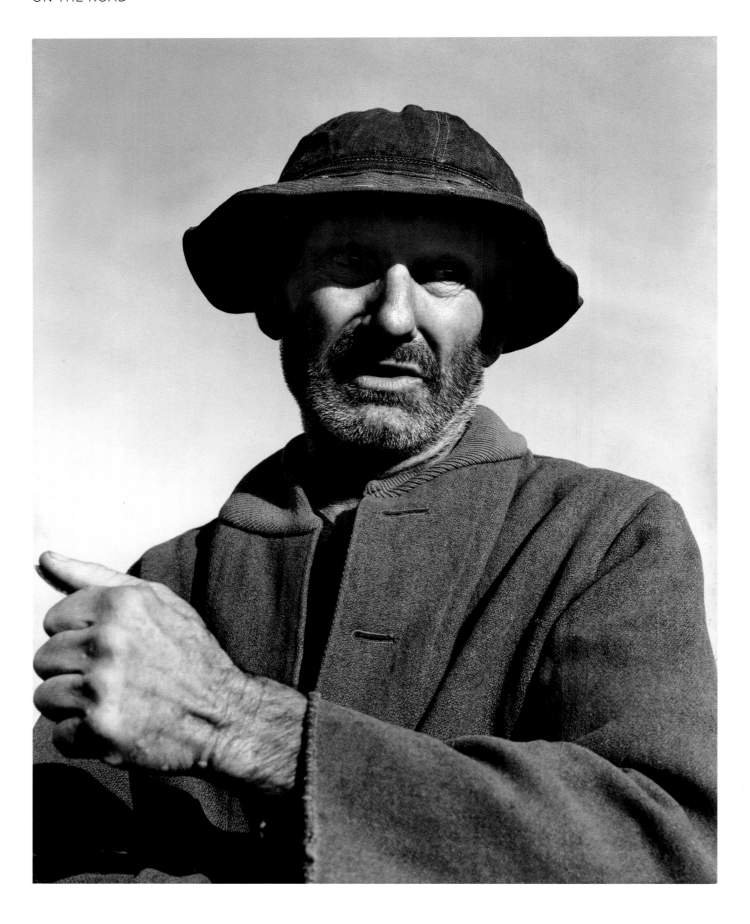

Dorothea Lange

Came from Webbers Falls, Oklahoma, with two grown sons in 1939. Cotton picker, Firebaugh, California. February, 1939.

Dorothea Lange

Napa Valley, California. More than twenty-five years a bindlestiff, he walks from the mines to the lumber camps to the farms. The type that formed the backbone of the International Workers of the World in California before the war. December, 1938.

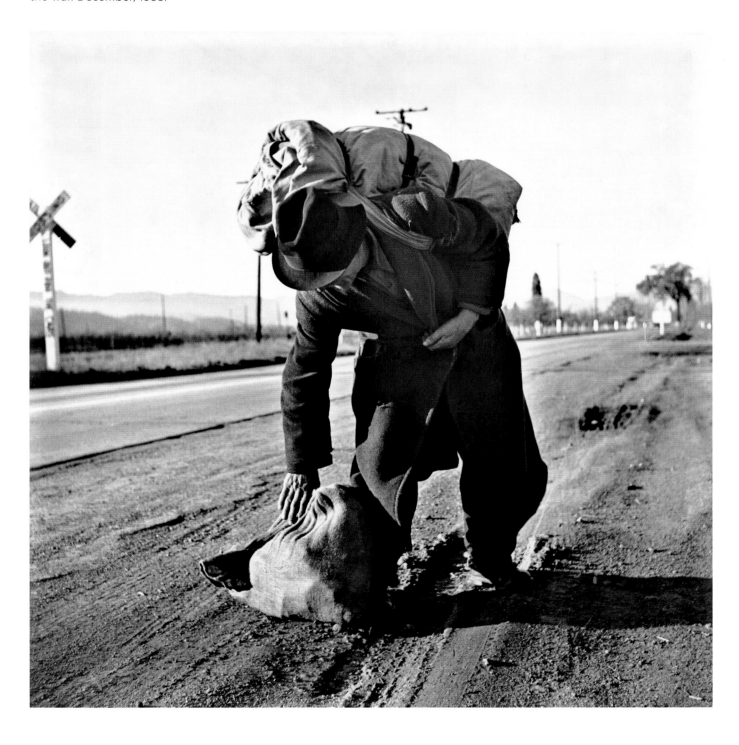

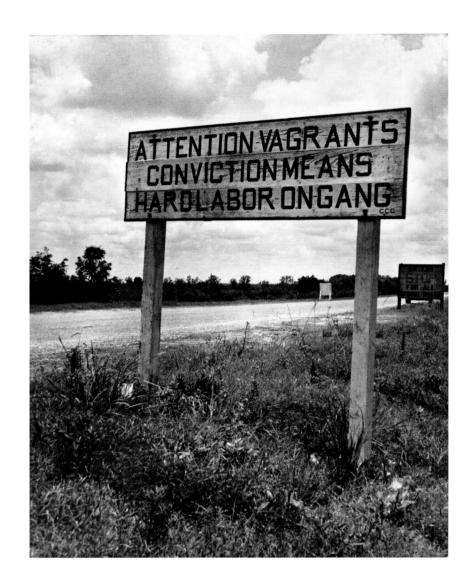

Dorothea Lange
Georgia road sign. Warning vagrants. 1938

Dorothea Lange
Imperial Valley, California. Old Mexican laborer
saying "I have worked hard all my life and all
I have now is my broken body." June, 1935.

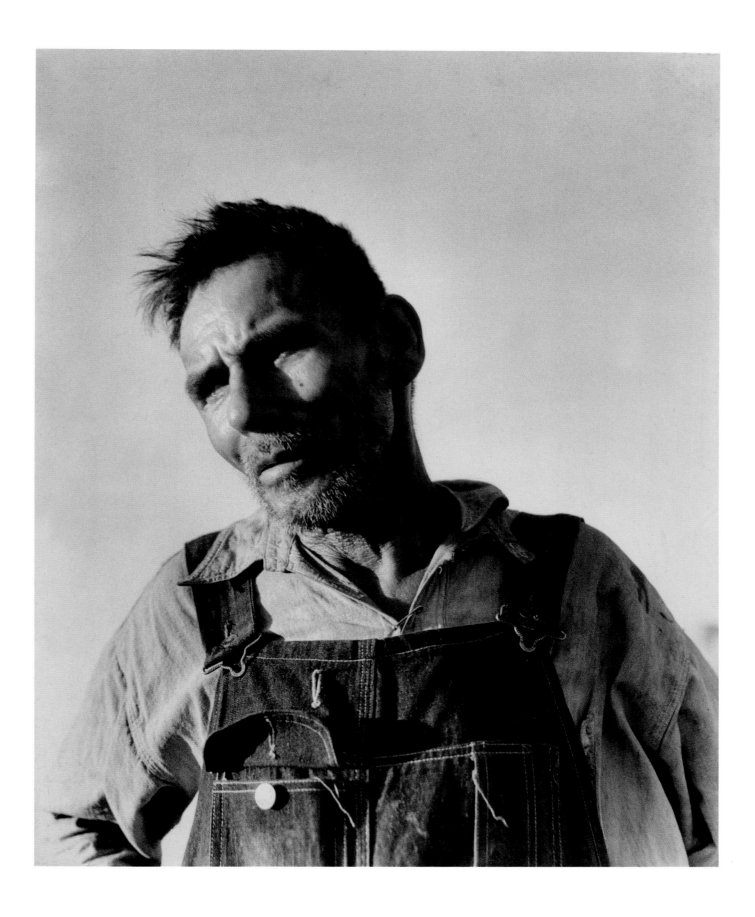

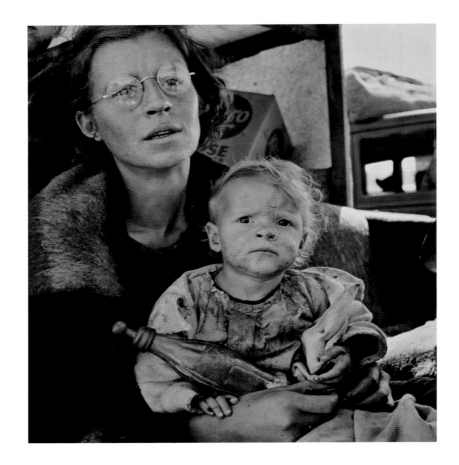

Dorothea Lange
Mother and baby of a family on the road,
Tulelake, Siskiyou County, California.
September, 1939.

Dorothea Lange
On U.S. Highway 99, near Brawley, Imperial
County, California. The homeless mother and
youngest child of seven walking the highway
from Phoenix, Arizona, where they picked
cotton. Bound for San Diego, where the father
hopes to get on the relief "because he once
lived there." February, 1939.

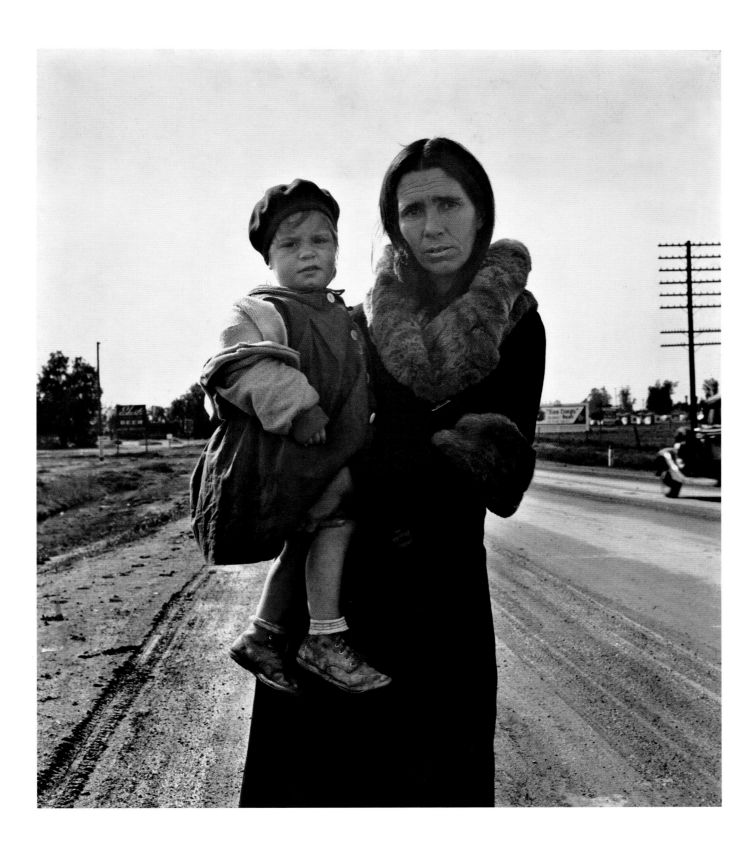

"THE PEOPLE WILL LIVE ON.

THE LEARNING AND BLUNDERING PEOPLE WILL LIVE ON.

THEY WILL BE TRICKED AND SOLD AND AGAIN SOLD

AND GO BACK TO THE NOURISHING EARTH FOR ROOTHOLDS,

THE PEOPLE SO PECULIAR IN RENEWAL AND COMEBACK,

YOU CAN'T LAUGH OFF THEIR CAPACITY TO TAKE IT.

THE MAMMOTH RESTS BETWEEN HIS CYCLONIC DRAMAS."

CARL SANDBURG

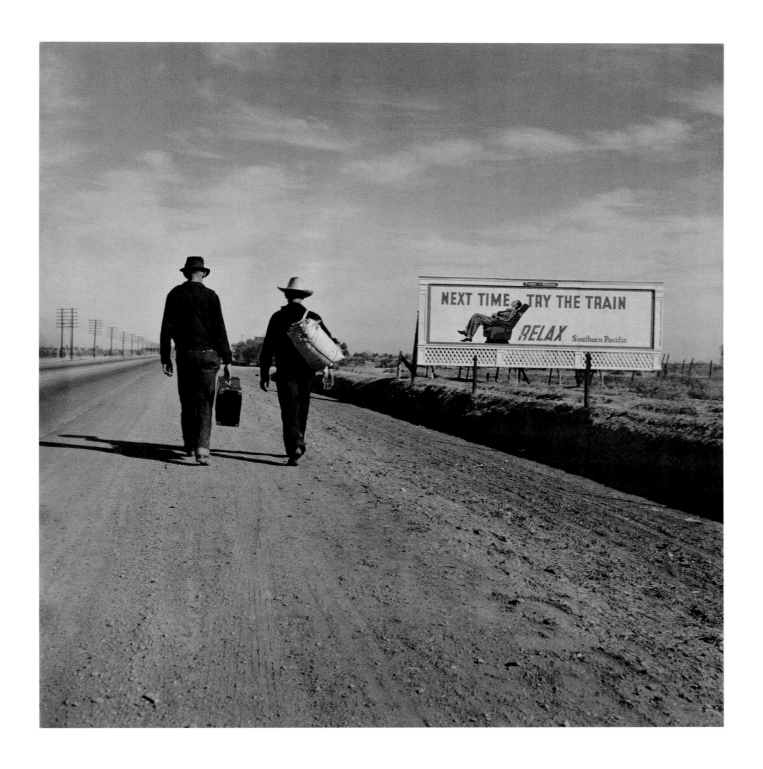

Dorothea Lange
Toward Los Angeles, California. March, 1937.

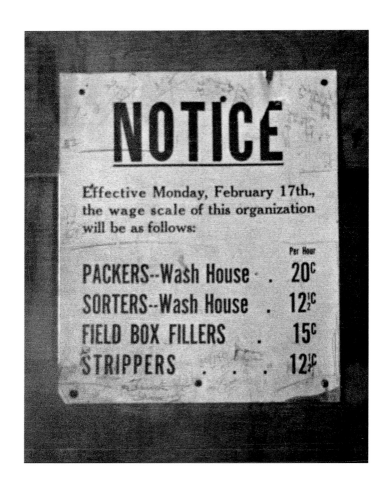

Arthur Rothstein
Notice to celery workers, Sanford, Florida.
January, 1937.

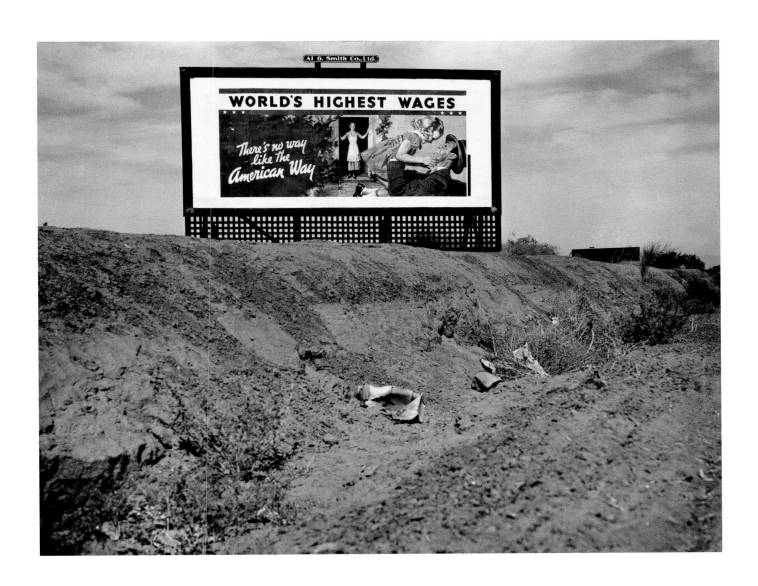

Dorothea Lange
Billboard on U.S. Highway 99 in California.
National advertising campaign sponsored by
the National Association of Manufacturers.
March, 1937.

"WE'LL BE DAMNED IF WE'LL WORK

FOR WHAT THEY PAY FOLKS HEREABOUTS."

Carl Mydans

Day laborer and wife. Migrants. Cotton workers
on the road with all they possess in the world,
Crittenden County, Arkansas. May, 1936.

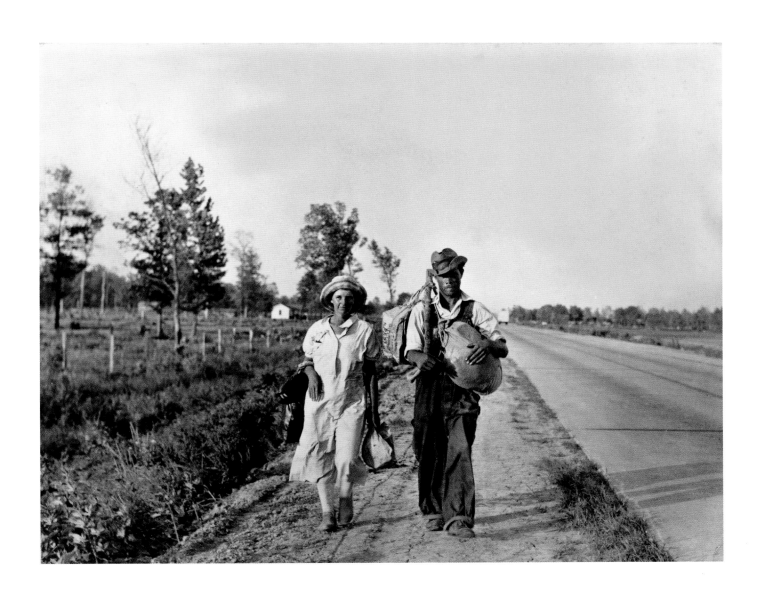

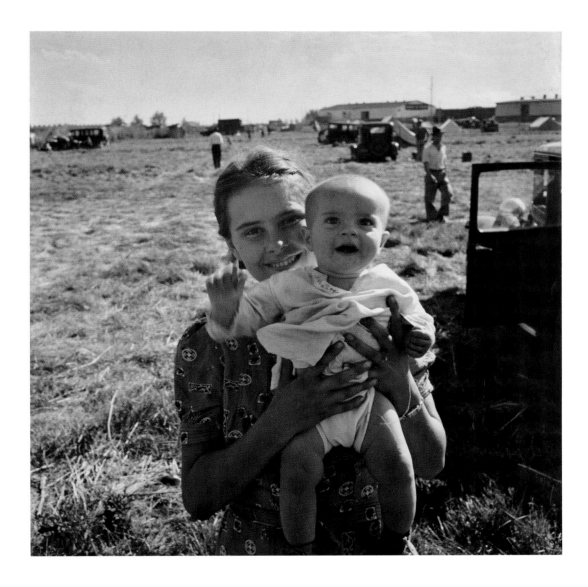

Dorothea Lange
13-year-old daughter of Negro sharecropper planting sweet potatoes. She walks down the row and places the young plants in the holes her father dug with a hoe. They will return down the row, water the plants with a bucket then cover the roots with earth. Olive Hill, North Carolina. July, 1939.

Dorothea Lange
Migrant potato pickers, Tulelake, Siskiyou County, California. September, 1939.

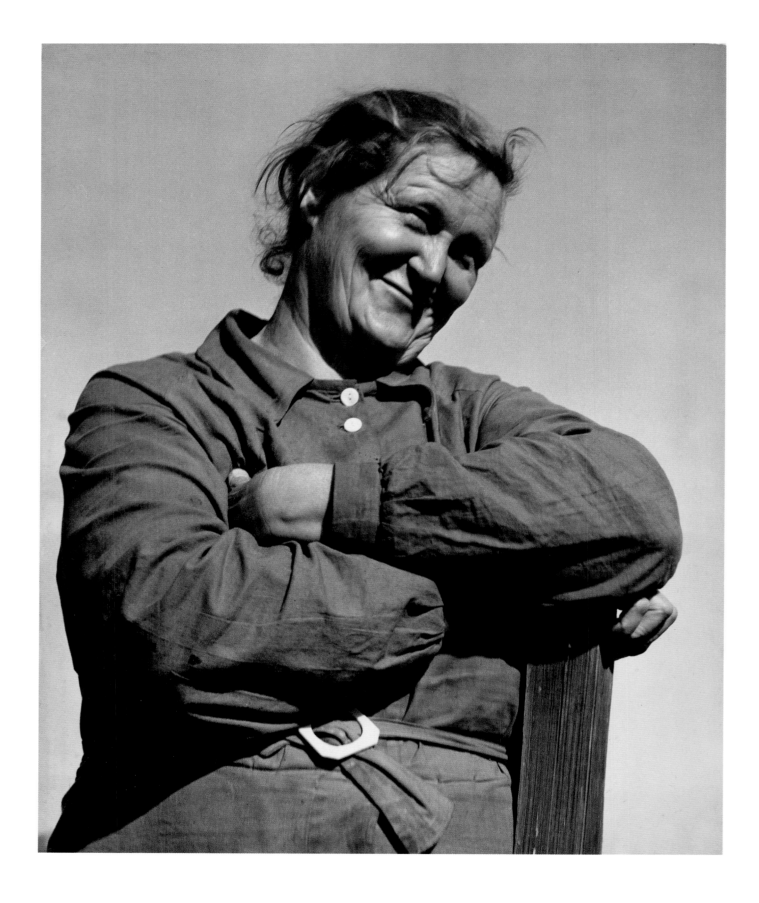

"IF YOU DON'T HAVE TO GO TO THE GOVERNMENT

MAN FOR WHAT BREAD YOU EAT I LIKE IT BETTER."

Dorothea Lange
Arkansas mother come to California for a new
start, with husband and eleven children. Now
a rural rehabilitation client, Tulare County,
California. November, 1938.

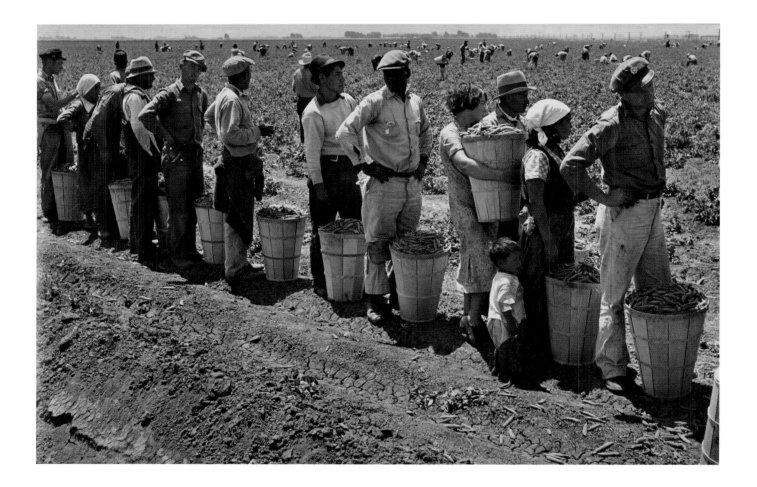

Dorothea Lange
Poverty in the Land of Plenty. Migrant pea
pickers lined up for weighing of filled hampers,
California. 1938.

"WE MADE A DOLLAR WORKIN' FROM DAWN TILL YOU JUST CAN'T SEE."

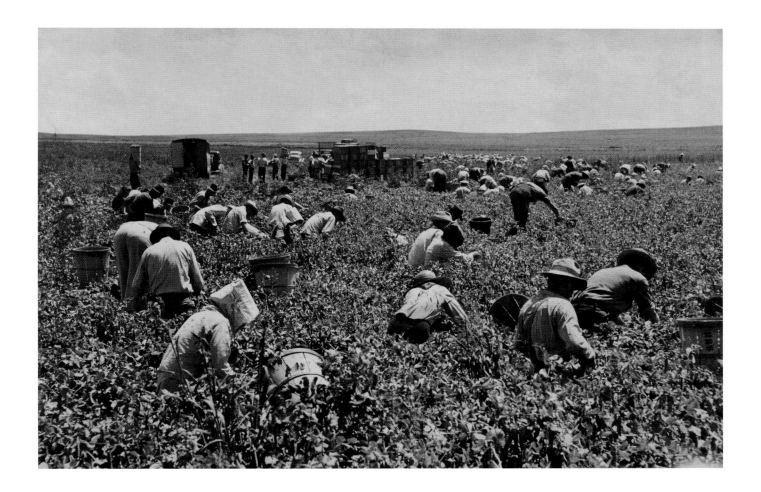

Russell Lee
Labor contractor's crew picking peas. (Pea pickers' wages in 1939: 1 cent per pound; hamper holds 28 pounds.) Nampa, Idaho. June, 1941.

Dorothea Lange
A former tenant farmer from Texas, now
working as a pea picker, Nipomo, California.
March, 1937.

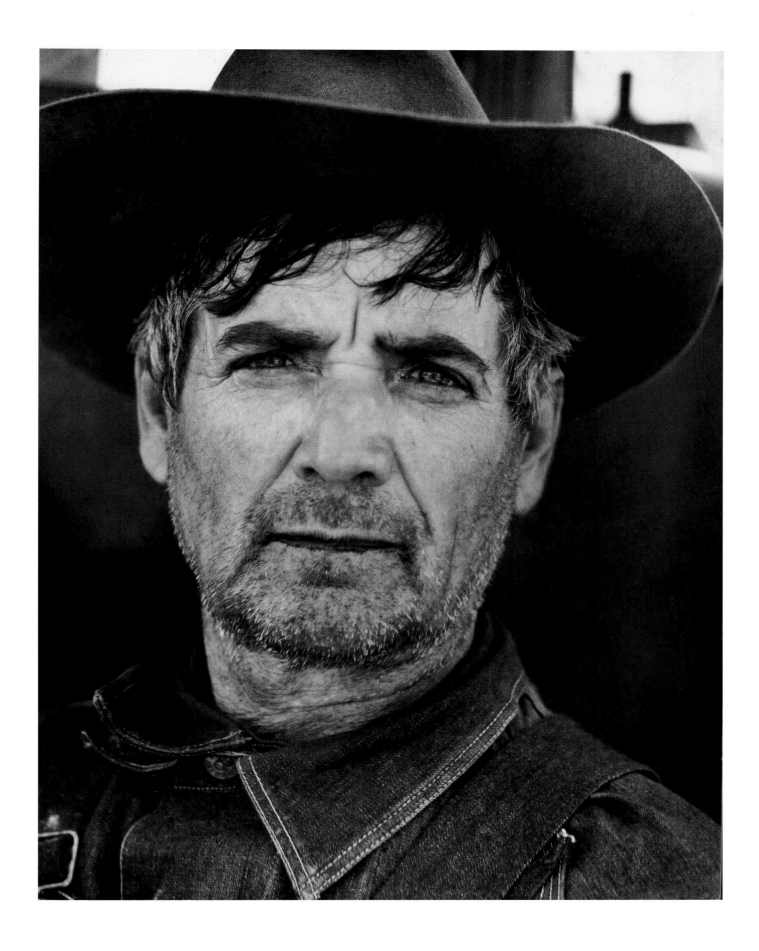

Edwin Locke
A street of tents in the camp for flood refugees
at Forrest City, Arkansas. February, 1937.

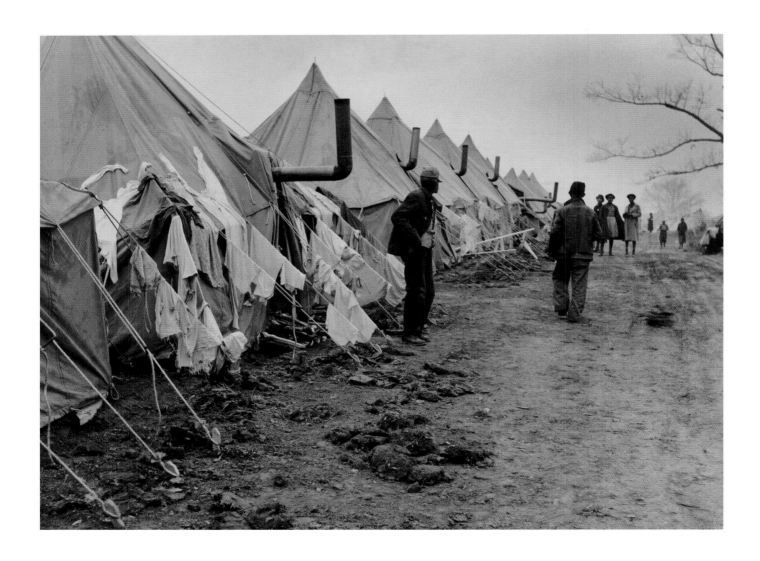

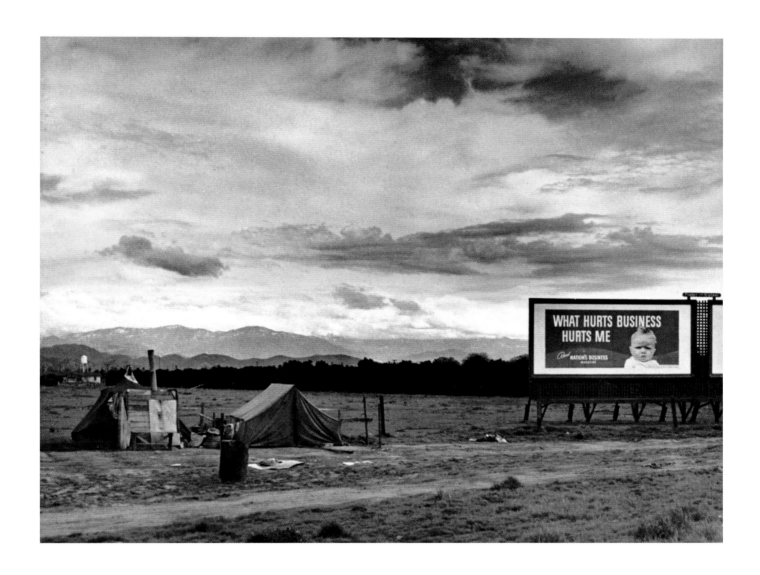

Dorothea Lange
Squatter camp on the flat where families
live during the orange-picking season, near
Porterville, California. February, 1938.

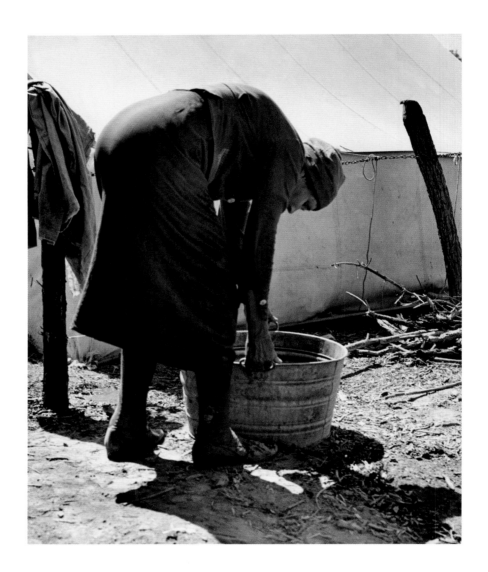

Dorothea Lange
A grandmother washing clothes in a migrant
camp, Stanislaus County, California. April, 1939.

"I'VE WROTE BACK THAT WE'RE WELL

AND SUCH AS THAT BUT I NEVER HAVE WROTE

THAT WE LIVE IN A TENT."

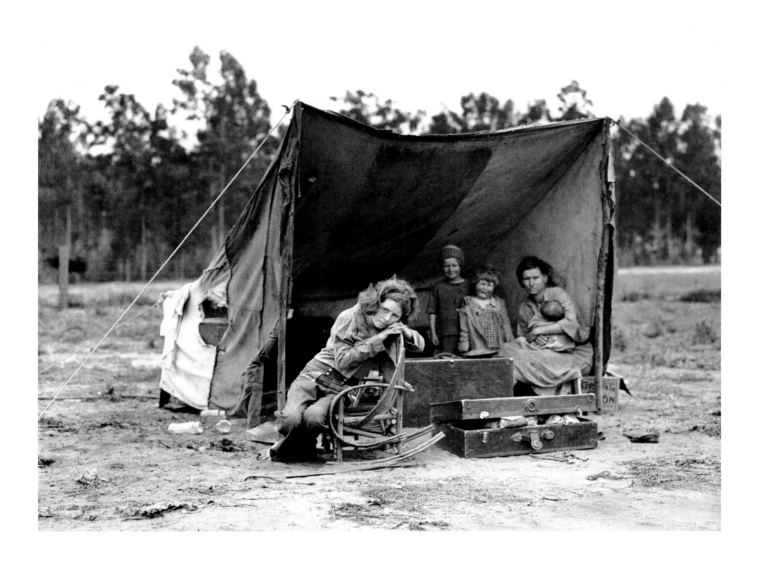

Dorothea Lange
A migrant agricultural worker's family: seven
hungry children, mother aged 32, father is
a native Californian. March, 1936.

Dorothea Lange
Destitute pea pickers in California; a 32-year-old
mother of seven children. Nipomo. February, 1936.

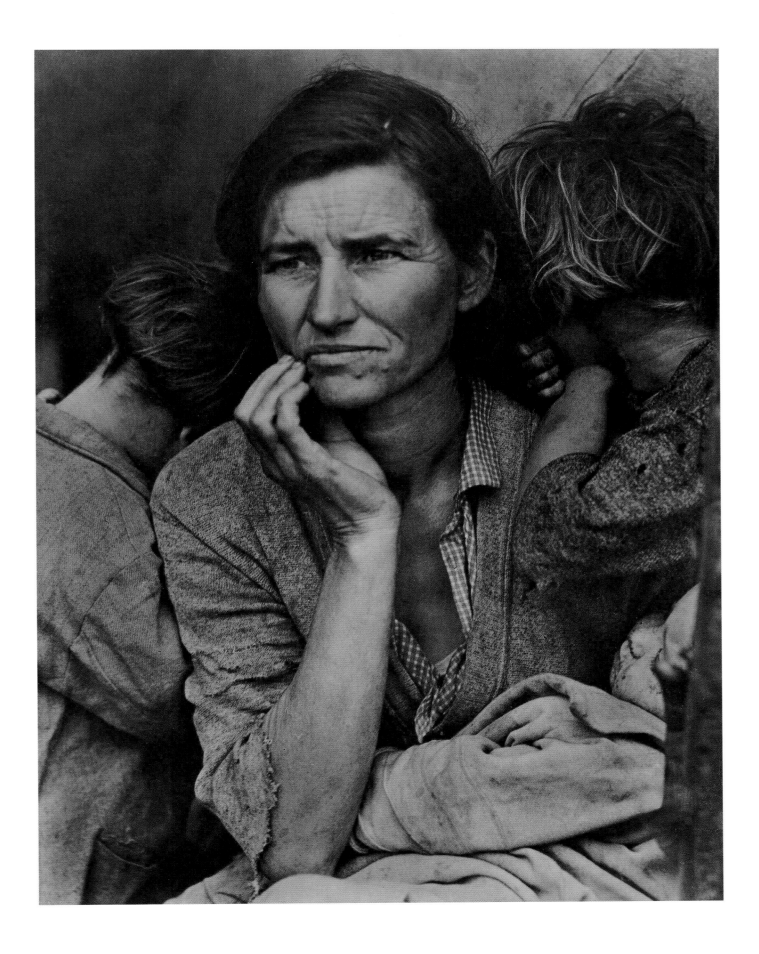

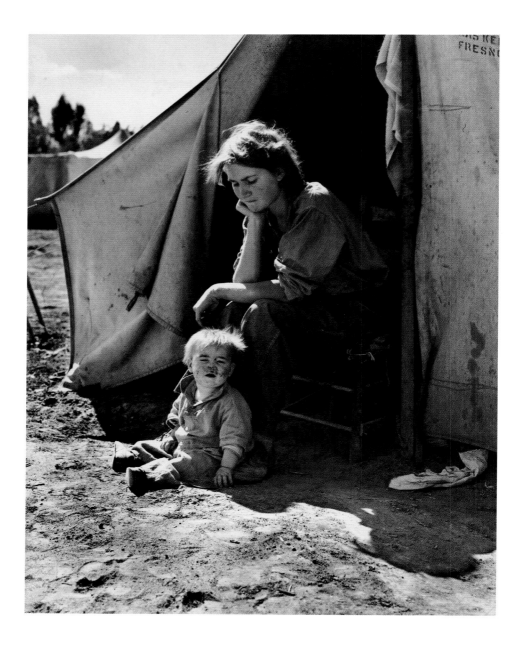

Dorothea Lange
18-year-old mother from Oklahoma,
now a California migrant. March, 1937.

Russell Lee
The tubercular wife and daughter of an
agricultural day laborer. She had lost six of her
eight children and the remaining two were pitifully
thin. The mother said she had tuberculosis
because she had always gone back to the fields
to work within two or three days of her children
being born. The shack home is on Potear Creek
near Spiro, Oklahoma. June, 1939.

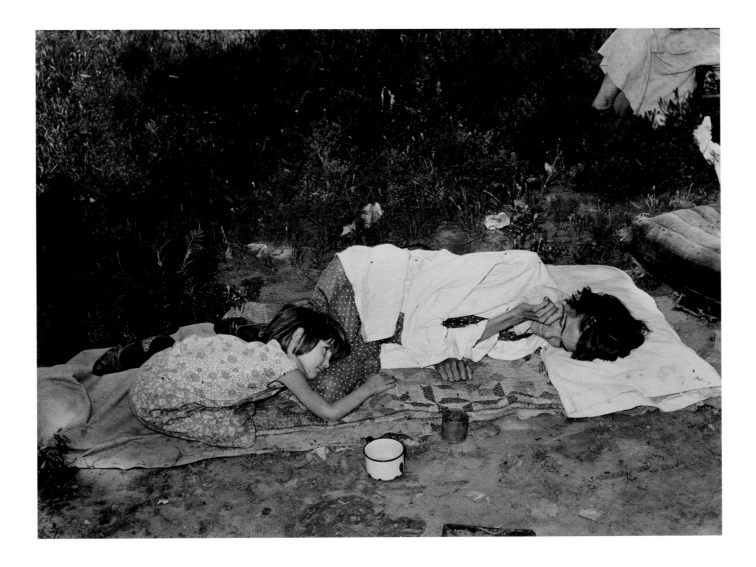

"IF I COULD GET ME A PLACE OF LAND

I'D GO TO DIGGIN IT WITH MY HANDS."

Dorothea Lange
Drought refugees from Oklahoma camping by
the roadside. They hope to work in the cotton
fields. There are seven in the family. Blythe,
California. August, 1936.

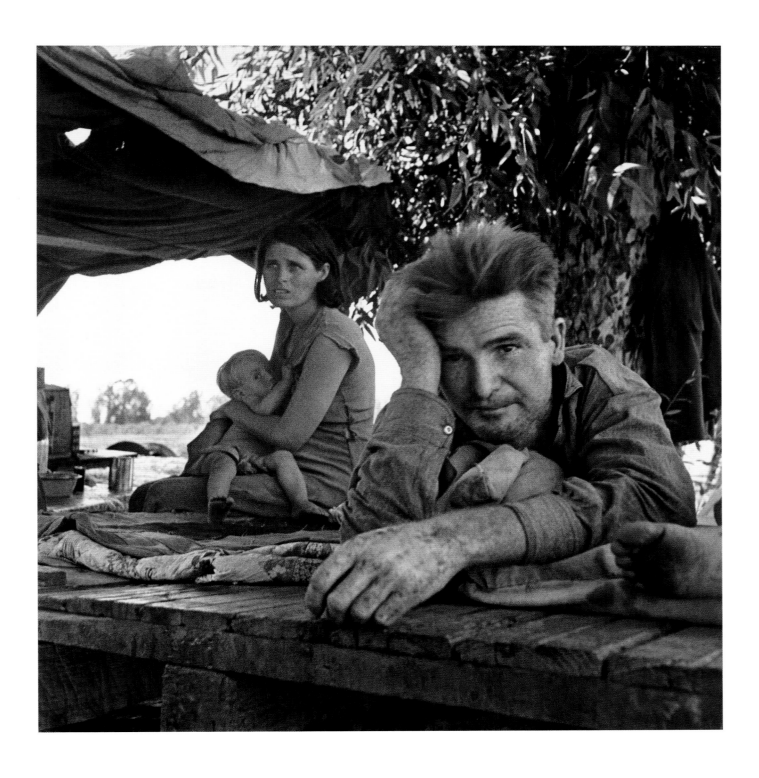

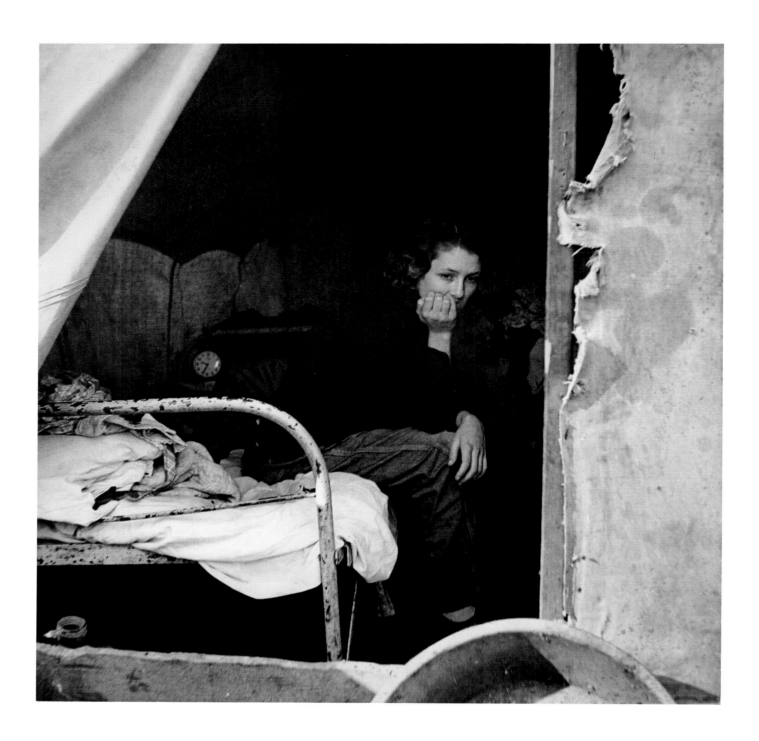

Dorothea Lange
Daughter of a migrant Tennessee coal miner,
living in the American River camp near
Sacramento, California. November, 1936.

Dorothea Lange
Resettled farm child from Taos Junction
to Bosque Farms project, New Mexico.
December, 1935.

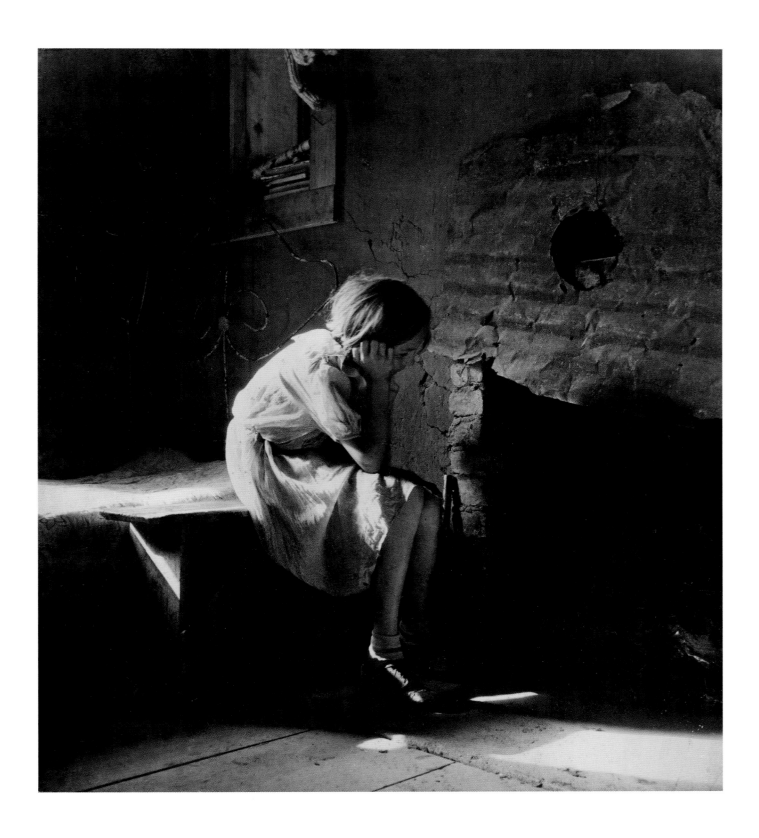

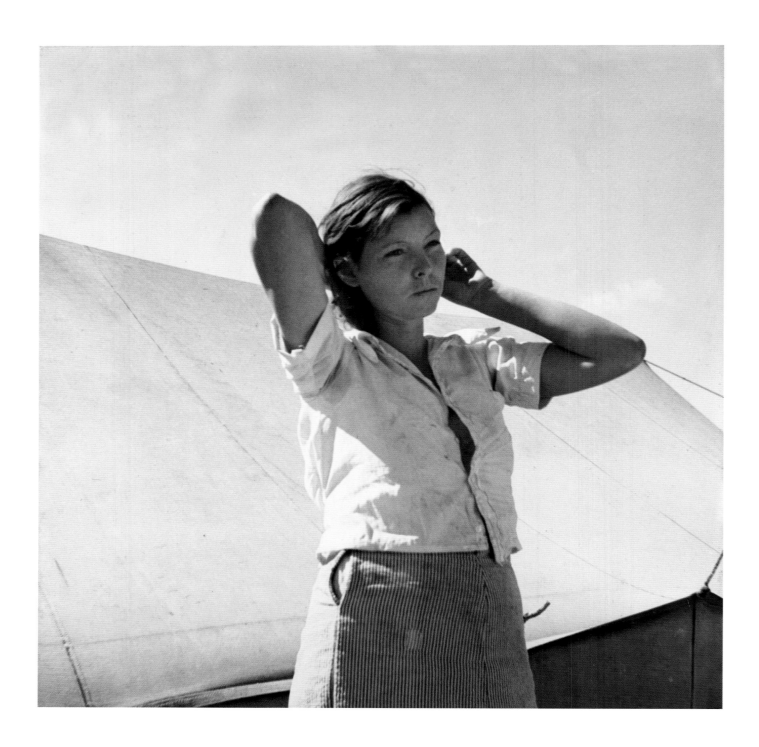

Dorothea Lange
A woman in a pea pickers' camp, California.
"I seen our corn dry up and blow over the fence
back there in Oklahoma." March, 1937.

Dorothea Lange
Drought refugees, California. February, 1936.

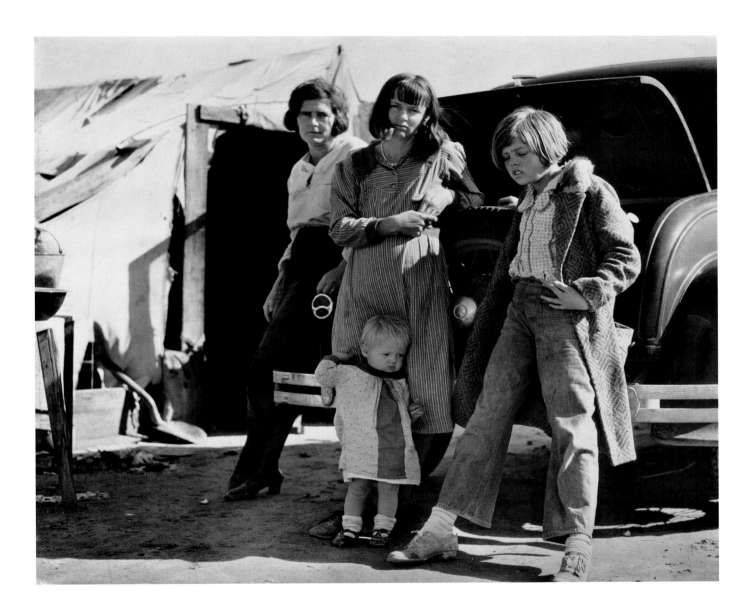

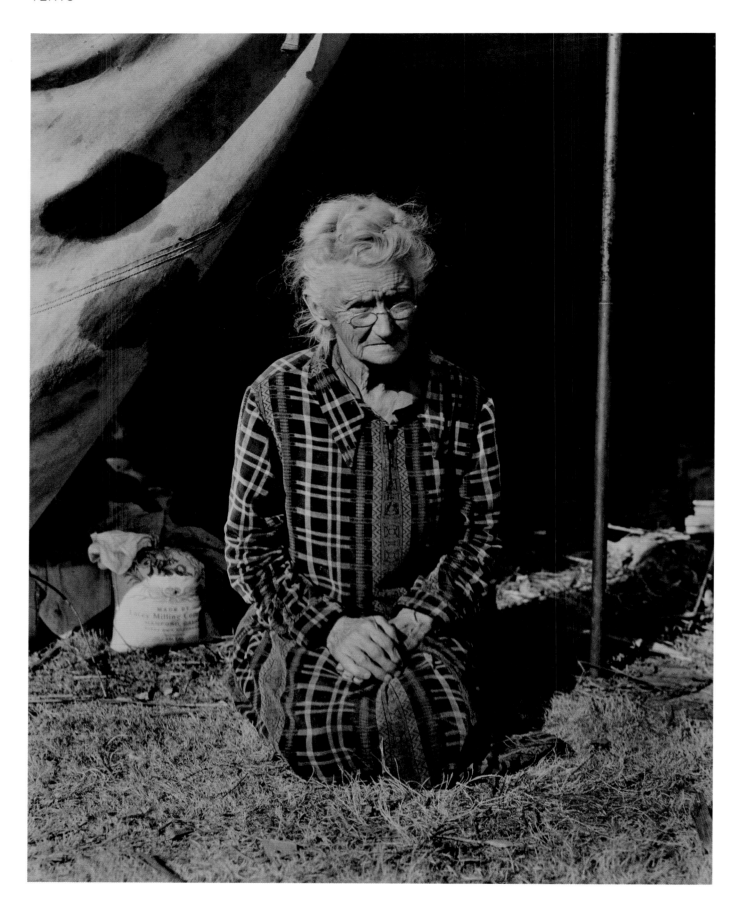

"IF YOU LOSE YOUR PLUCK,

YOU LOSE THE MOST THERE IS IN YOU –

ALL YOU'VE GOT TO LIVE WITH."

Dorothea Lange
Grandmother of twenty-two children, from
a farm in Oklahoma; 80 years old. Now living in
a camp on the outskirts of Bakersfield, California.
November, 1936.

Dorothea Lange
A migratory field worker's home on the edge
of a pea field. The family lived here through the
winter, Imperial Valley, California. March, 1937.

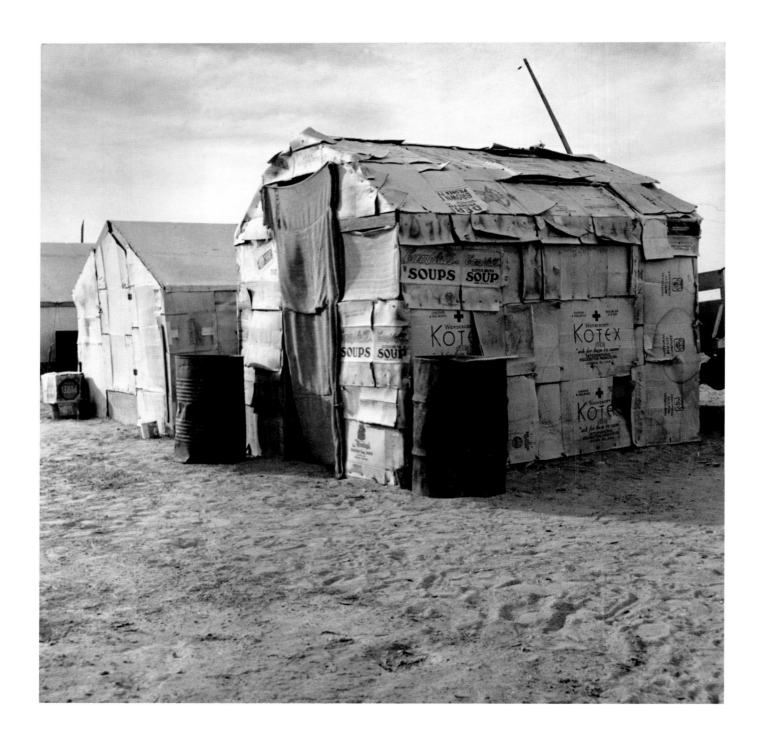

Dorothea Lange
An aged woman from Oklahoma, Kern migrant
camp (FSA camp), California. November, 1936.

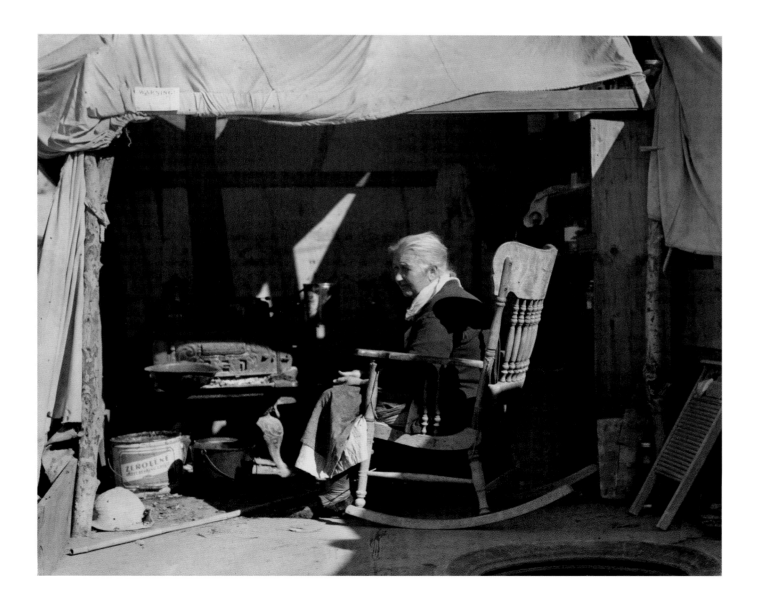

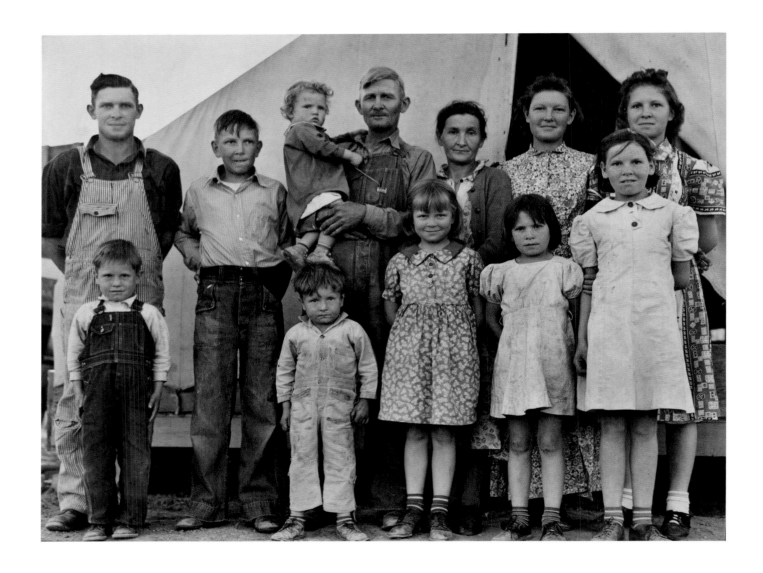

"ALL WE GOT TO START WITH IS A FAMILY OF KIDS."

Dorothea Lange
Family of father, mother, and eleven children,
originally from Mangum, Oklahoma, in FSA
migratory labor camp, Brawley, Imperial Valley,
California. February, 1939.

Dorothea Lange

Young migrant mother with 6-week-old baby in a labor contractor's camp, near Westley, California. The baby was born in a hospital with the aid of the FSA medical association for migratory workers. "I try to keep him eatin' and sleepin' regular like I got him out of the hospital." April, 1939.

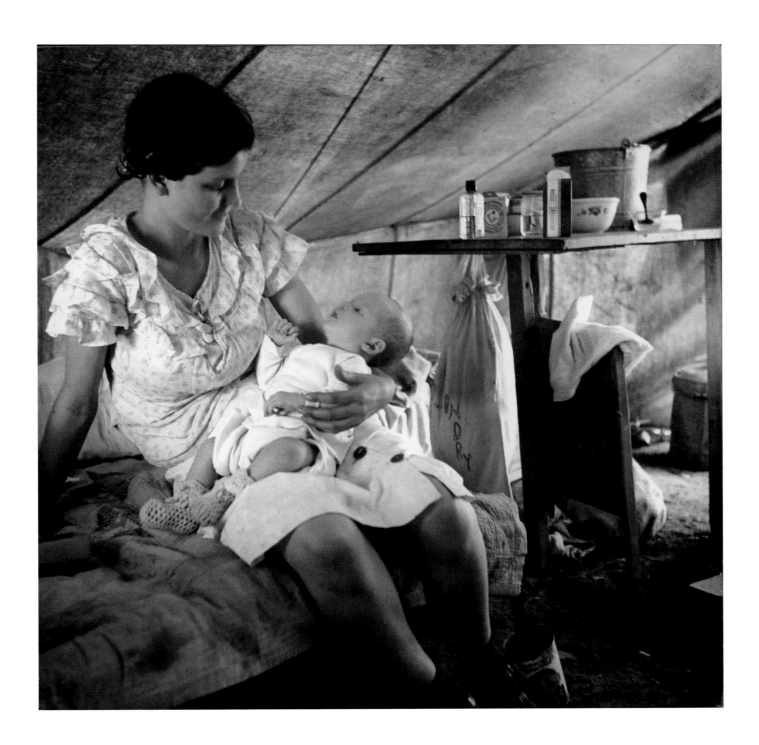

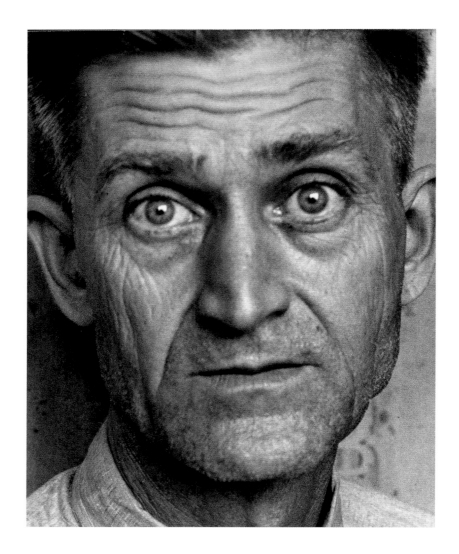

Dorothea Lange

J. R. Butler, President of the Southern Tenant
Farmers' Union, in Union Hall at the time of
a strike of sharecroppers, Memphis, Tennessee.
June, 1938.

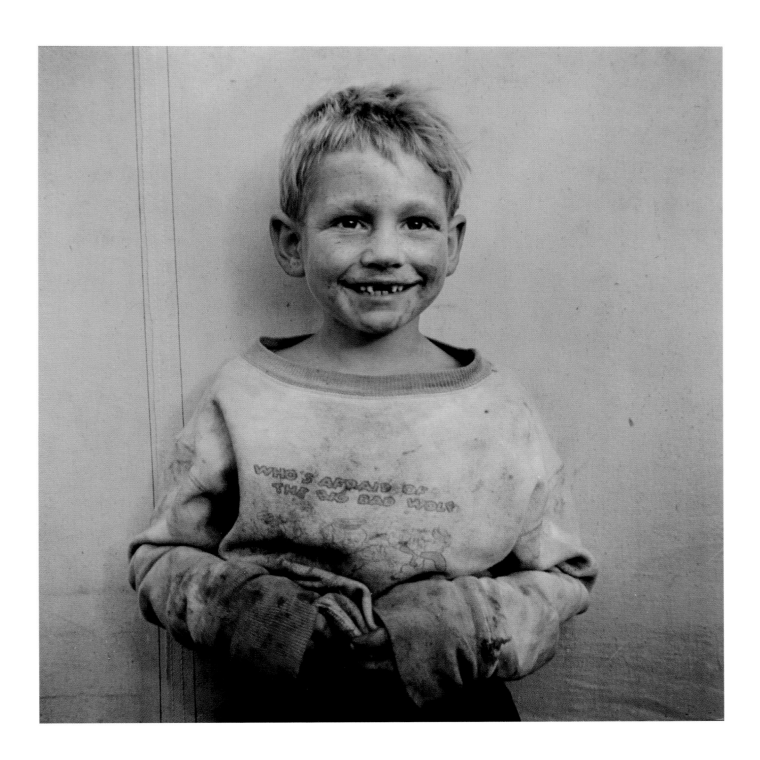

Dorothea Lange
Migrant cotton-picker's child who lives in a tent
in the government camp instead of along the
highway or in a ditch bank. Shafter camp for
migrants, California. November, 1938.

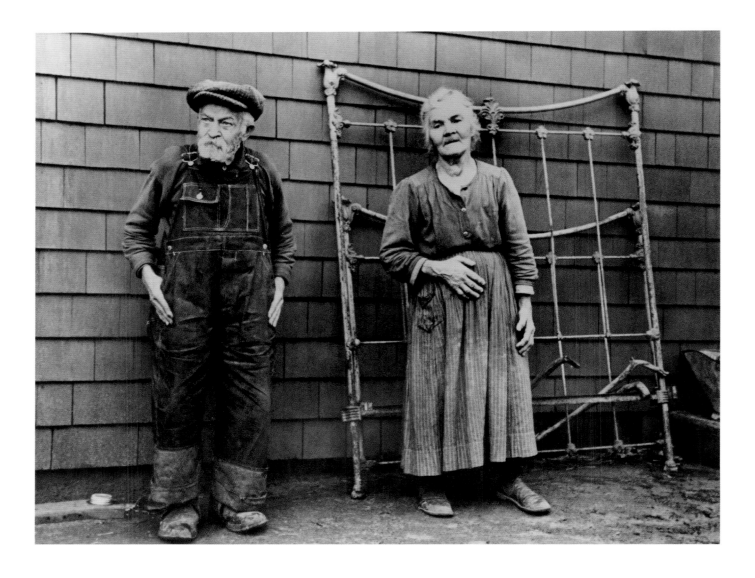

Russell Lee
Mr. and Mrs. Andrew Ostermeyer, homesteaders,
Miller Township, Woodbury County, Iowa.
December, 1936.

Russell Lee

Hands of Mrs. Andrew Ostermeyer, wife of
a homesteader, Miller Township, Woodbury
County, Iowa. December, 1936.

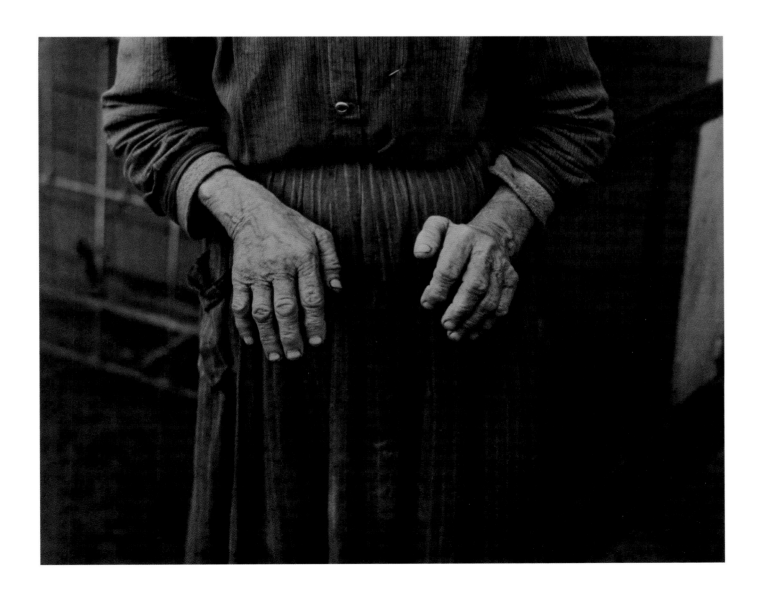

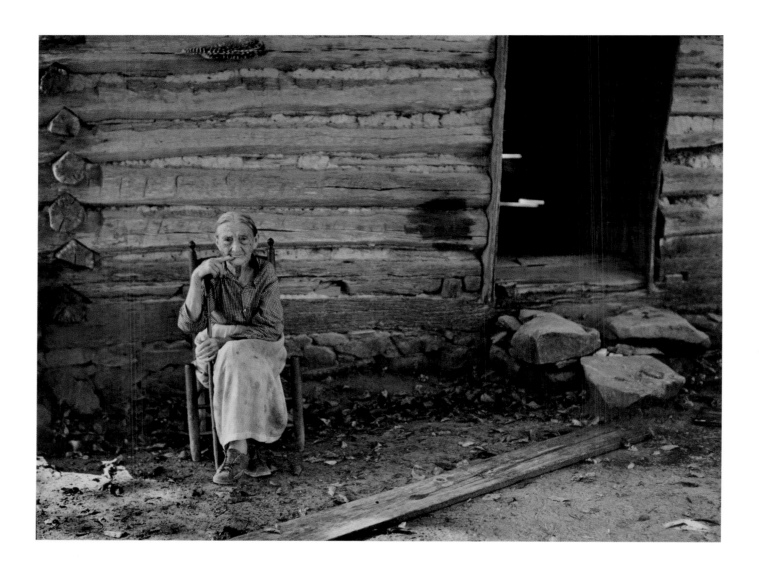

Marion Post Wolcott
Mrs. Lloyd, 91-year-old mother of Miss Nettie
Lloyd, was born and reared in Orange County,
North Carolina, and has lived on this spot
since her marriage sixty-nine years ago.
September, 1939.

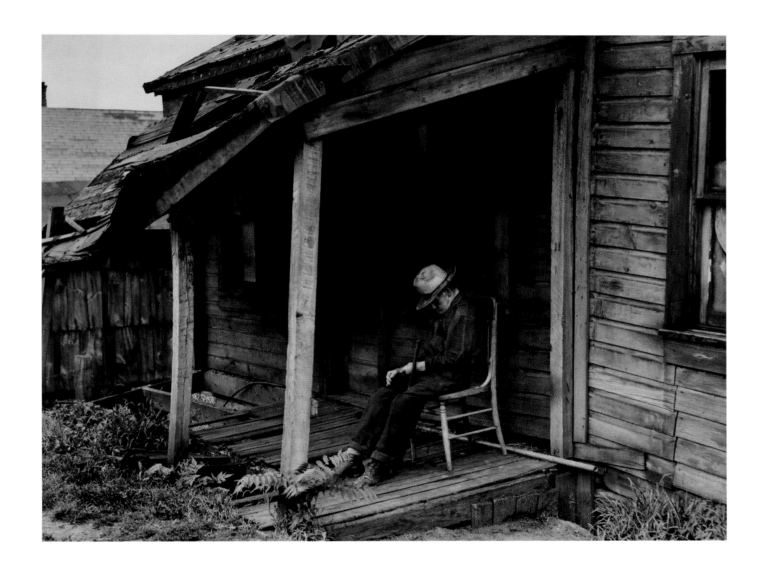

Dorothea Lange
"Old Age," near Washington, Pennsylvania.
July, 1936.

"WHEN THEY GET THROUGH WORKING YOU

THEY WANT YOU OUT OF THE WAY."

Dorothea Lange
White Angel Breadline, San Francisco. 1933.

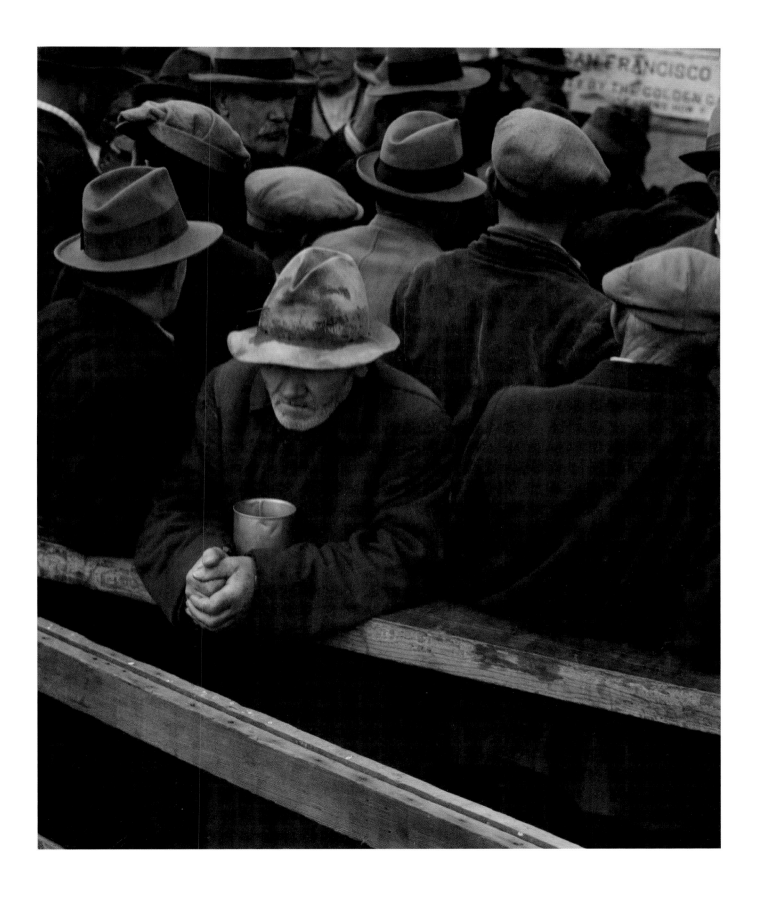

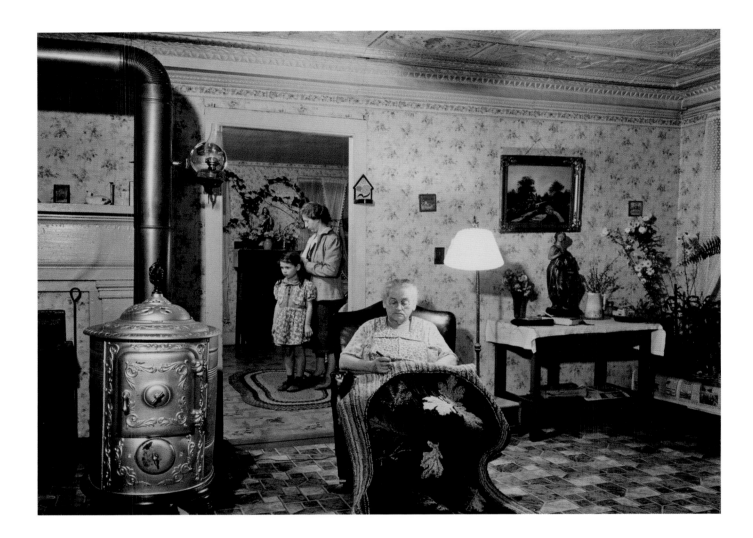

Jack Delano

In the home of Steve Dino, Italian FSA client,
near Canterbury, Connecticut. His mother sells
hooked rugs to supplement their farm income.
November, 1940.

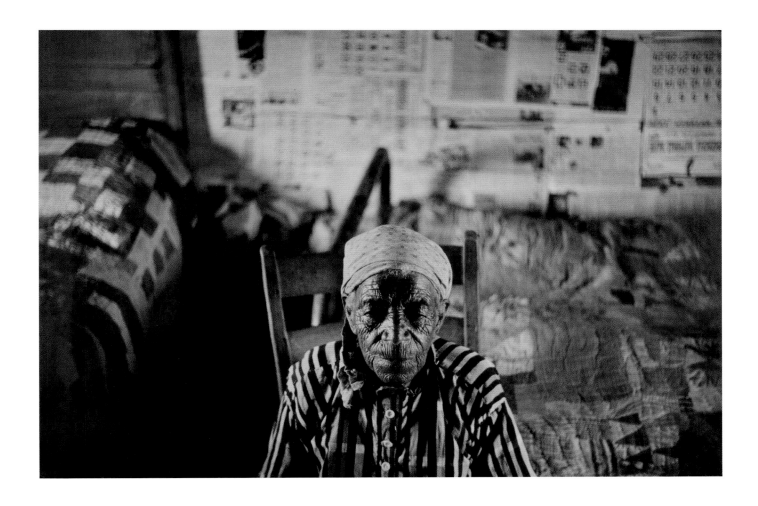

Jack Delano
Old ex-slave on a farm near Greensboro,
Alabama. May, 1941.

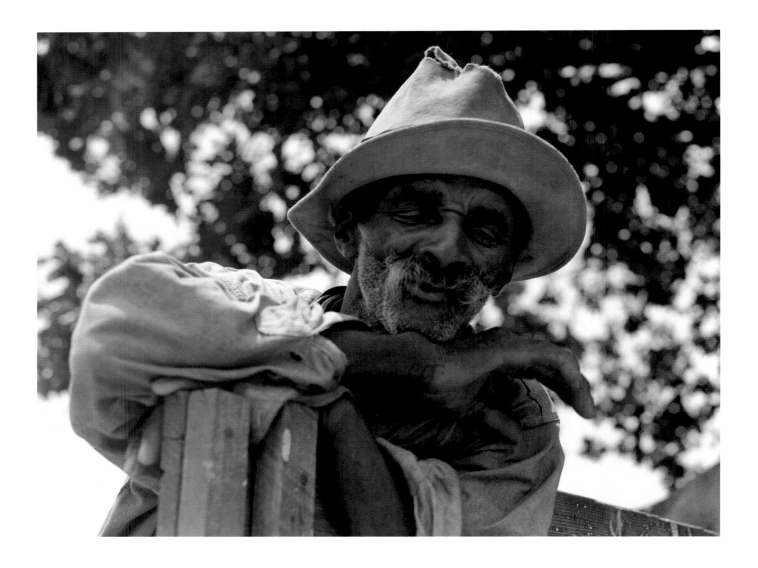

Dorothea Lange
This man was born a slave in Greene County,
Georgia. July, 1937.

Jack Delano
Hands of Mr. Henry Brooks, ex-slave, Parks Ferry
Road, Greene County, Georgia. May, 1941

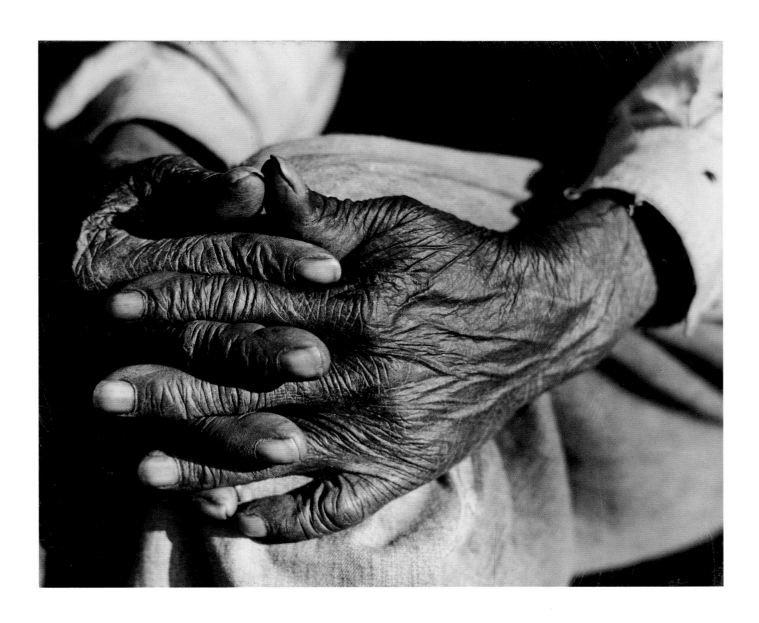

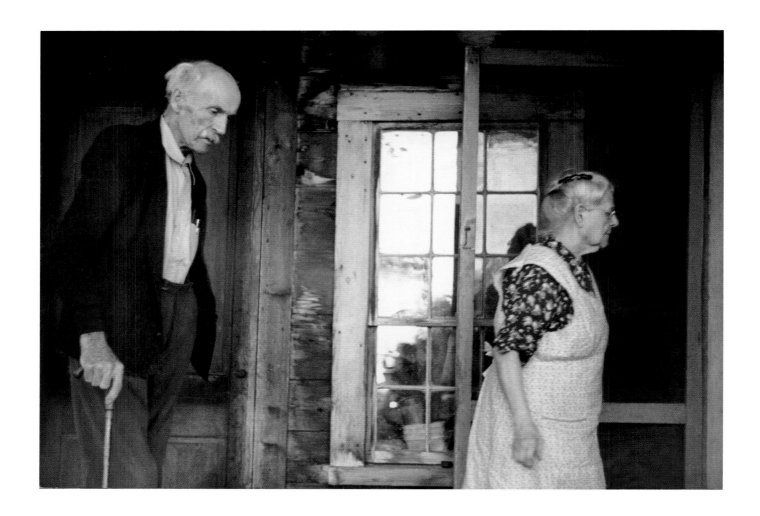

Jack Delano
Aged couple at an auction in East Albany,
Vermont. August, 1941.

Dorothea Lange
Annie Moore Schwein, born a slave in south
Texas. Corpus Christi. August, 1936.

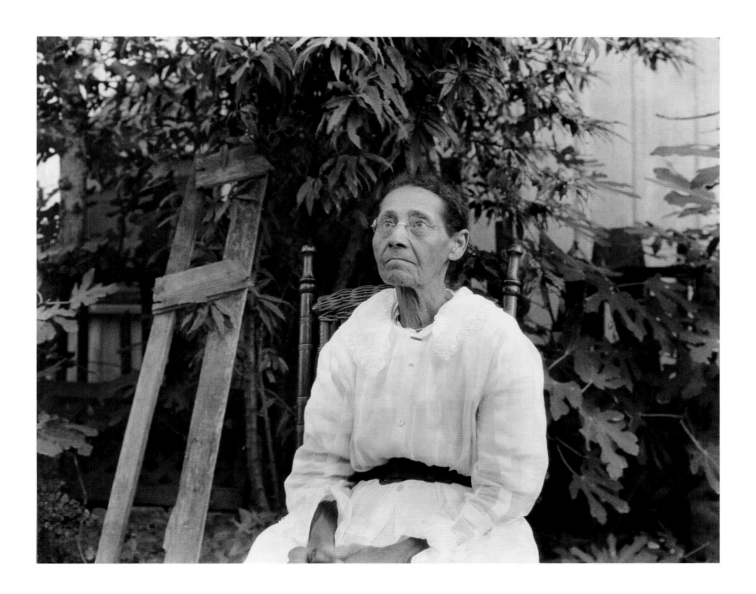

Russell Lee
Exhausted flood-refugees resting, Sikeston, Missouri. February, 1937.

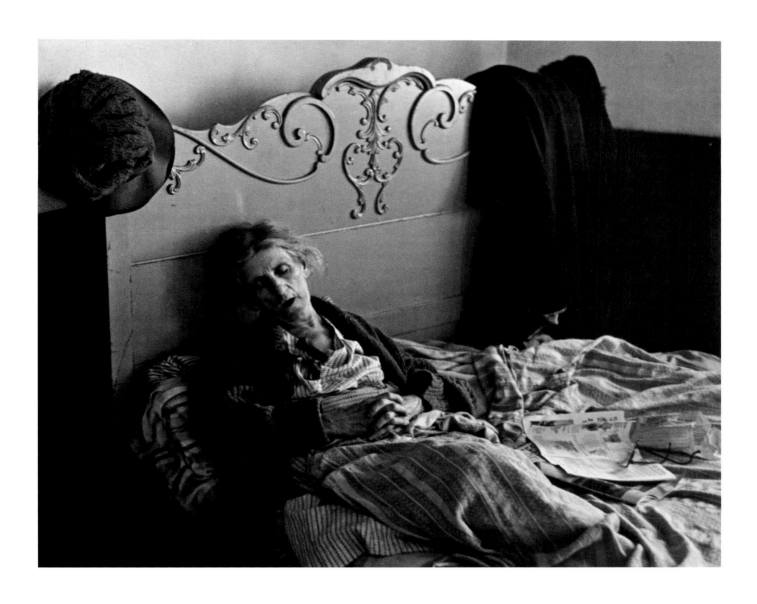

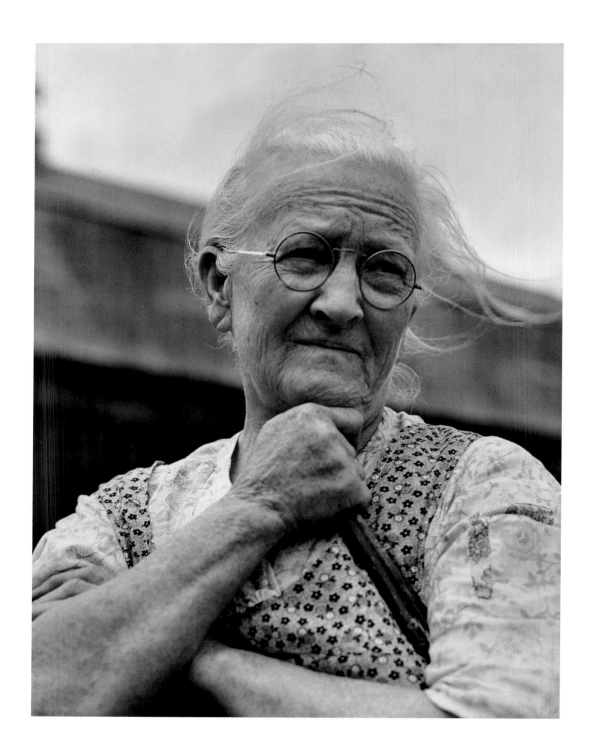

Jack Delano
Mrs. Carrie E. Loadwick, lifelong resident of an area
being taken over by the Army, who is moving to the
town of Adams. Leraysville, New York. August, 1941.

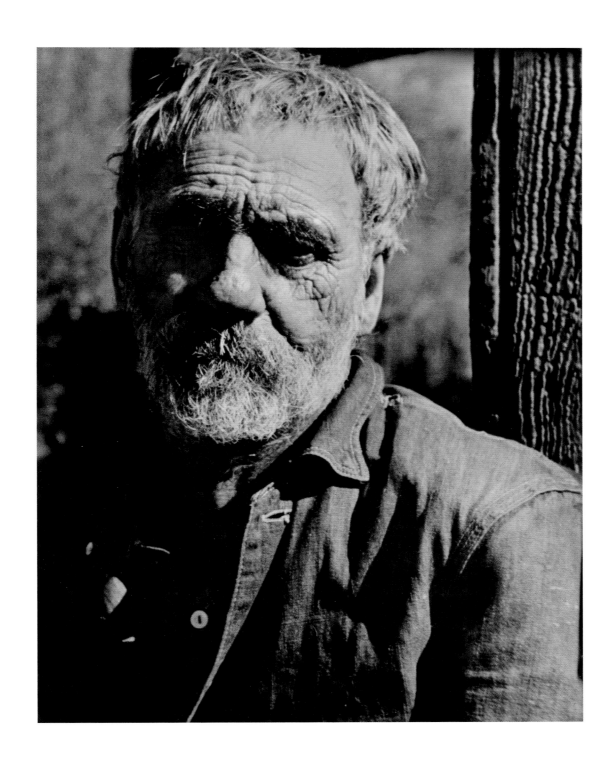

Arthur Rothstein
Fennel Corbin who is being resettled on new
land, Corbin Hollow, Virginia. October, 1935.

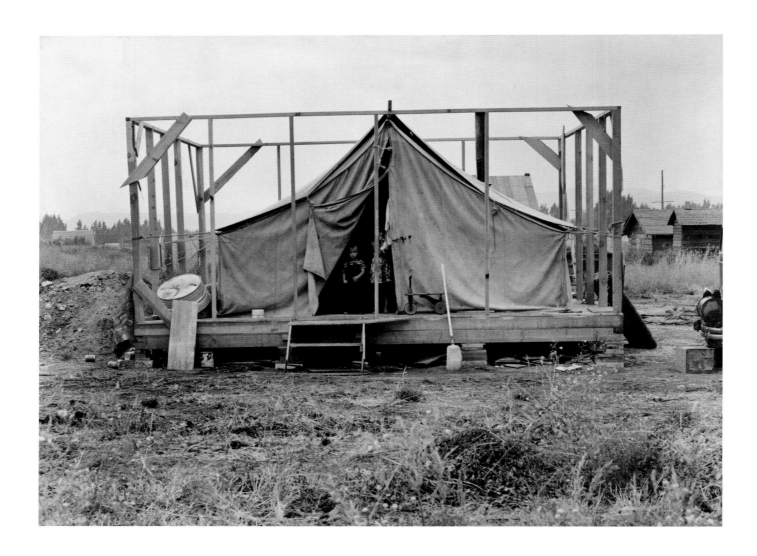

Dorothea Lange
Family living in a tent and building the house
around them, near Klamath County, Oregon.
August, 1939.

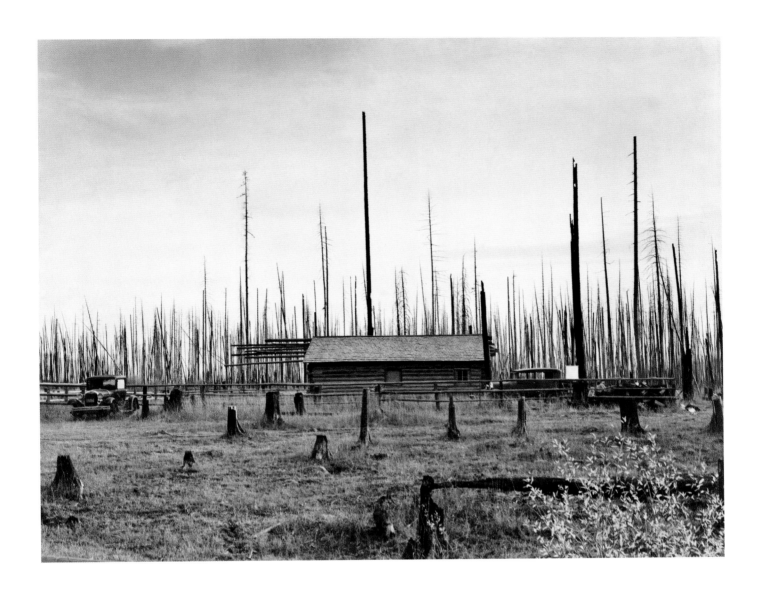

Dorothea Lange
Home of a FSA borrower who moved onto
this land six years ago, built the log house and
buildings. Cut enough hay between stumps to
feed 8 cows and 3 calves and 2 horses through
the winter of 1938. $315 land clearing loan.
Priest River Peninsula, Bonner County, Idaho.
October, 1939.

Dorothea Lange

Home of rural rehabilitation client, Tulare County, California. They bought 20 acres of raw, unimproved land with a first payment of $50, which was money saved out of relief budget (August, 1936). They received an FSA loan of $700 for stock and equipment. Now they have a one-room shack, 7 cows, 3 sows and a homemade pumping plant, along with 10 acres of improved permanent pasture. Cream check approximately $30 per month. Husband also works about ten days a month on odd jobs outside the farm. Husband is 26 years old, wife 22, three small children. Been in California five years. "Piece by piece this place gets put together. One more piece of pipe and our water tank will be finished." November, 1938.

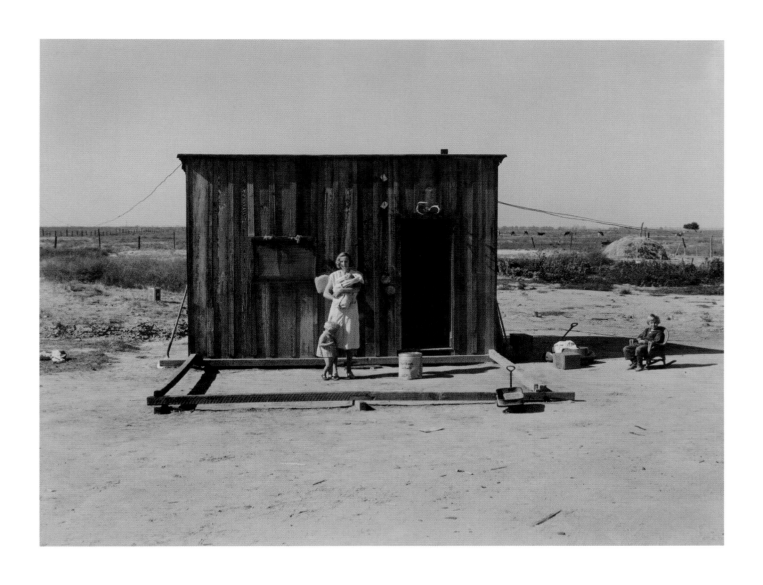

237

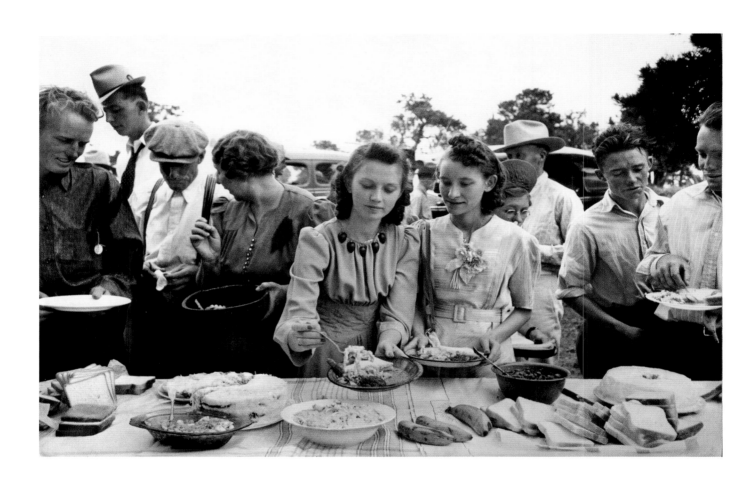

"THE PEOPLE WILL LIVE ON."

Russell Lee
Helping the plates at dinner on the grounds,
all-day community sing, Pie Town, New Mexico.
June, 1940.

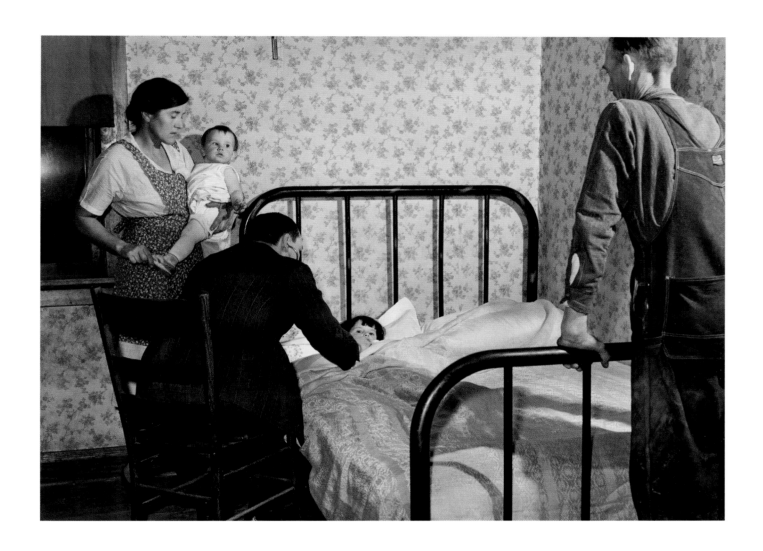

Arthur Rothstein

A physician cooperating with the FSA medical health plan visits the home of a rehabilitation client, St. Charles County, Missouri. November, 1939.

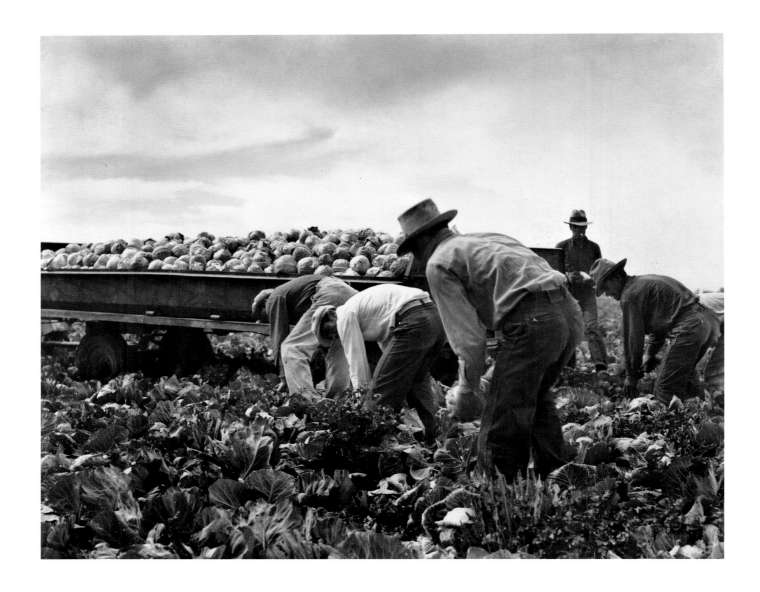

Dorothea Lange
Cabbage cutting and hauling by the new Vessey
(flat truck) system now also used in carrots and
lettuce, Imperial Valley, California. March, 1937.

Dorothea Lange
Gang of Filipino lettuce cutters, Salinas Valley,
California. 1935.

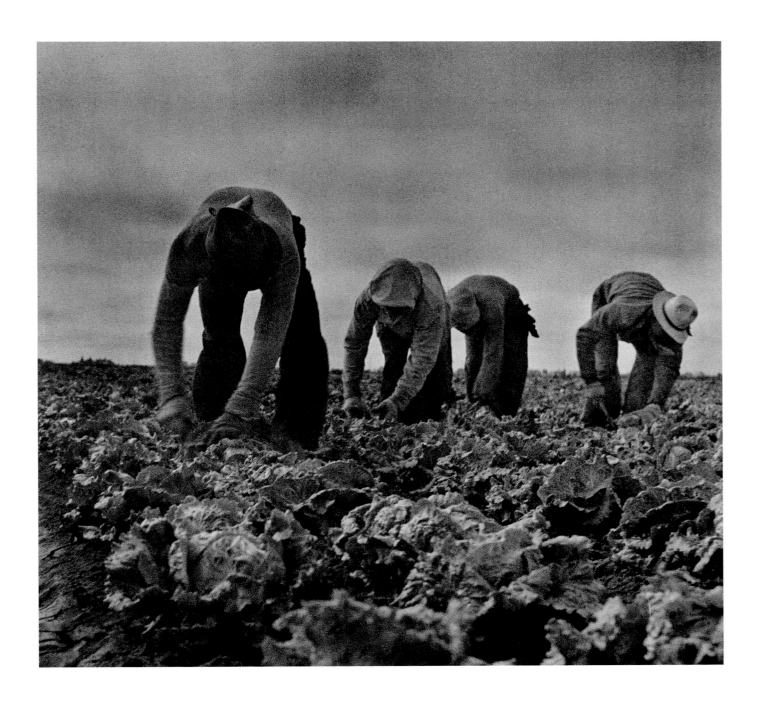

Dorothea Lange
Migrant agricultural worker, waiting for the
second pea crop, after the winter crop froze,
near Holtville, California. February, 1937.

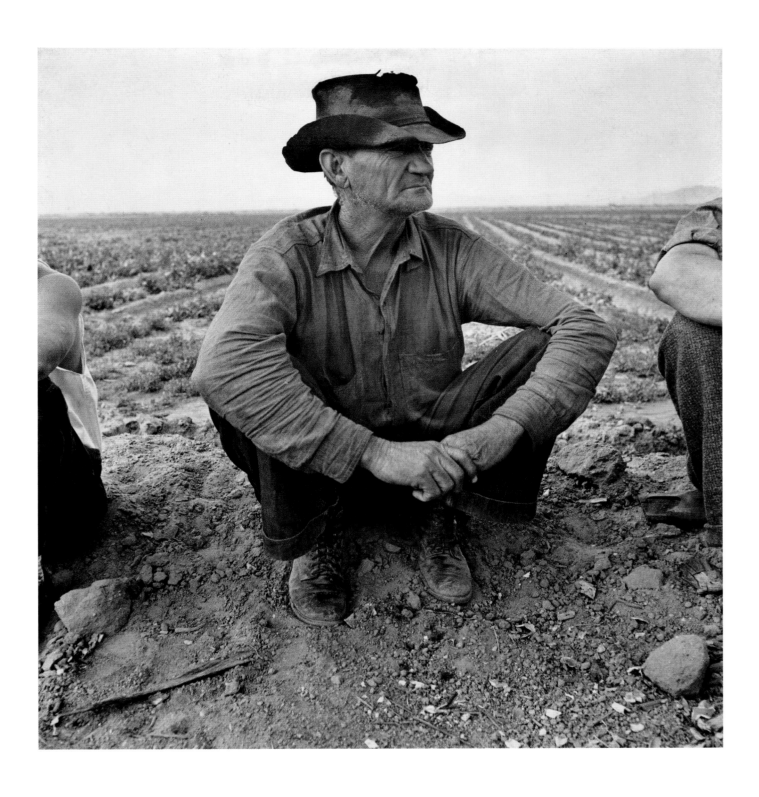

"WHEN YOU GITS DOWN TO YOUR LAST BEAN YOUR BACKBONE

AND YOUR NAVEL SHAKES DICE TO SEE WHICH GITS IT."

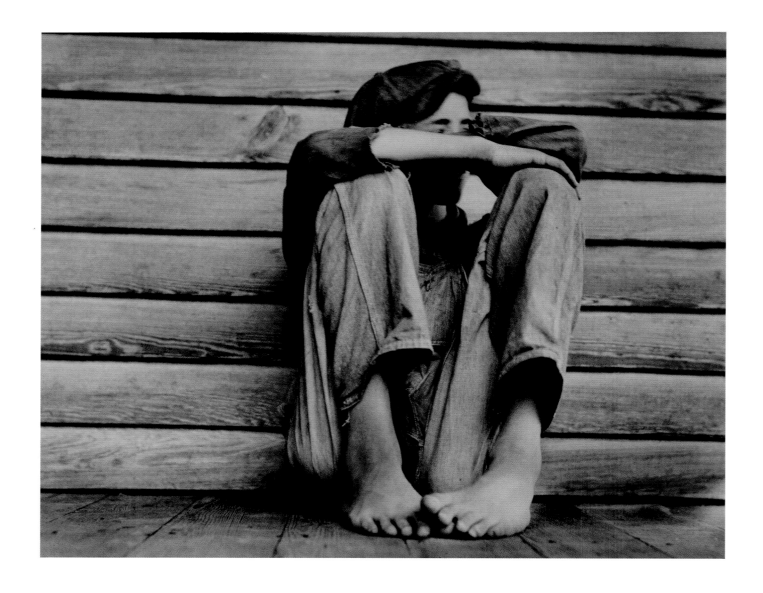

"THE UNEMPLOYED

WITHOUT A STAKE IN THE COUNTRY

WITHOUT JOBS OR NEST EGGS

MARCHING THEY DON'T KNOW WHERE

MARCHING NORTH SOUTH WEST –

AND THE DESERTS

MARCHING EAST WITH DUST

DESERTS OUT OF HOWLING DUST-BOWLS

DESERTS WITH WINDS MOVING THEM

MARCHING TOWARD OMAHA TOWARD TULSA –

THESE LEAD TO NO EASY PLEASANT CONVERSATION

THEY FALL INTO A DUSTY DISORDERED POETRY."

CARL SANDBURG

Dorothea Lange
Sharecropper boy, Chesnee, South Carolina.
June, 1937.

John Vachon
Line of men waiting in an alley outside the City Mission. They are waiting for the meal which will be served at 5 p.m., Dubuque, Iowa. April, 1940.

Dorothea Lange
Ex-tenant farmer on a relief grant in the Imperial Valley, California. March, 1937.

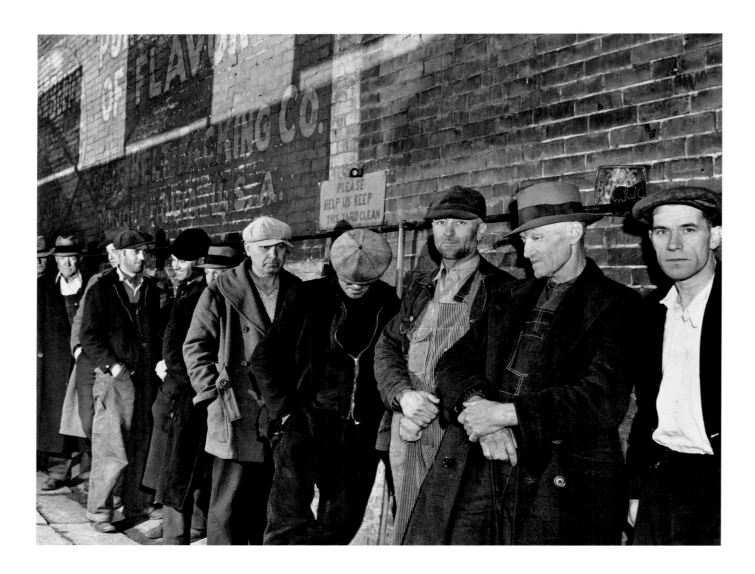

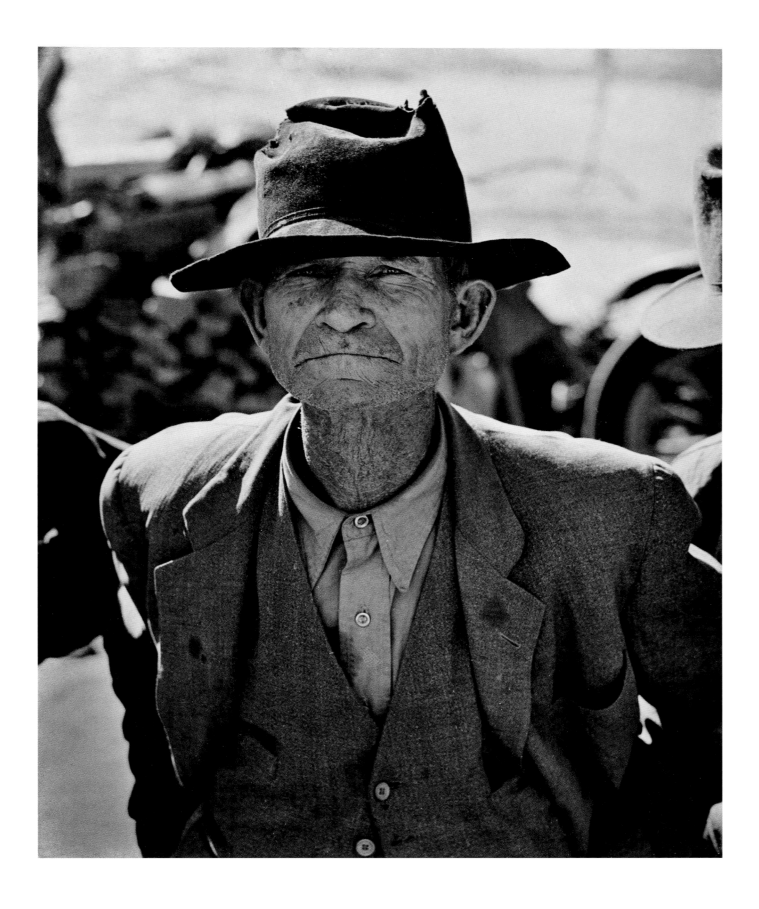

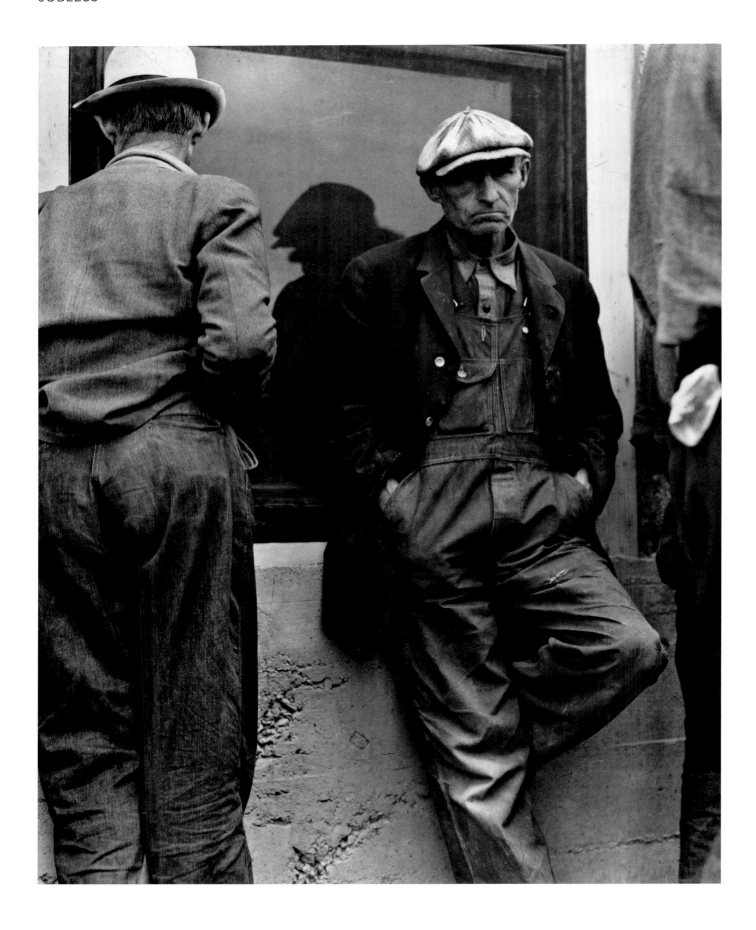

Dorothea Lange
Waiting for the semi-monthly relief checks at
Calipatria, Imperial Valley, California. Typical story:
Fifteen years ago they owned farms in Oklahoma.
Lost them through foreclosure when cotton
prices fell after the war. Became tenants and
sharecroppers. With the drought and dust they
came west – 1934–37. Never before left the county
where they were born; now although in California
over a year they haven't been continuously
resident in any single county long enough to
become a legal resident. Reason: migratory
agricultural laborers. March, 1937.

Ben Shahn
Unemployed trappers, Plaquemines Parish,
Louisiana. October, 1935.

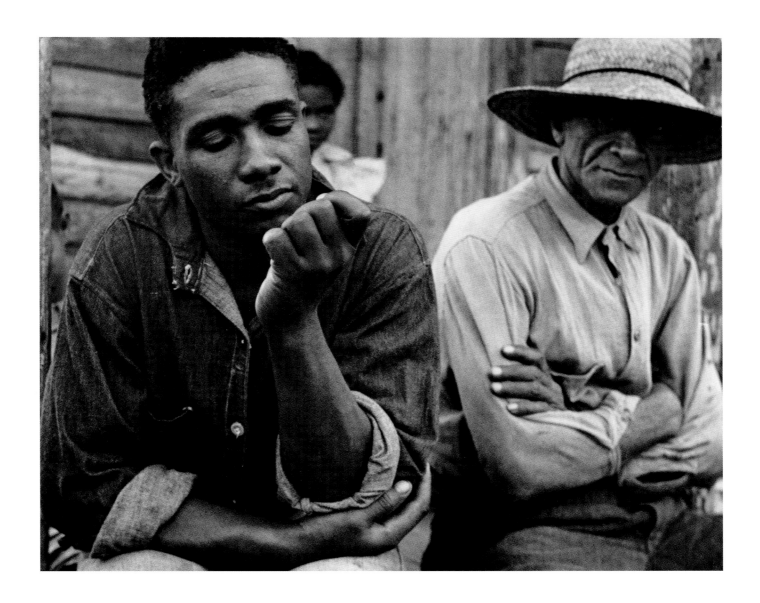

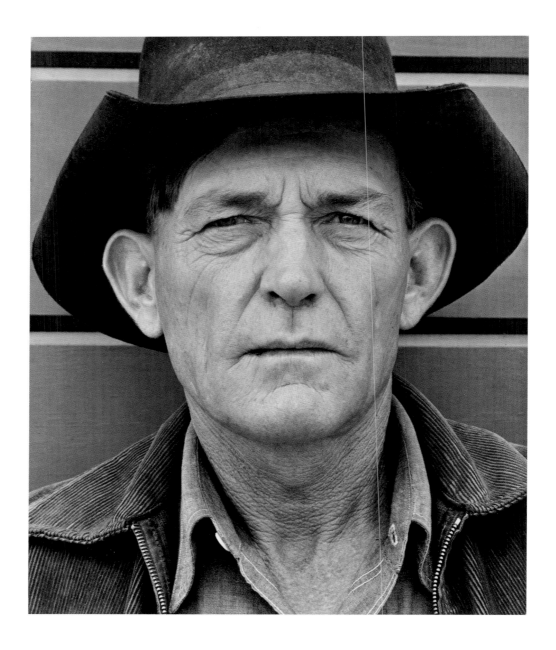

Arthur Rothstein
Migrant field worker, Tulare migrant camp,
Visalia, California. March, 1940.

Dorothea Lange

Former Texas tenant farmers displaced
by power farming. May, 1937.

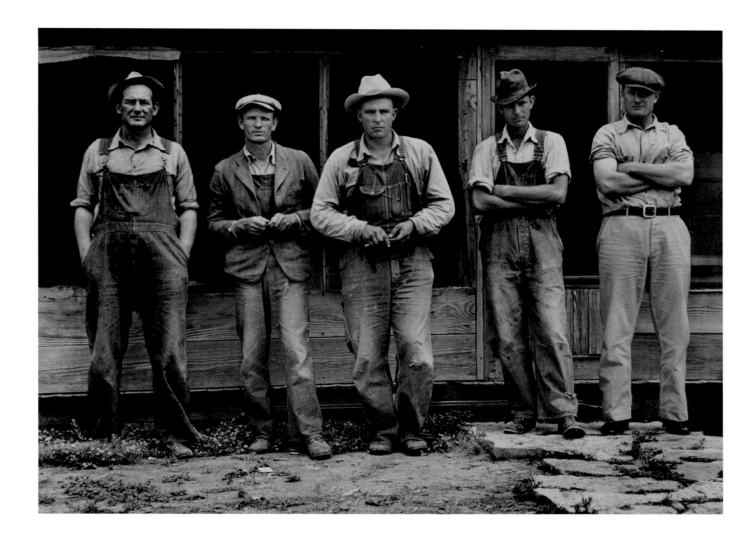

"MR. R. B. WHITLEY, A BIG LAND AND COTTON-MILL OWNER,

PRESIDENT OF THE BANK,

WHO PRACTICALLY OWNS THE WHOLE TOWN."

Marion Post Wolcott

Mr. R. B. Whitley visiting his general store. He
is president of the bank and practically owns
and runs the town. He is a big land owner,
owns Whitley-Davis farm and a cotton mill
in Clayton. He said he cut down the trees and
pulled up the stumps out of the main street and
was the first man in that town of Wendell, Wake
County, North Carolina. September, 1939.

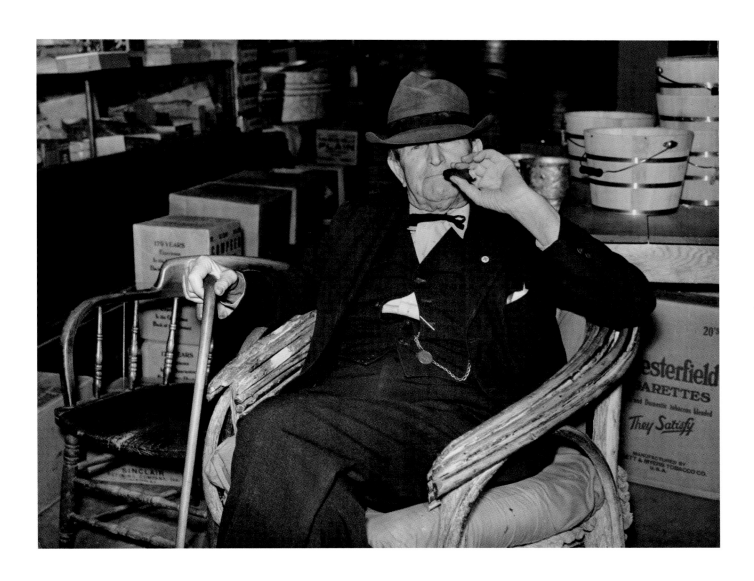

Dorothea Lange
Father and son. Idle American workmen near
Bridgeton, New Jersey. July, 1936.

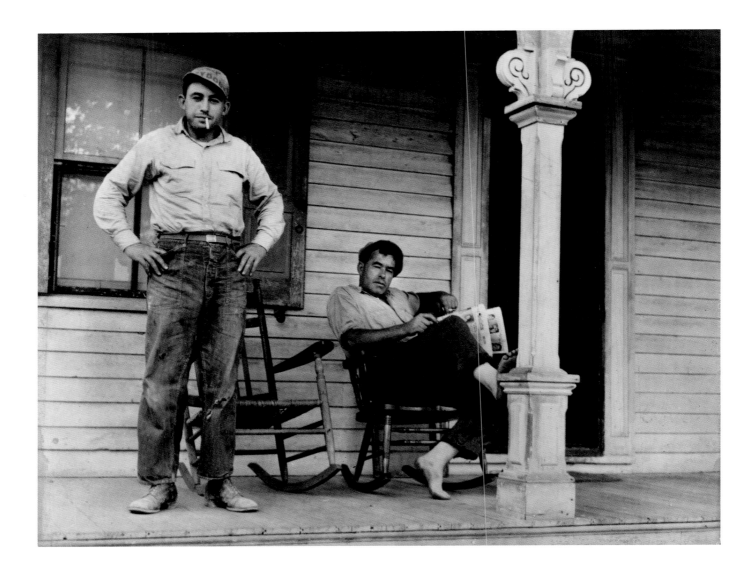

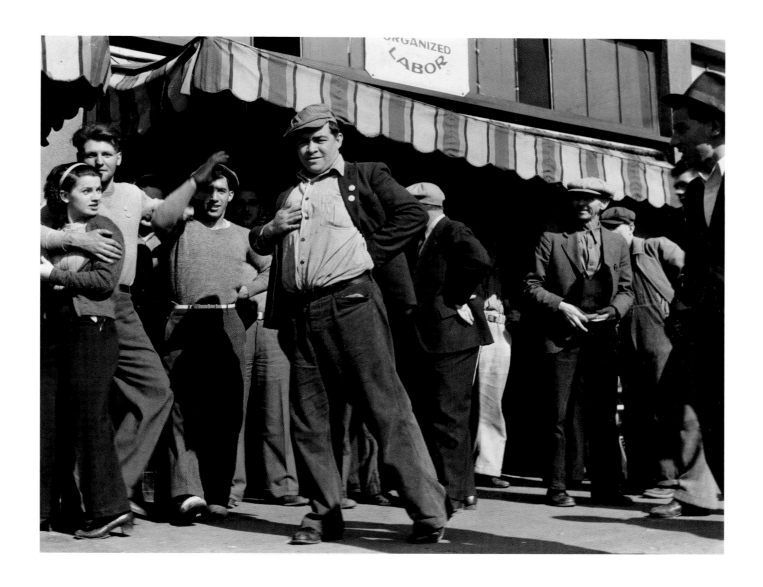

Dorothea Lange
The day after the election, Oakland, California.
November 12, 1936.

Ben Shahn
A deputy with a gun on his hip during the
September, 1935, strike in Morgantown,
West Virginia.

Dorothea Lange
Sign during great cotton strike,
Kern County, California. 1938.

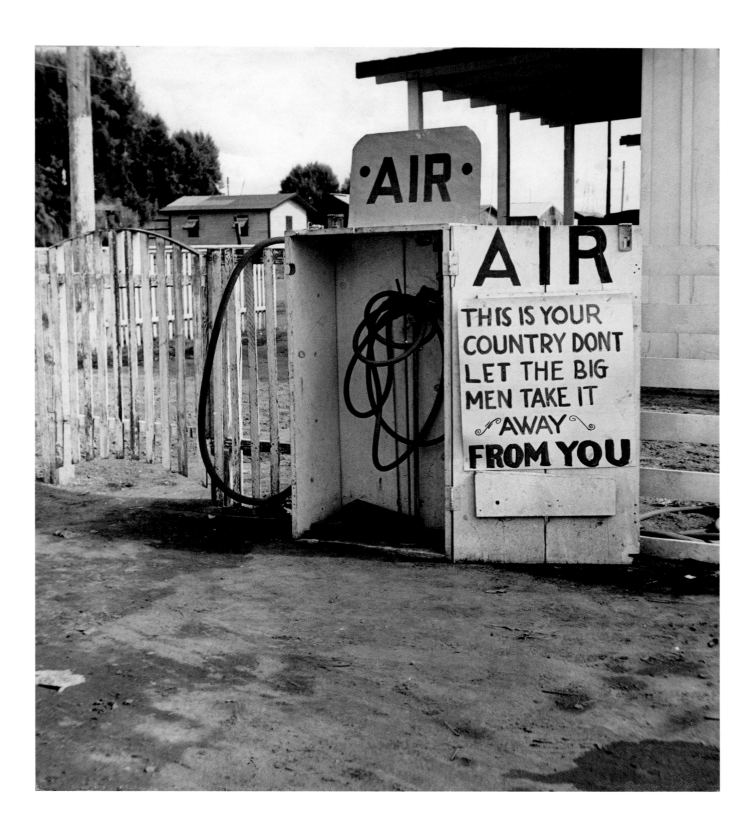

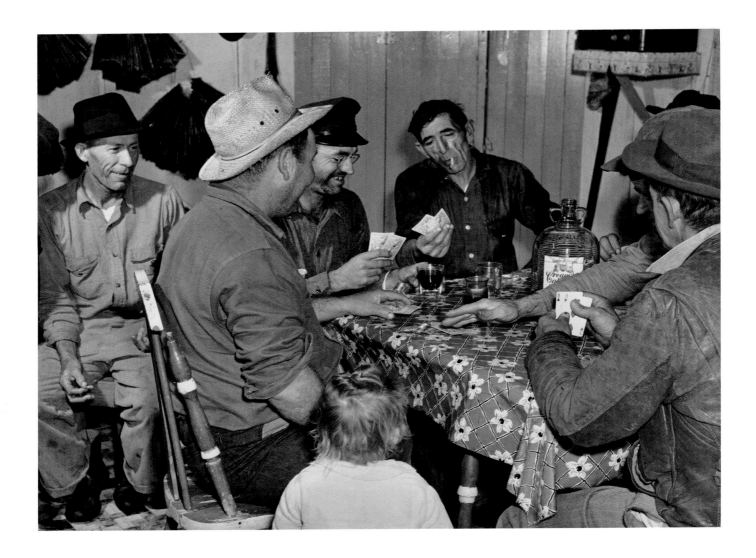

Marion Post Wolcott
Spanish muskrat trappers drinking wine and
playing "cache," a form of poker, in their camp in
the marshes, Delacroix Island, St. Bernard Parish,
Louisiana. January, 1941.

Dorothea Lange
Meeting of the camp council, FSA camp for
migratory agricultural workers, Farmersville,
California. May, 1939.

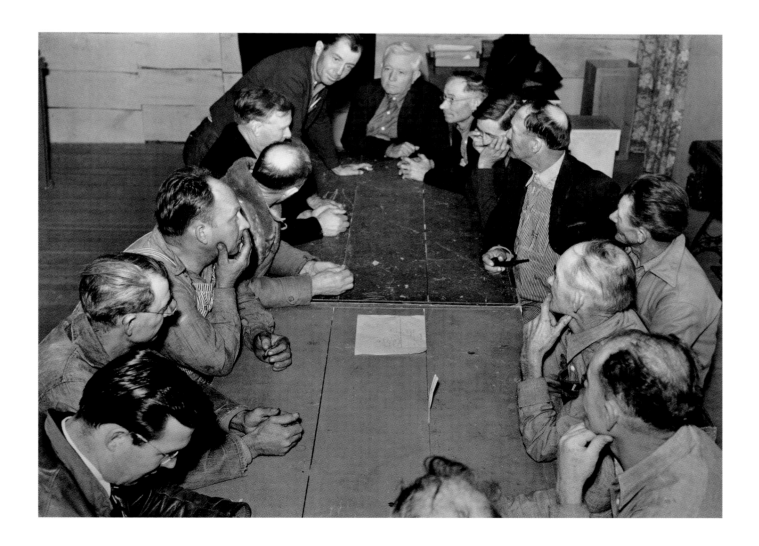

Russell Lee
Farm children playing on a homemade
merry-go-round, Williams County, North
Dakota (drought area). November, 1937.

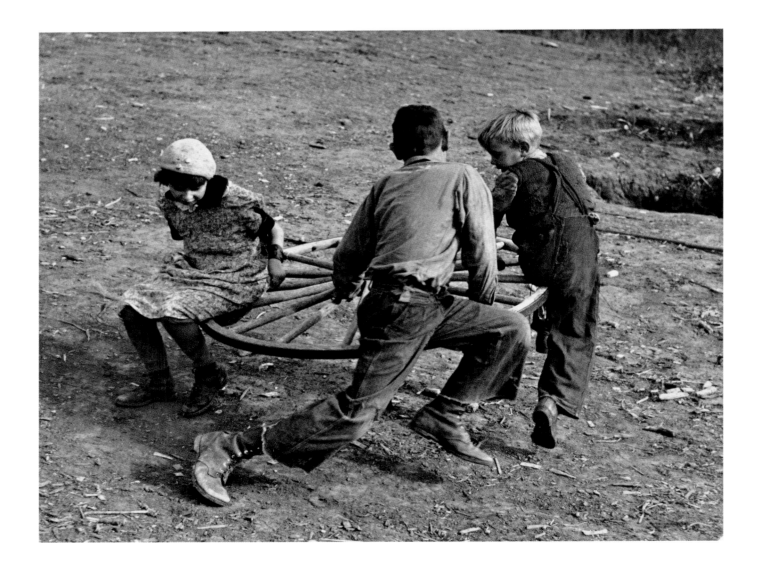

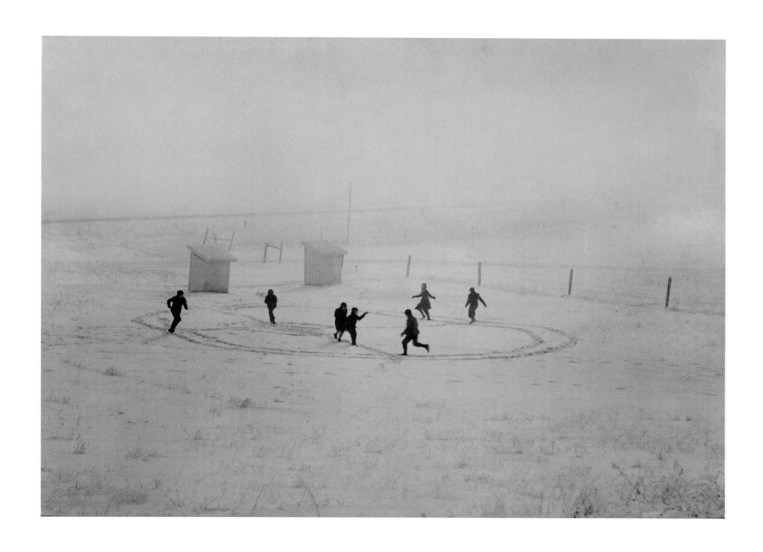

John Vachon
Playing "Cut that Pie" or "Fox and Geese" at
noon recess at a rural school, Morton County,
North Dakota. February, 1940.

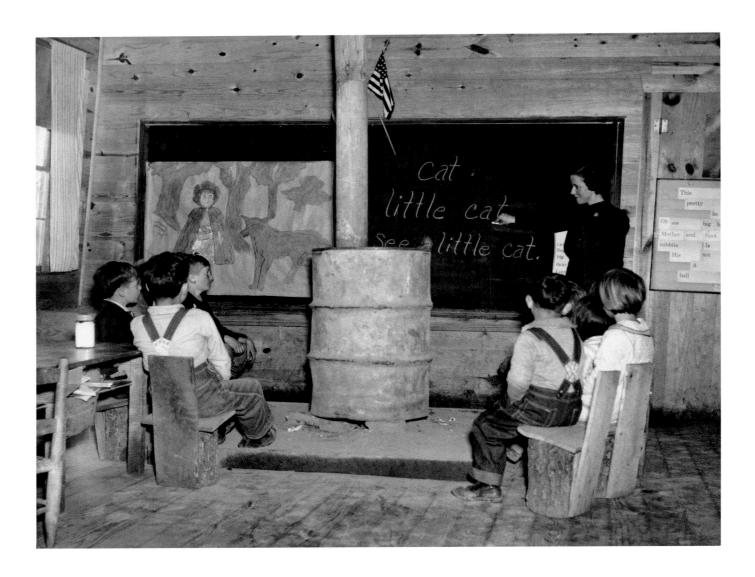

Arthur Rothstein
School at Skyline Farms, Alabama. February, 1937.

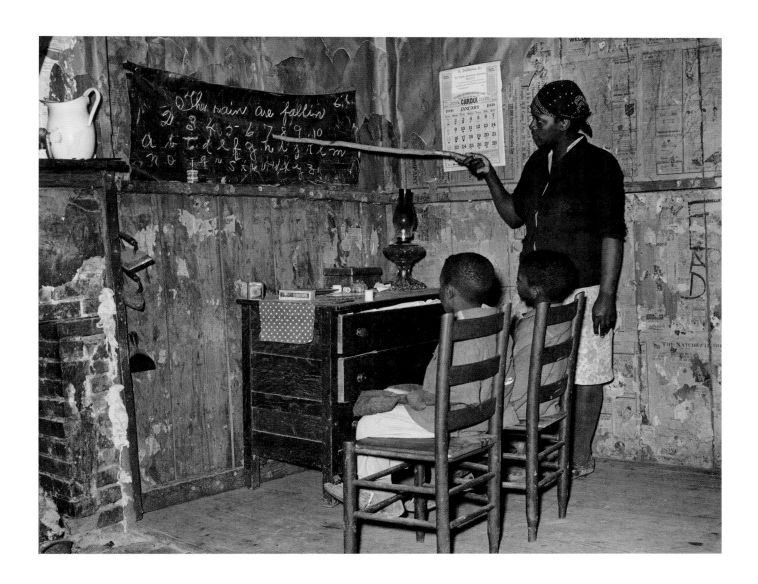

Russell Lee
Negro mother teaching children numbers and
the alphabet in the home of a sharecropper,
Transylvania, Louisiana. January, 1939.

Jack Delano
The three-teacher Negro school, White Plains,
Greene County, Georgia. October, 1941.

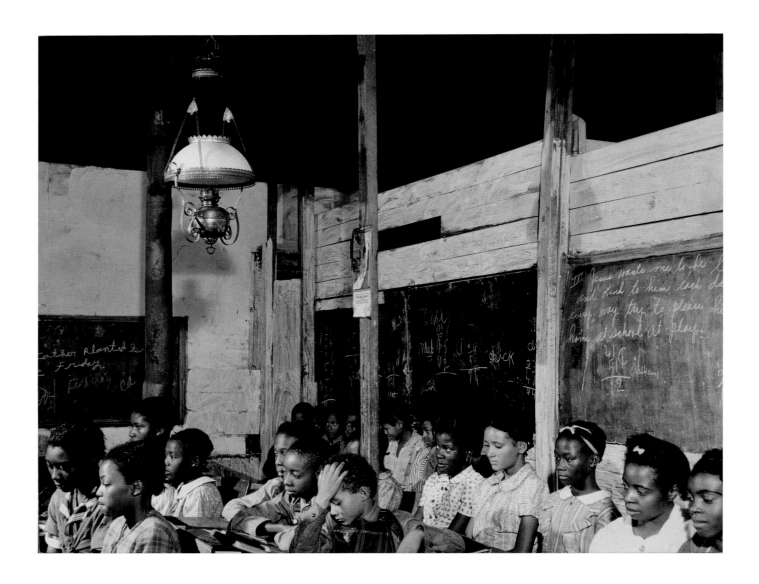

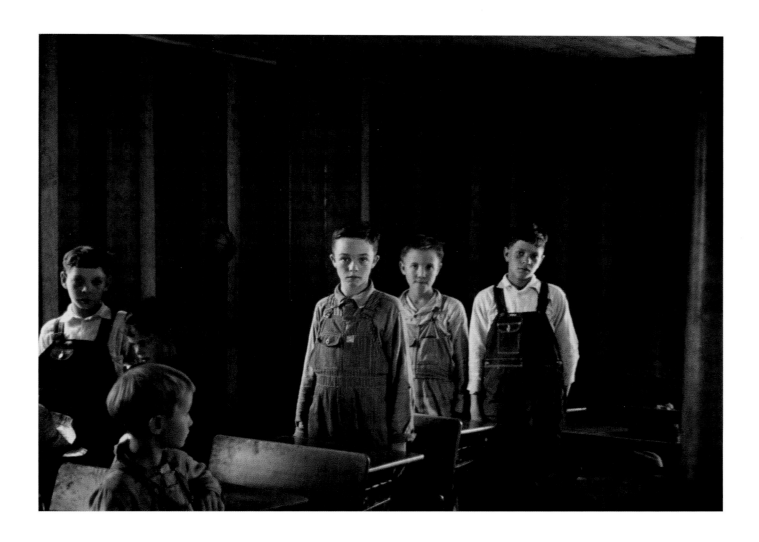

Ben Shahn
Interior of Ozark school, Arkansas.
September, 1935.

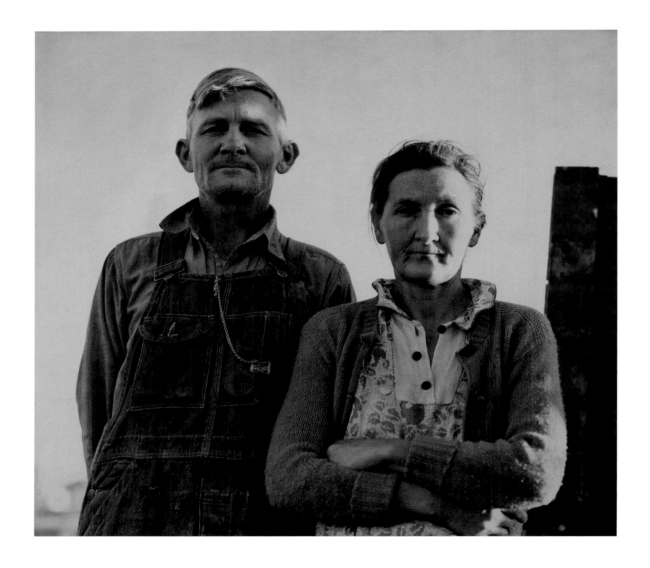

"THESE ARE MEN AND WOMEN OF THE AMERICAN SOIL.

THEY ARE A HARDY STOCK. THEY INHABIT OUR PLAINS,

OUR PRAIRIES, OUR DESERTS, OUR HILLS AND OUR VALLEYS."

DOROTHEA LANGE

Dorothea Lange
Migratory labor workers, Brawley, Imperial
Valley, California. February, 1939.

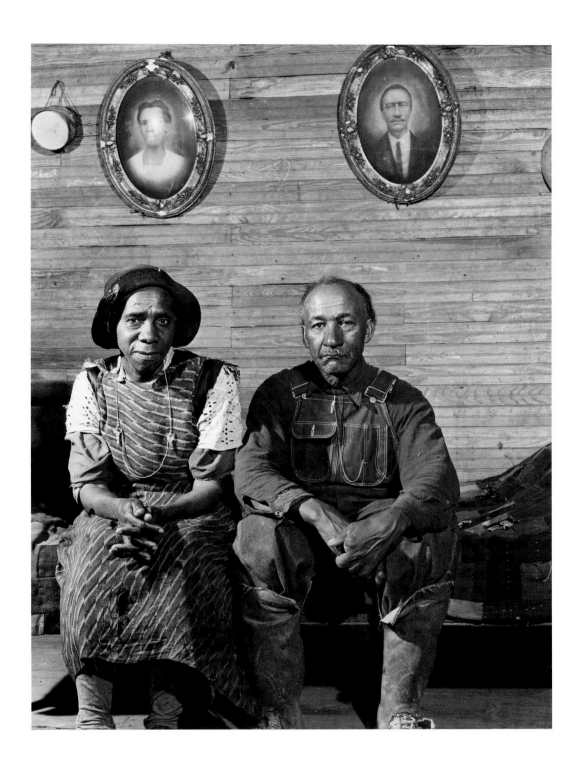

Jack Delano

Negro preacher and his wife sitting under photos
taken of them twenty years ago. They live in
an old converted schoolhouse with two grand-
children. The rest of their children have moved out
of the county. Heard County, Georgia. April, 1941.

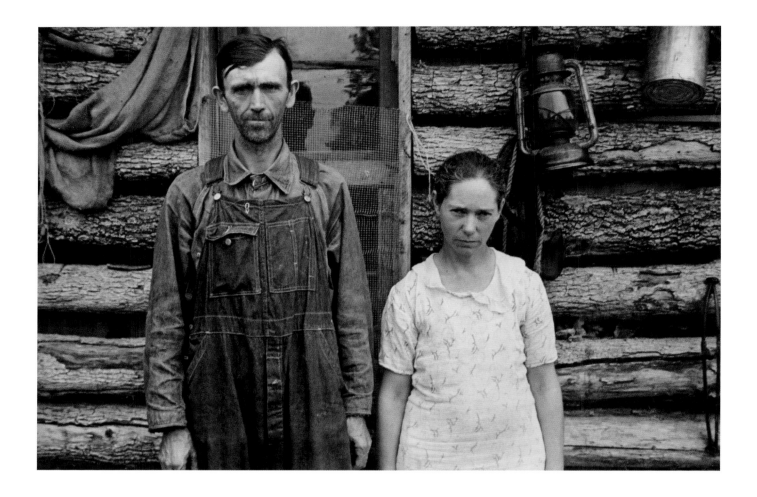

Ben Shahn
Rehabilitation clients, Boone County,
Arkansas. October, 1935.

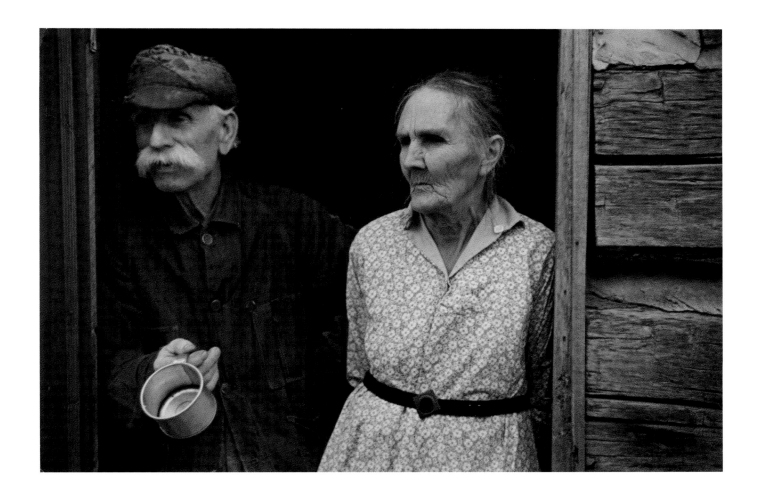

Theodor Jung
Prospective clients whose property has been optioned by the government, Brown County, Indiana. October, 1935.

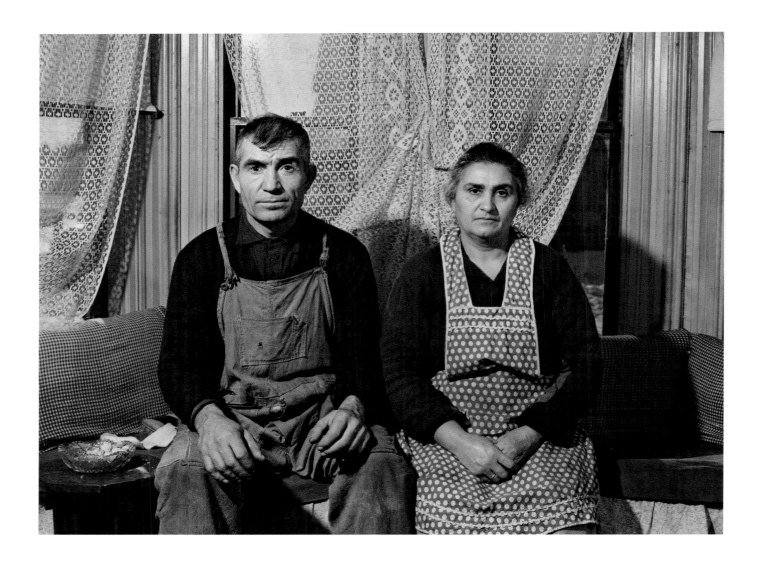

Jack Delano
Mr. and Mrs. Ovgen Arakelian – Armenian
vegetable farmers in West Andover,
Massachusetts. They have an 11-acre farm and
a son who works in a blanket factory in Lowell
to help support the family. January, 1941.

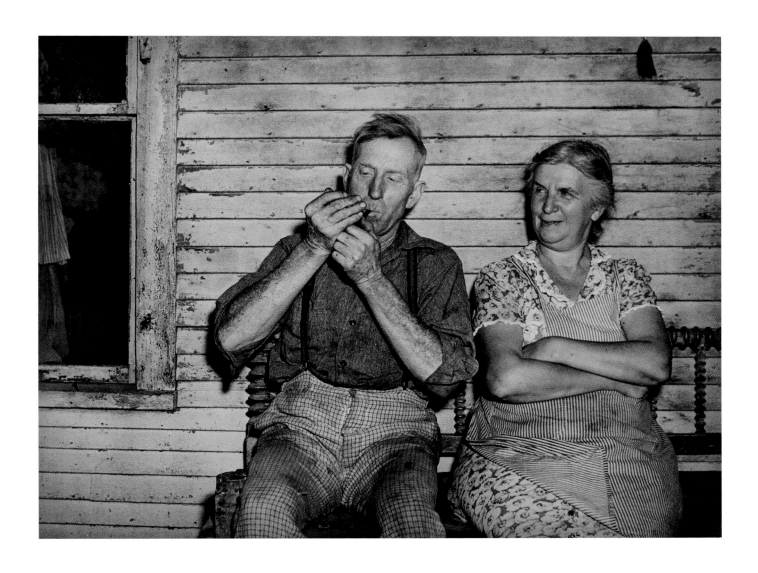

Jack Delano

Farmer and his wife who live in one of the hill
farms east of Burlington, Vermont. August, 1941.

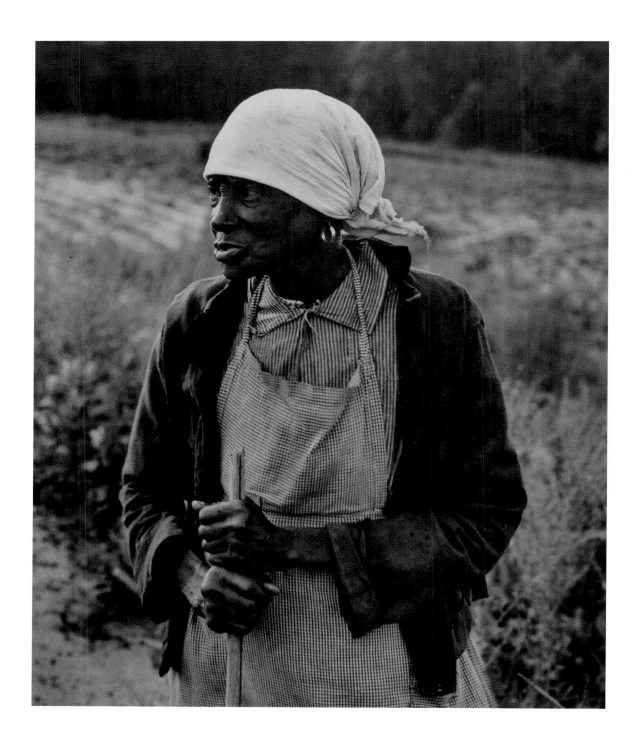

Dorothea Lange
Ex-slave with a long memory, Alabama. 1938.

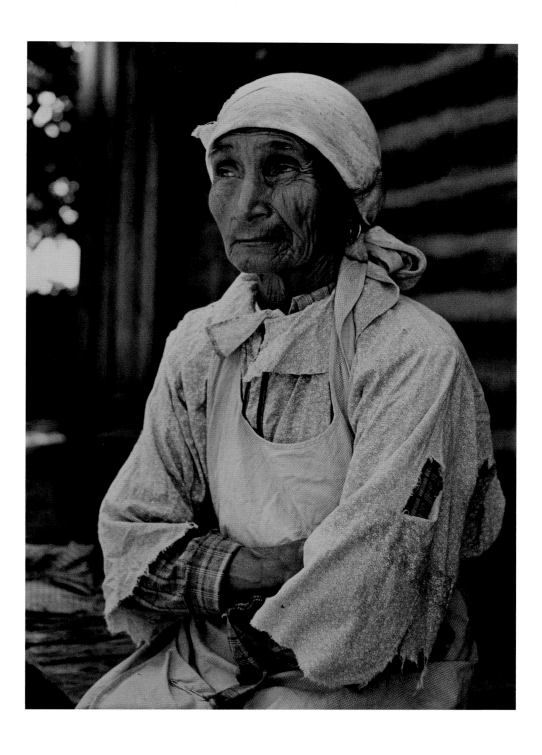

Russell Lee
Indian woman, wife of a farmer, McIntosh County,
Oklahoma. June, 1939.

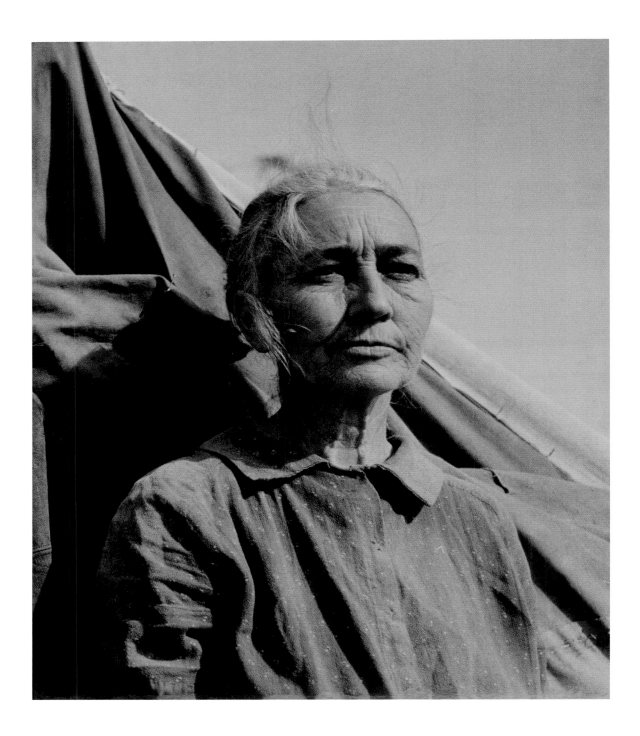

Russell Lee
Migrant man and wife camped near Sebastian,
Texas (wife only). January, 1939.

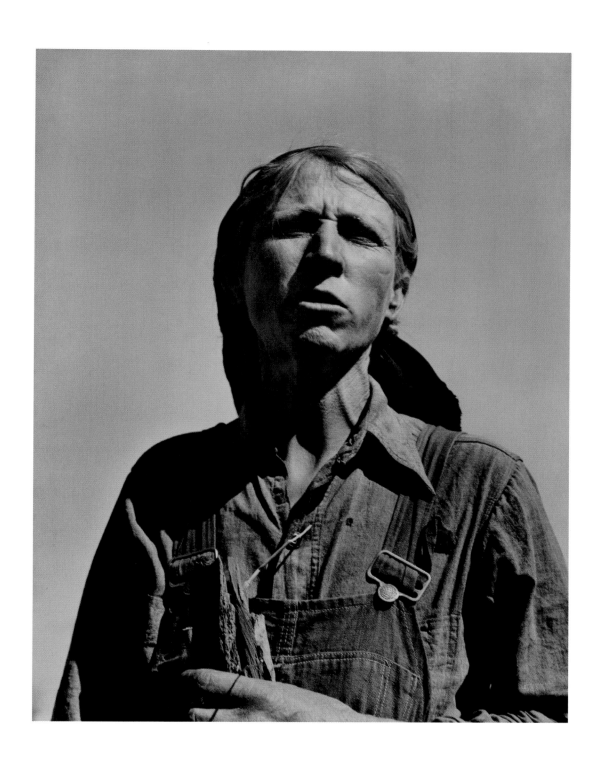

Dorothea Lange

"This is a hard way to serve the Lord." Oklahoma
drought refugee, California. March, 1937.

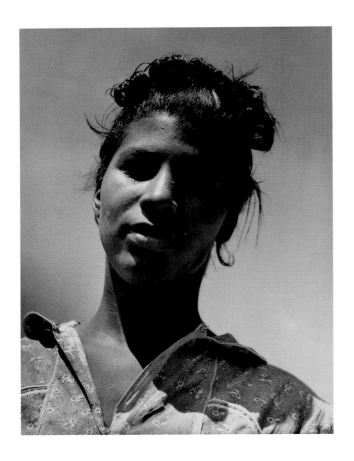

"I LOVE YOU," SAID A GREAT MOTHER.

"I LOVE YOU FOR WHAT YOU ARE

KNOWING SO WELL WHAT YOU ARE.

AND I LOVE YOU MORE YET, CHILD,

DEEPER YET THAN EVER, CHILD,

FOR WHAT YOU ARE GOING TO BE,

KNOWING SO WELL YOU ARE GOING FAR,

KNOWING YOUR GREAT WORKS ARE AHEAD,

AHEAD AND BEYOND,

YONDER AND FAR OVER YET."

CARL SANDBURG

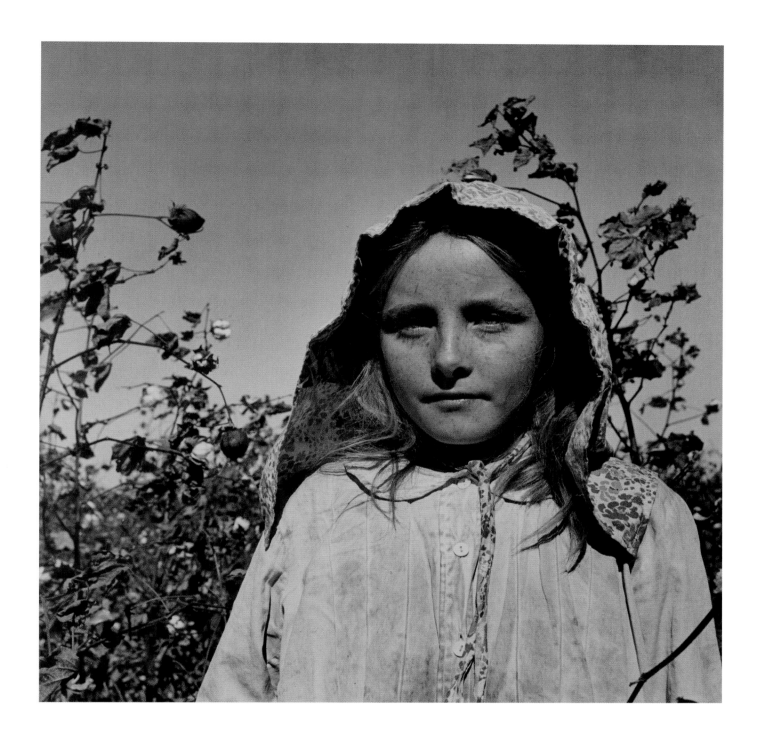

Jack Delano
Daughter of Mr. Buck Grant, preacher
and FSA borrower, near Union Point,
Greene County, Georgia. June, 1941.

Dorothea Lange
Elizabeth. Cotton child. Casa Grande,
Arizona. 1940.

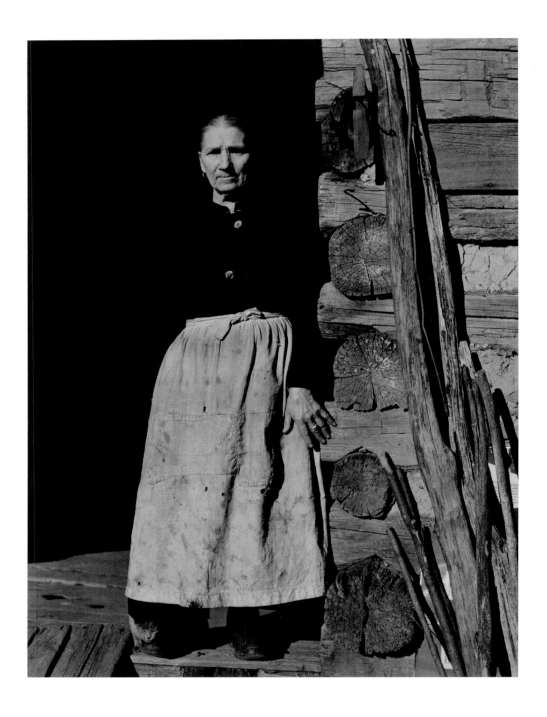

Arthur Rothstein
Minnie Knox, widow living with her daughter on
a farm, Garrett County, Maryland. December, 1937.

Dorothea Lange
Ma Burnham, an "Arkansas Hoosier" born in 1855,
Conway, Arkansas. June, 1938.

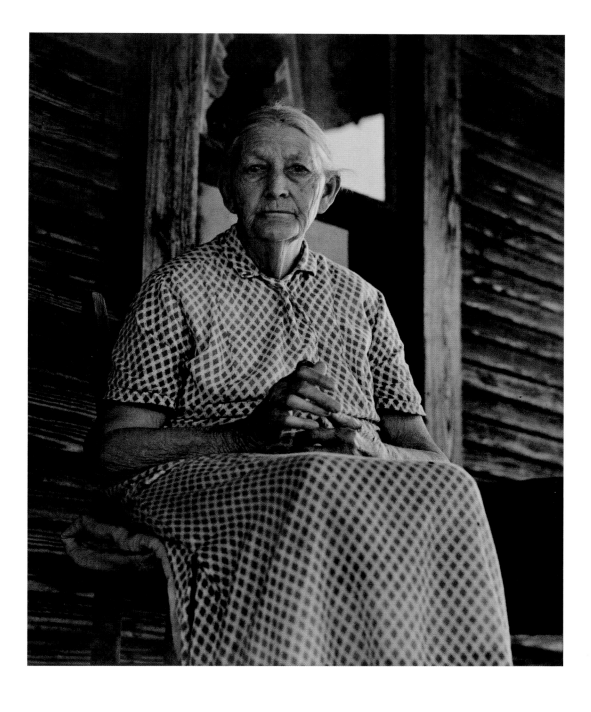

"MY FATHER WAS A CONFEDERATE SOLDIER. HE GIVE HIS AGE A YEAR OLDER THAN WHAT IT WAS TO GET INTO THE ARMY. AFTER THE WAR HE BOUGHT 280 ACRES FROM THE RAILROAD AND CLEARED IT. WE NEVER HAD A MORTGAGE ON IT.

IN 1920 THE LAND WAS SOLD AND THE MONEY DEVIDED. NOW NONE OF THE CHILDREN OWN THEIR LAND. IT'S ALL DONE GONE, BUT IT RAISED A FAMILY. I'VE DONE MY DUTY – I FEEL LIKE I HAVE. I'VE RAISED 12 CHILDREN - 6 DEAD, 6 ALIVE, AND 2 ORPHANS...

THEN ALL OWNED THEIR FARMS. THE LAND WAS GOOD AND THERE WAS FREE RANGE. WE MADE ALL WE ATE AND WORE. WE HAD A LOOM AND WHEEL. THE OLD SETTLERS HAD THE CREAM. NOW THIS HILL LAND HAS WASHED. AND WE DON'T GET ANYTHING FOR WHAT WE SELL. WE HAD TWO TEAMS WHEN THIS DEPRESSION HIT US. WE SOLD ONE TEAM – WE HAD TO TO GET BY – AND WE SOLD FOUR COWS.

IN 1935 WE GOT ONLY 50 AND 60 CENTS A HUNDRED POUNDS FOR PICKING, AND IN 1936 ONLY 60 AND 75 CENTS, AND WE HOE FOR 75 CENTS A DAY. THEN THE GOVERNMENT REDUCED THE ACREAGE AND WHERE THERE WAS ENOUGH FOR TWO BIG FAMILIES NOW THERE'S JUST ONE. SOME OF THE LANDOWNERS WOULD RATHER WORK THE COTTON LAND THEMSELVES AND GET ALL THE GOVERNMENT MONEY. SO THEY CUT DOWN TO WHAT THEY CAN WORK THEMSELVES, AND THE FARMING PEOPLE ARE RENTED OUT. THEY GO TO TOWN ON RELIEF – IT'S A 'HAVE TO' CASE. SHARECROPPERS ARE JUST CUT OUT.

THEN THE LORD TAKEN A HAND, AND BY THE TIME HE'D TAKEN A SWIPE AT IT THERE WAS DROUGHT AND ARMY WORM. I DON'T KNOW WHETHER THAT DROUGHT WAS THE DEVIL'S WORK OR THE LORD'S WORK – IN 3 DAYS EVERYTHING WILTED.

FOLKS FROM THIS PART HAS LEFT FOR CALIFORNIA IN JUST THE LAST YEAR OR SO. MY TWO GRANDSONS – THEY WERE RENTERS HERE AND NO MORE – WENT TO CALIFORNIA TO HUNT WORK. THOSE WHO HAVE GONE FROM HERE...

IF YOU SEE MY GRANDSONS IN CALIFORNIA TELL 'EM YOU MET UP WITH MA BURNHAM OF CONWAY, ARKANSAS."

MA BURNHAM, JUNE 28, 1938

NOTES

Of Power and Politics: Steichen at MoMA Ariane Pollet

1 "Natural Pathos, Harald Szeemann (1933–2005)," *Parkett*, no. 73, 2005, p. 175.

2 John Szarkowski took up his post in July 1962 and relinquished it in July 1991.

3 According to a press report dated October 15, 1962, "The photographs were selected by Edward Steichen, Director Emeritus of the Museum's Department of Photography, from 270,000 taken for the FSA to record the plight of the farm population during the Great Depression. Davis Pratt was in charge of the picture research. The installation was designed by Kathleen Haven."

4 On his arrival, Steichen took over the curatorship of a retrospective entitled "Alfred Stieglitz Exhibition: His Photographs, His Collection" (a two-part exhibition, from June 10 to September 21, 1947). The first exhibition he organized in his own right was entitled "Three Young Photographers" (September 30 to December 7, 1947) and showed the work of Leonard McCombe, Wayne Miller, and Homer Page.

5 René d'Harnoncourt, letter to Edward Steichen, November 14, 1962 (MoMA Archives, Monroe Wheeler Papers, New York).

6 *Edward Steichen, A Life in Photography*. New York: Bonanza Books, 1985, ch. 13, "The Museum of Modern Art and *The Family of Man*," n.p.: "When I took over the job as director of photography at The Museum of Modern Art, I decided I could not do a satisfactorily objective job if I were an active photographer myself. So I laid aside my own photographic work. One day when I was looking over a young photographer's work and discussing it with him, I discovered how effective my decision had been. At one point he asked me if I had ever made any photographs myself!" We might do well to be a little skeptical about this story, since it is told by Steichen himself and may just be part of some private mythology.

7 With regard to the 291 period, see *Modern Art and America: Alfred Stieglitz and His New York Galleries*, ed. Sarah Greenough. Washington, D.C.: National Gallery of Art, 2000; and more specifically Anne McCauley, "Edward Steichen: Artist, Impresario, Friend," in ibid.; Hélène Seckel, "Alfred Stieglitz et la Photo-Sécession: 291 Fifth Avenue, New York," *Paris-New York*. Paris: Centre Georges Pompidou; Philadelphia: Philadelphia Museum of Art, 1977.

8 See *Edward Steichen: Selected Texts and Bibliography*, ed. Ronald Gedrim. Oxford: Clio Press, 1996; *Modern Art and America*, ed. Sarah Greenough; *The New Vision: Photography Between the World Wars. Ford Motor Company Collection at the Metropolitan Museum of Art*, ed. Maria Morris Hambourg and Christopher Phillips. New York: The Metropolitan Museum of Art, 1994; Patricia Johnston, *Real Fantasies: Edward Steichen's Advertising Photography*. Berkeley: University of California Press, 2000.

9 See Christopher Phillips, "Steichen's Road to Victory," *Exposure*, vol. 18, no. 2, 1981; Christopher Phillips, "The Judgement Seat of Photography," *October*, no. 2, autumn 1982; Mary Anne Staniszewski, *The Power of Display: A History of Exhibition Installations at the Museum of Modern Art*. Cambridge, MA: MIT Press, 1998; Olivier Lugon, "La photographie mise en espace. Les expositions didactiques allemandes (1922–1945)," *Études photographiques*, no. 5, November 1998; Olivier Lugon, "Des cheminements de pensée. La gestion de la circulation dans les expositions didactiques," *Art Press*, special number "Oublier l'exposition," October 2000; Olivier Lugon, "Kodakoration, photographie et scénographie d'exposition autour de 1900," *Études photographiques*, no. 16, May 2005.

10 Herbert Bayer, "Aspects of Design of Exhibitions and Museums," *Curator*, vol. 4, no. 3, 1961, pp. 257–8.

11 Since it was founded in 1929, MoMA had been using the most innovative PR methods. Numerous publicity campaigns to attract the attention of the public were accompanied by regular mentions in the newspapers. MoMA was also the first museum to use radio broadcasting for publicity and information purposes. In 1931, the museum employed a public-relations agency, and from 1933 this job was entrusted to a full-time publicity director.

Russell Lynes, *Good Old Modern: An Intimate Portrait of the Museum of Modern Art*. New York: Atheneum, 1973, pp. 126–35.

12 "War Comes to the People: History Written with the Lens by Thérèse Bonney" ran from December 11, 1940 to January 5, 1941. Curated by the American photographer and photojournalist Thérèse Bonney, the exhibition showed 206 of Bonney's photographs of Finnish victims prior to, during, and following the conflict between Russia and Finland during World War II.

13 "Sixty Photographs: A Survey of Camera Esthetics" ran from December 31, 1940 to January 12, 1941 and showed works by Berenice Abbott, Ansel Adams, Eugène Atget, Mathew B. Brady, Walker Evans, Dr. Arnold Genthe, D. O. Hill, Man Ray, Charles Sheeler, Edward Steichen, Alfred Stieglitz, Paul Strand, Edward Weston, and Clarence White.

14 Curated by Beaumont Newhall, "Seven American Photographers" showed fifty-one works and ran from May 10 to September 30, 1939.

15 Of the thirty-four exhibitions organized by the department between 1940 and 1945, the eight that fell into this particular category were "War Comes to the People," 1940; "Britain at War," 1941; "Two Years of War in England," 1942; "Road to Victory," 1942; "Tunisian Triumph," 1943; "Pacific Report," 1944; "Manzaanar," 1945; and "Power in the Pacific," 1945. Two of these were curated by Edward Steichen.

16 Serge Ricard, *The Mass Media in America since 1945*. Paris: Armand Colin, 1998, p. 22: "Interestingly, the media (including Hollywood and other cultural industries) on the whole proved remarkably respectful of the general public for whom they were broadly catering, irrespective of age, ethnicity, religion or ideology (a form of political correctness before its time)..."

17 Edward Steichen, "My Life in Photography," *The Saturday Review*, March 28, 1959, p. 18.

18 William M. Milliken (Director of the Cleveland Museum of Art), "The Museum as a Community Center," *Art in America*, vol. 34, no. 4, 1946, p. 221.

19 See Serge Guibault, *Comment New York vola l'idée d'art moderne*, ed. Jacqueline Chambon. Nîmes: Hachette, 1988; Christopher Grunenberg, "The Politics of Presentation: The Museum of Modern Art," in *Art Apart: Art Institutions and Ideology across England and North America*, ed. Marcia Pointon. Manchester and New York: Manchester University Press, 1994.

20 Located at 9 West 54th Street, the Photography Center housed a collection of two thousand photographs and served as a place of research and a meeting point for photographers.

21 Benjamin Buchloh, *Essais historiques I*. Villeurbanne: Art Édition, 1992, p. 7.

22 Staniszewski, *The Power of Display*, p. 110.

23 "Road to Victory," 1942; "Power in the Pacific," 1945; "Three Young Photographers," 1947; "In and Out of Photography: A Survey of Today's Photography," 1948; "The Exact Instant: Events and Faces in 100 Years of News Photography," 1949; "Six Women Photographers," 1949; "Color Photography," 1950; "Korea: The Impact of War in Photographs," 1951; "Memorable Life Photographs," 1951; the "Diogenes With a Camera" series (five exhibitions), 1952–61; "Post-War European Photography," 1953; "The Family of Man," 1955; "Harry Callahan and Robert Frank," 1962; "The Bitter Years 1935–1941," 1962. Current political tensions, the use of color, and the approach of a new breed of photographer – the photojournalist – provided Steichen with a range of thematic possibilities.

24 Phillips, "Steichen's Road to Victory," p. 39.

25 Interview for *Holiday Magazine*, October 27, 1955 (Steichen Collection, MoMA Archives, New York). Transcript of the interview, pp. 35–6.

26 "The whole thing has to have the impact of a single great photograph that gains through being part of a combined image," Steichen once said, "but it also has to read as a complete statement." Quoted by Rita Sylvan and Avis Berman, "Edward Steichen, a Memoir: The Making of *The Family of Man*," *Connoisseur*, vol. 218, no. 913, 1988, p. 124.

27 The magazine publisher Time Inc., co-founded by Henry Luce in 1923, developed the idea of the photo essay in order to give greater credibility to the content of a type of publication still relatively unfamiliar to its readers. The acknowledged aim of these essays was to enquire into subjects of a serious and socially committed nature, and also to popularize a certain vision

of America. They were to prove an ideal medium for ideological propaganda.

28 Steichen, *A Life in Photography*, ch. 13, "The Museum of Modern Art and *The Family of Man*," n.p.

29 See note 5 above.

30 It was not until the Magnum agency was created in 1947 that the names of reporters began to appear alongside their photographs. But it was only with the creation of press agencies, in the 1970s, that their position really improved – to the point where today merely reading a reporter's name can bring a particular image to mind.

31 The figures mentioned in the abundant correspondence with photographers, between 1950 and 1960, never exceed five to ten dollars per print – the same amount that Alfred Stieglitz paid Steichen for his very first prints in 1900.

32 Steichen, *A Life in Photography*, ch. 13, "The Museum of Modern Art and *The Family of Man*," n.p.

33 Phillips, "Steichen's Road to Victory," pp. 45-6.

Testimony or Instrument of Propaganda: What is the Role of Photography? Gabriel Bauret

1 "The FSA Collection of Photographs," in Roy E. Stryker and Nancy Wood, *In This Proud Land: America 1935–1943 As Seen in the FSA Photographs*. New York: Galahad Books, 1973.

2 Remarks made in Edward Steichen, "The FSA Photographers," *U.S. Camera Annual 1939*, New York: William Morrow, 1938, p. 45. Also quoted by Grace Mayer in *The Bitter Years, 1935–1941: Rural America as Seen by the Photographers of the Farm Security Administration*. New York: Museum of Modern Art, 1962, p. vi.

3 "I made five exposures, working closer and closer from the same direction," (Dorothea Lange) quoted by Nancy Wood, "Portrait of Stryker," in Stryker and Wood, *In This Proud Land*, p. 19.

4 Stryker and Wood, *In This Proud Land*, p.13.

5 Grace Mayer, who helped Edward Steichen to organize "The Bitter Years," refers in the catalog to the talent of Dorothea Lange and Walker Evans and the fact that they were included along with seventeen other photographers in a reference work entitled *Masters of Photography* (New York: Braziller), published in 1956. The book was written by Beaumont Newhall, Steichen's predecessor as head of the photography department at MoMA.

6 "Car cette subjectivité, si caractéristique de certaines photographies de la FSA, n'enlève rien à leur fonction d'observation, bien au contraire. On pourrait même prétendre que Roy E. Stryker, en laissant aux photographes une très grande liberté de manœuvre, en n'exigeant d'eux rien de définitivement programmé, avait compris l'intérêt de conserver intacte leur faculté d'apprécier individuellement les situations auxquelles ils étaient confrontés." Gilles Mora, "L'Esthétique documentaire de la FSA : Entre regard et vision," in Gilles Mora and Beverly W. Brannan, *Les Photographes de la FSA, Archives d'une Amérique en Crise*. Paris: Editions du Seuil, 2006, p. 262.

7 New York: St. Martin's Press, 1976.

8 Steichen's epigraph for the exhibition catalogue for "The Bitter Years" is a call for remembrance: "I believe it is good at this time to be reminded of those 'Bitter Years' and to bring them into the consciousness of a new generation which has problems of its own, but is largely unaware of the endurance and fortitude that made the emergence from the Great Depression one of America's victorious hours." *The Bitter Years, 1935–1941*, p. iii.

9 "Our editors, I'm afraid, have come to believe that the photograph is an end in itself. They've forgotten that the photograph is only the subsidiary, the little brother, of the word." Stryker in Stryker and Wood, *In This Proud Land*, p. 8.

10 "Il fallait attendre l'arrivée au sein de la FSA d'Ed Rosskam en 1939 pour que celui-ci définisse une politique éditoriale claire (publications et expositions). Elle permettait aux photographes engagés par Stryker de mieux savoir à quel usage était destinée leur production, tout en les écartant des décisions prises […]." Mora, "L'Esthétique documentaire de la FSA: Entre regard et vision," in Mora and Brannan, *Les Photographes de la FSA*, p. 258.

11 Remark made in 1969, on the occasion of his ninetieth birthday. Originally in

Edward Steichen, *The Family of Man*, New York: Museum of Modern Art, 1955, p. 3. "The exhibition […] demonstrates that the art of photography is a dynamic process of giving form to ideas and of explaining man to man."

12 Stryker, *In This Proud Land*, pp. 8-9.

13 Ansel Adams quoted by Stryker and Wood, *In This Proud Land*, p. 8.

14 Wood, "Portrait of Stryker," in Stryker and Wood, *In This Proud Land*, p. 8.

15 Jean Dieuzaide, "Les années amères de l'Amérique en crise. 1935-1942." Galerie municipale du Château d'Eau, Toulouse, 1980.

16 Susan Sontag, *On Photography*. New York: Farrar, Straus, and Giroux, 1977, p. 62.

17 *Walker Evans at Work*. London: Thames & Hudson, 1982, p. 112.

18 Michael Brix "L'œuvre photographique de Walker Evans entre 1928 et 1938. Un combat contre le bon sens et l'optimisme," in Birgit Mayer, *Walker Evans. L'Amérique : Photos des années de la Dépression*. Munich and Paris: Schirmer/Mosel, 1990, p. 26.

19 Steichen, "The FSA Photographers," in *U.S. Camera Annual 1939*, p. 45.

20 Russell Lee in *U.S. Camera One*, 1941, quoted by Mora in Mora and Brannan, *Les Photographes de la FSA*, p. 259.

21 As quoted by Milton Meltzer. Dorothea Lange refers to the Francis Bacon quotation as a guideline for her work. She had it pinned on her darkroom door. Milton Meltzer, *Dorothea Lange: A Photographer's Life*. Syracuse, NY: Syracuse University Press, 1999, p. 286.

22 Dorothea Lange, *Photographs of a Lifetime*. New York: Aperture, 1982, p. 127.

23 Steichen, "The FSA Photographers," in *U.S. Camera Annual 1939*, p. 45.

24 Ibid.

25 *Arbeiter-Illustrierte-Zeitung*, 1931.

26 "[She] thought that my pictures might help her, and so she helped me." Dorothea Lange, quoted in Stryker and Wood, *In This Proud Land*, p. 19.

"A Very Living Document of Our Age": Constructing and Deconstructing the FSA Archive Miles Orvell

1 In February of 1962 – "The Bitter Years" would open in October of the same year – Steichen presented a lecture that emphasized the esthetics of photography, called "Toward Abstraction," which explored the way photographers incorporated formal elements into a medium that was inherently realistic. Steichen discussed, among others, Ernst Haas, Wynn Bullock, and Harry Callahan, including black-and-white and color slides as examples. His continuing interest in abstraction makes it all the more significant that he would mount a major exhibition on social documentary photography in his last year at MoMA. "Edward Steichen to Lecture at Museum of Modern Art," Press Release, MoMA Archives. http://www.moma.org/docs/press_archives/2955/releases/MOMA_1962_0014_14.pdf?2010. Accessed January 11, 2012.

2 Edward Steichen, "The FSA Photographers," *U.S. Camera Annual 1939*, reprinted in *Photography: Essays and Images*, ed. Beaumont Newhall. New York: Museum of Modern Art, 1980, pp. 268-9. On the interactions between the FSA and *U.S. Camera*, see Cara A. Finnegan, *Picturing Poverty: Print Culture and FSA Photographs*. Washington, D.C.: Smithsonian Press, 2003, pp. 132-45.

3 Roy Emerson Stryker, "The FSA Collection of Photographs," in *In This Proud Land: America 1935-1943 As Seen in the FSA Photographs* by Roy E. Stryker and Nancy Wood. New York: Galahad Books, 1973, p. 9.

4 Ibid., p. 7.

5 On Stryker's evolving sense of purpose in his FSA years, see Michael Lesy, *Long Time Coming: A Photographic Portrait of America, 1935-1943*. New York and London: W. W. Norton, 2002, p. 115.

6 Roy E. Stryker, "Documentary Photography," in *The Complete Photographer*, ed. Willard Morgan. New York: National Educational Alliance, 1942-3, p. 1,365.

7 It is not clear whether Brady might have known of Roger Fenton's photographs of the Crimean War ten years earlier.

8 The FSA photographers were well aware of Hine's example, and Stryker tried to promote the exhibition of his work during the 1930s, by which time Stryker probably felt the photographer was too old to work for the FSA.

9 Walker Evans, "The Reappearance of Photography," *Hound and Horn* 5 (October–November 1931), p. 128.

10 See Alan Trachtenberg, "From Image to Story: Reading the File," in *Documenting America, 1935–1943*, ed. Carl Fleischhauer and Beverly W. Brannan. Berkeley: University of California Press, 1988, p. 60.

11 Charles Cross, *A Picture of America: The Photostory of America – as It Is – and as It Might Be, Told by the News Camera*. New York: Simon and Schuster, 1932.

12 Agnes Rogers and Frederick Lewis Allen, eds, *Metropolis: An American City in Photographs*. New York: Harper & Brothers, 1934, Preface.

13 Published as part of "Arts Beat," *New York Times*, April 23, 2010, by Blake Wilson, in "'The Show-Book of the World': Henry Luce's *Life* Magazine Prospectus." http://www.scribd.com/doc/30411545/Life-Magazine-Prospectus. Accessed January 12, 2012.

14 From "Selected Shooting Scripts," Stryker, *In This Proud Land*, p. 187.

15 For more on Vachon, see Miles Orvell, *John Vachon's America: Photographs and Letters from the Depression to World War II*. Berkeley: University of California Press, 2003, pp. 3–36.

16 Vachon, "Standards of the Documentary File," in Orvell, *John Vachon's America*, p. 283.

17 Ibid., p. 284.

18 Ibid., p. 285.

19 Ibid., p. 285.

20 "Appendix: The FSA-OWI Collection," in *Documenting America*, p. 331. Fleischhauer and Brannan estimate that 70 percent of the FSA-OWI collection, or about 77,000 prints, were produced under Stryker's direction. Many more pictures – about an equal number – were taken but did not find their way into the file.

21 "Appendix," pp. 332–3.

22 Trachtenberg, "From Image to Story," p. 52.

23 Paul Vanderbilt, "Computations for a Viewfinder," *Afterimage* (September 1976), p. 12; quoted in Trachtenberg, "From Image to Story," p. 52.

24 I am grateful to Barbara Orbach Natanson, Head, Reference Section, Prints and Photographs Division, Library of Congress, for providing information on the digitizing of the Collection at the Library. E-mail to author, January 11, 2012.

25 An ongoing project at Yale University, *Photogrammar Beta*, initiated by graduate students Lauren Tilton and Arnold Taylor, has created an online database of the FSA photographs, retrievable by county using a map of the U.S. as starting point. See http://euler.stat.yale.edu/~tba3/fsa/index.html

26 On the relationship between history, fact, and the photographic archive, see Allan Sekula, who argues that the archive as an institutional structure is never innocent and always subject to the power of narrative authority. Sekula, "Reading an Archive: Photography Between Labour and Capital," in *The Photography Reader*, ed. Liz Wells. New York and London: Routledge, 2003, pp. 443–52.

27 Archibald MacLeish, *Land of the Free*, 1938. New York: Da Capo Press, 1977, p. 89.

28 Dorothea Lange and Paul Schuster Taylor, *An American Exodus: A Record of Human Erosion*. New York: Reynal and Hitchcock, 1939. Lange and Taylor were explicitly countering, in the structure and approach of their work, the more sensationalistic depiction of Southern poverty in Erskine Caldwell and Margaret Bourke-White's *You Have Seen Their Faces*, a work that garnered much attention and praise when it came out in 1936 but that was held in suspicion by the FSA group. Bourke-White was, at the time she made the trip to the South, one of the most highly paid professional photographers, but was never a member of the FSA team.

29 Sherwood Anderson, *Home Town*, with photographs by the Farm Security Photographers, ed. Edwin Rosskam. New York: Alliance Book Corporation, 1940, p. 144.

30 Richard Wright, *12 Million Black Voices*, photo direction by Edwin Rosskam, 1941. New York: Thunder's Mouth Press, 1988. For a discussion of Wright's book, and the muting of individual experience in favor of a more generalized "folk" history, see Nicholas Natanson, *The Black Image in the New Deal: The Politics of FSA Photography*. Knoxville: University of Tennessee Press, 1992, pp. 245–55.

31 Trachtenberg, "From Image to Story," p. 64.

32 Edward Steichen, Foreword, *The Bitter Years, 1935–1941*. New York: Museum of Modern Art, 1962, p. iii.

33 In 1986, HarperCollins brought out *A Day in the Life of America*, edited by Rick Smolan and David Cohen, which featured the work of two hundred photographers all trying to capture "America" visually on May 2, 1986. The resulting project, sequenced as a single day, from dawn to night, has a hit-or-miss quality. More recently, the Wattis Institute for Contemporary Arts (California College of the Arts) commissioned a group of contemporary photographers to document the U.S. in 2011, mounting their work alongside images from the FSA archive that inspired the project. See "More American Photographs," CCA Wattis Institute for Contemporary Arts, http://www.wattis.org/exhibitions/more-american-photographs. Accessed January 15, 2012.

34 Roy E. Stryker and Nancy Wood, *In This Proud Land: America 1935–1943 As Seen in the FSA Photographs*. New York: Galahad Books, 1973.

35 Ibid., p. 7.

36 Ibid., p. 184.

37 Hank O'Neal, *A Vision Shared: A Classic Portrait of America and Its People, 1935–1943*. New York: St. Martin's Press, 1976.

38 Gilles Mora and Beverly W. Brannan, *FSA: The American Vision*. New York: Harry N. Abrams, 2006.

39 Stu Cohen and Peter Bacon Hales, *The Likes of Us: Photography and the Farm Security Administration*. Boston: David R. Godine, 2008.

40 Michael Lesy, *Long Time Coming: A Photographic Portrait of America, 1935–1943*. New York: W. W. Norton, 2002. The urban images produced by John Vachon are likewise featured in *John Vachon's America*, edited by Miles Orvell.

41 Paul Hendrickson, *Bound for Glory: America in Color, 1939–1943*. New York: Harry N. Abrams, 2004. Sally Stein first brought the FSA color work to the surface in her 1979 article, "FSA Color: The Forgotten Document," *Modern Photography* (January 1979), pp. 90–9, 162–4, 166.

42 William E. Jones, *"Killed": Rejected Images of the Farm Security Administration*. New York: PPP Editions, 2010. I am indebted to Dimitra Ermeidou for calling my attention to this volume. Nancy Wood observes, in the Stryker volume *In This Proud Land*, that "The discrepancy between the 70,000 file pictures and the 170,000 negatives is accountable for the most part to duplication of subject material. Of the 270,000 photographs actually taken during the project's lifetime, Stryker killed – by punching holes in the negatives – about 100,000" (p. 17). Wood's deadpan observation of Stryker's remarkable practice starts and stops with these sentences.

43 Jones, "Perversion," in *"Killed": Rejected Images of the Farm Security Administration*, n.p.

44 Dimitra Ermeidou, *The Stryker Bullet Series*, 2011. Work in progress, Tyler School of Art.

The Château d'Eau: A Water Tower as Cultural Reservoir
Antoinette Lorang

1 For the history of Dudelange and the Dudelange steelworks, see *Dudelange, l'usine centenaire 1882–1982*. Luxembourg: Arbed S.A., 1982; Jean-Pierre Conrardy, Robert Krantz, *Dudelange. Passé et présent d'une ville industrielle*, vol. 1: *Bourg agricole – Ville moderne*. Luxembourg: Editpress, 1991; Ady Christoffel and Claude Kugeler, *Dudelange/Düdelingen, 'Mémoire en Images/Die Reihe Archivbilder'* series. Oostakker: Uitgeverij Tempus, 2004.

2 Marcel Lorenzini, "Renaissance d'un quartier. La 'Petite Italie' à Dudelange," in *Centenaire Diddeleng 1907–2007*. Luxembourg: Éditions Ville de Dudelange, 2007, pp. 68–77; Christian Kandzia, *'Klein-Italien' in Luxemburg, ein Kulturdenkmal von europäischem Rang (La 'Petite Italie' au Luxembourg, un patrimoine de rang européen)*. Dudelange: Centre de Documentation sur les Migrations Humaines, 2001.

3 Thank you to Edouard Back and Victor Kolb for information about the water tower.

4 *Centenaire Diddeleng 1907–2007*. Luxembourg: Éditions Ville de Dudelange, 2007.

FURTHER READING

Agee, James, and Walker Evans, *Let Us Now Praise Famous Men: Three Tenant Families*. Boston: Houghton Mifflin, 1941 (1st edition) and 2001

Back, Jean, and Viktoria Schmidt-Linsenhoff, *The Family of Man 1955-2001: Humanismus und Postmoderne: Eine Revision von Edward Steichens Fotoausstellung/Humanism and Postmodernism: A Reappraisal of the Photo Exhibition by Edward Steichen*. Marburg: Jonas Verlag, 2004

Brandow, Todd, and William A. Ewing, *Edward Steichen: Lives in Photography*. New York: W. W. Norton; London: Thames & Hudson, 2007

Cohen, Stu, and Peter Bacon Hales, *The Likes of Us: Photography and the Farm Security Administration*. Boston: David R. Godine, 2008

Coles, Robert, *Doing Documentary Work*. New York: Oxford University Press, 1997

Coles, Robert, and Dorothea Lange, *Dorothea Lange: Photographs of a Lifetime*. New York: Aperture, 1982 (1st edition) and 2005

Crump, James, *Walker Evans: Decade by Decade*. Hatje Cantz, 2010

'Fields of Vision' series, photographs by individual photographers from the Farm Security Administration collection. Washington, D.C., and London: D. Giles Limited in association with the Library of Congress (from 2008)

Finnegan, Cara A., *Picturing Poverty: Print Culture and FSA Photographs*. Washington, D.C.: Smithsonian Press, 2003

Fleischhauer, Carl, Beverly W. Brannan, Lawrence W. Levine, and Alan Trachtenberg, *Documenting America, 1935-1943*. Berkeley: University of California Press in association with the Library of Congress, 1988

Hariman, Robert, and John Louis Lucaites, *No Caption Needed: Iconic Photographs, Public Culture, and Liberal Democracy*. Chicago: University of Chicago Press, 2011

Hendrickson, Paul, *Bound for Glory: America in Color, 1939-43*. New York: Harry N. Abrams in association with the Library of Congress; London: Thames & Hudson, 2004

Hoffmann, Jens, and Blake Stimson, *More American Photographs*. San Francisco: CCA Wattis Institute for Contemporary Arts, 2012

Hurley, F. Jack, *Portrait of a Decade. Roy Stryker and the Development of Documentary Photography in the Thirties*. Baton Rouge: Louisiana State University Press, 1972

Lee, Russell, J. B. Colson, and Linda Peterson, *Russell Lee Photographs: Images from the Russell Lee Photograph Collection at the Center for American History*. Austin, Texas: University of Texas Press, 2007

Lesy, Michael, *Long Time Coming: A Photographic Portrait of America, 1935-1943*. New York: W. W. Norton, 2002

Lugon, Olivier, *Le Style documentaire. D'August Sander à Walker Evans, 1920-1945*. Paris: Macula, 2001

Maharidge, Dale, and Michael Williamson, *And Their Children After Them: The Legacy of* Let Us Now Praise Famous Men. James Agee, Walker Evans, and the Rise and Fall of Cotton in the South. New York: Pantheon Books, 1989 (1st edition); New York: Seven Stories Press, 2008

Mora, Gilles, and Beverly W. Brannan, *FSA: The American Vision*. New York: Harry N. Abrams, 2006

Ribalta, Jorge, *Public Photographic Spaces: Exhibitions of Propaganda, from Pressa to The Family of Man, 1928-55*. Barcelona: Museu d'Art Contemporani de Barcelona, 2008

Sandeen, Eric J., *Picturing an Exhibition: The Family of Man and 1950s America*. Albuquerque: University of New Mexico Press, 1995 (1st edition) and 2010

Spirn, Anne Whiston, *Daring to Look: Dorothea Lange's Photographs and Reports from the Field*. Chicago: University of Chicago Press, 2008

Staniszewski, Mary Anne, *The Power of Display: A History of Exhibition Installations at the Museum of Modern Art*. Cambridge, MA: MIT Press, 1998

Steichen, Edward, "The F.S.A. Photographers," in *U.S. Camera Annual 1939*, ed. T. J. Maloney. New York: William Morrow, 1938

—, *A Life in Photography*. Garden City, NY: Doubleday, 1963

Stimson, Blake, *The Pivot of the World: Photography and Its Nation*. Cambridge, MA: MIT Press, 2006

Stryker, Roy Emerson, and Nancy Wood, *In This Proud Land: America 1935-1943 As Seen in the FSA Photographs*. New York: Galahad Books, 1973; London: Secker & Warburg, 1974

Terkel, Studs, *Hard Times: An Oral History of the Great Depression*. New York: Pantheon Books, 1970 (1st edition); New York: The New Press, 2005

Vachon, John, and Miles Orvell, *John Vachon's America: Photographs and Letters from the Depression to World War II*. Berkeley: University of California Press, 2003

PICTURE CREDITS

The majority of the images in this book are located in the Library of Congress, Prints & Photographs Division, FSA/OWI Collection. In the list below, the call numbers of photographs from that collection are mostly listed under the name of the respective photographer and by the page number on which the image appears.

a=above, b=below, l=left, r=right

pp.9 and 13 Courtesy of the Estate of Edward Steichen. Copyright Photo Scala, Florence.
p.11 Courtesy of Homer Page. Copyright Photo Scala, Florence.
p.17 Library of Congress, Prints & Photographs Division, FSA/OWI Collection, LC-USF34-026345-D.
p.18 *U.S. Camera Annual 1939*, William Morrow, New York, 1938.
p.21 Library of Congress, Prints & Photographs Division, FSA/OWI Collection, LC-N47 3 [P&P].
p.22 Angus McDougall, Courtesy of International Harvester Co.
p.25 Library of Congress, Prints & Photographs Division, FSA/OWI Collection, LC-USW3-019968-E [P&P].
p.28 Copyright Rheinisches Bildarchiv. Arkadi Shaikhet, rba_c022388. Collection Museum Ludwig, Cologne.
p.32 Library of Congress, Prints & Photographs Division, FSA/OWI Collection, BIOG FILE-Stryker, Roy [item] [P&P].
p.35 Library of Congress, Prints & Photographs Division, FSA/OWI Collection, LC-USF34-9058-C.
p.42 Archives de la Ville de Dudelange – Fonds Jean-Pierre Conrardy.
p.47 photo Romain Girtgen. Copyright CNA.

Paul Carter: p.129 LC-USF341-002841-B [P&P].

Jack Delano: p.67 LC-USF34-044763-D [P&P], p.84(l) LC-USF34-044593-D [P&P], p.84(r) LC-USF34-046508-D [P&P], p.110 LC-USF34-043556-D [P&P], p.111 LC-USF34-043568-D [P&P], p.123 LC-USF34-043996-D [P&P], p.127 LC-USF34-044563-D [P&P], p.224 LC-USF34-042296-D [P&P], p.225 LC-USF33-020949-M2 [P&P], p.227, LC-USF34-044273-D [P&P], p.228 LC-USF34-044273-D [P&P], p.232 LC-USF34-045320-D [P&P], p.264 LC-USF34-046226-D [P&P], p.267 LC-USF34-043918-D [P&P], p.270 LC-USF34-042816-D [P&P], p.271 LC-USF346-045615-D [P&P], p.276 LC-USF34-044571-D [P&P].

Walker Evans: p.29 LC-USF342-001295-A [P&P], p.36 LC-USF33-031322-M5, p.80 LC-USF33-009217-M3 [P&P], p.97 LC-USF342-008137-A [P&P], p.98 LC-USF342-008141-A [P&P], p.99 LC-USF342-008143-A [P&P], p.101 LC-USF342-008147-A [P&P], p.102 LC-USF342-008145-A [P&P], p.103 LC-USF342-008127-A [P&P], p.108 LC-USF342-008144-A [P&P], p.109 LC-USF342-008156-A [P&P], p.118 LC-USF33-031294-M2 [P&P], p.125 LC-USF33-031296-M3 [P&P], p.126 LC-USF342-008133 [P&P], p.138 LC-USF342-008138-A [P&P], p.140 LC-USF342-008139-A [P&P], p.141 LC-USF342-008140-A [P&P].

Theodor Jung: p.128 LC-USF33-004048-M5 [P&P], p.269 LC-USF33-004051-M4 [P&P].

Dorothea Lange: pp.2–3 LC-USF34-018667-C [P&P], p.6 LC-USF34-002392-E [P&P], p.7 LC-USF34-009599-C [P&P], p.54 © The Dorothea Lange Collection, Oakland Museum of California, City of Oakland. Gift of Paul S. Taylor, p.56 LC-USF34-001638-E [P&P], p.57 LC-USF34-002328-C [P&P], p.68 LC-USF34-018607-C [P&P], p.70 LC-USF34-002812-E [P&P], p.77 © The Dorothea Lange Collection, Oakland Museum of California, City of Oakland. Gift of Paul S. Taylor, p.83 LC-USF34-017753-E [P&P], p.85 LC-USF34-009884-E [P&P], p.86 LC-USF34-017464-E [P&P], p.88 LC-USF33-011674-M1 [P&P], p.89 LC-USF34-009328-C [P&P], p.92 LC-USF34-018392 [P&P], p.94 LC-USF34-009599-C [P&P], p.107 LC-USF34-017081-C [P&P], p.130 LC-USF34-016980-E [P&P], p.131LC-USF34-017269-C [P&P], p.142 LC-USF34-017327-C [P&P], p.149 LC-USF34-018281-C [P&P], p.150 LC-USF34-017128-C [P&P], p.157 LC-USF34-016453-E [P&P], p.158 LC-USF34-021823-E [P&P], p.159(a) LC-USF34-002461-E [P&P], p.159(b) LC-USF34-016418-C [P&P], p.167 LC-USF34-009740-C [P&P], p.168 LC-USF34-018227-C [P&P], p.170 LC-USF34-016318-E [P&P], p.171 LC-USF346-018271-C [P&P], p.173 LC-USF34-016912-E [P&P], p.174 LC-USF34-016102-C [P&P], p.175 LC-USF34-017790-E [P&P], p.176 LC-USF34-018789-E [P&P], p.177 LC-USF34-018801-E [P&P], p.179 LC-USF34-001618-C [P&P], p.180 LC-USF34-020985-E [P&P], p.181 LC-USF34-019185-E [P&P], p.183 LC-USF34-016317-E [P&P], p.185 LC-USF34-016213-C [P&P], p.188 LC-USF34-019978-E [P&P], p.189 LC-USF34-020960-E [P&P], p.190 LC-USF34-018660-C [P&P], p.192 LC-USF34-018304-E [P&P], p.195 LC-USF34-016230-B [P&P], p.197 LC-USF34-018307-E [P&P] LOT 346, p.198 LC-USF34-019479-C [P&P], p.199 LC-USF34-009098 [P&P], p.201 LC-USF34-009058-C [P&P], p.202 LC-USF34-016270-C [P&P], p.205 LC-USF34-009666-E [P&P], p.206 LC-USF34-009909-E [P&P], p.207 LC-USF34-001638-E [P&P], p.208 LC-USF34-016302-E [P&P], p.209 LC-USF34-001823-C [P&P], p.210 LC-USF34-009857-C [P&P], p.212 LC-USF34-016439-E [P&P], p.213 LC-USF34-016013-C [P&P], p.214 LC-USF33-009208-E [P&P], p.215 LC-USF34-019486-E [P&P], p.216 LC-USF34-018285-C [P&P], p.217 LC-USF34-018440-E [P&P] LOT 356, p.221 LC-USF34-009679-C [P&P], p.223 © The Dorothea Lange Collection, Oakland Museum of California, City of Oakland. Gift of Paul S. Taylor, p.226 LC-USF34-017970-C [P&P], p.229 LC-USF34-009743-C [P&P], p.234 LC-USF34-020902-D [P&P], p.235 LC-USF34-021800-C [P&P], p.237 LC-USF34-018667-C [P&P], p.240 LC-USF34-016166-C [P&P], p.241 LC-USF347-000826-D [P&P], p.243 LC-USF34-016113-E [P&P], p.244 LC-USF34-017373-C [P&P], p.247 LC-USF347-016336-C [P&P], p.248 LC-USF34-016271-C [P&P], p.251 LC-USF341-017265-C [P&P], p.254 LC-USF34-009123-C [P&P], p.255 LC-USF34-009930-C [P&P], p.257 LC-USF34-018401-E [P&P], p.259 LC-USF34-019524-C [P&P], p.266 LC-USF34-019227-C [P&P], p.272 © The Dorothea Lange Collection, Oakland Museum of California, City of Oakland. Gift of Paul S. Taylor, p.275 LC-USF34-016239-C [P&P], p. 277 © The Dorothea Lange Collection, Oakland Museum of California, City of Oakland. Gift of Paul S. Taylor, p.279 LC-USF34-018289-C [P&P].

Russell Lee: p.74 LC-USF33-006032-M3 [P&P], p.78 LC-USF34-010124-D [P&P], p.79 LC-USF34-033952-D [P&P], p.90 LC-USF33-011674-M1 [P&P], p.112 LC-USF34-031221 [P&P], p.113 LC-USF33-006174-M4 [P&P], p.117 LC-USF34-033651-D [P&P], p.120 LC-USF34-034008-D [P&P], p.121 LC-USF33-011938-M1 [P&P], p.128 LC-USF34-031000-D [P&P], p.133 LC-USF33-011442-M2 [P&P], p.134 LC-USF33-011849-M5 [P&P], p.144 LC-USF34-030459-D [P&P], p.147 LC-USF34-032230-D [P&P], p.193 LC-USF33-013063-M1 [P&P], p.203 LC-USF34-033601-D [P&P], p.218 LC-USF33-011121-M3 [P&P], p.219 LC-USF33-011121-M1 [P&P], p.231 LC-USF33-011159-M4 [P&P], p.238 LC-USF33-012785-M2 [P&P], p.260 LC-USF33-011375-M5 [P&P], p.263 LC-USF34-031938-D [P&P], p.273 LC-USF33-012244-M5 [P&P], p.273 LC-USF33-012244-M5 [P&P], p.274 LC-USF33-012022-M4 [P&P].

Edwin Locke: p.196 LC-USF34-013160-D [P&P]. In the original exhibition documents, this image was erroneously attributed to Carl Mydans..

Carl Mydans: p.53 LC-USF33-000550-M5 [P&P], p.143 LC-USF33-000528-M2 [P&P], p.187 LC-USF34-006322-D [P&P].

Arthur Rothstein: p.62 LC-USF34-004091-E [P&P], p.63 LC-USF34-004380-D [P&P], p.65 LC-USF346-025121-D [P&P], p.66 LC-USF34-005045-D [P&P], p.71 LC-USF34-004052 [P&P] LOT 1536, p.104 LC-USF34-025359-D [P&P], p.105 LC-USF33-002022-M4 [P&P], p.119 LC-USF33-002140-M4 [P&P], p.135 LC-USF34-025391-D [P&P], p.155 LC-USF33-002975-M3 [P&P], p.160 LC-USF34-025485-D [P&P], p.163 LC-USF33-002393-M2 [P&P], p.164 LC-USF33-002372-M3 [P&P], p.184 LC-USF33-002350-M3 [P&P], p.233 LC-USF33-002187-M4 [P&P], p.239 LC-USF34-029111-D [P&P], p.250 LC-USF34-024211-D [P&P], p.262 LC-USF34-025198-D [P&P], p.278 LC-USF34-026097-D [P&P].

Ben Shahn: p.39 LC-USF33-006035-M4, p.58 LC-USF33-006135-M4 [P&P], p.73 LC-USF33-006029-M1 [P&P], p.75 LC-USF33-006032-M3 [P&P], p.91 LC-USF33-006220-M4 [P&P], p.95 LC-USF33-006029-M3 [P&P], p.113 LC-USF33-011609-M5 [P&P], p.114 LC-USF33-006035-M4 [P&P], p.116 LC-USF34-033651-D [P&P], p.124 LC-USF33-006066-M3 [P&P], p.132 LC-USF33-006037-M3 [P&P], p.148 LC-USF33-006434-M5 [P&P], p.161 LC-USF33-006018-M5 [P&P], p.165 LC-USF33-006071-M4 [P&P], p.249 [P&P], p.256 LC-USF33-006121-M3 [P&P], p.265 LC-USF33-006090-M5 [P&P], p.268 LC-USF33-006034-M2 [P&P].

John Vachon: p.41 LC-USF33-001312-M3, p.60 LC-USF33-016151-M5 [P&P], p.137 LC-USF34-061054-D [P&P], p.151 LC-USF34-064630-D [P&P], p.154 LC-USF34-014006-E [P&P], p.246 LC-USF34-060517-D [P&P], p.261 LC-USF34-064805-D [P&P].

Marion Post Wolcott: p.1 LC-USF347-050720-E-A [P&P], p.59 LC-USF33-030180-M2 [P&P], p.64 LC-USF347-050720-E-A [P&P], p.81 LC-USF33-030350-M4 [P&P], p.87 LC-USF34-054481-E [P&P], p.93(a) LC-USF33-030628-M3 [P&P], p.93(b) LC-USF33-030527-M1 [P&P], p.220 LC-USF34-052102 [P&P], p.253 LC-USF34-052710-D [P&P], p.258 LC-USF34-056850-D [P&P].

ACKNOWLEDGMENTS

Jean Back

The re-creation of an industrial site and its transformation into a cultural space is a fascinating challenge. In the process, interests, collaborations and passions develop and are shared by the project team. I would like to thank profoundly the Luxembourg Minister of Culture, Madame Octavie Modert, for her kind and firm support throughout the process. I am also grateful to the previous Minister of Culture, Madame Erna Hennicot-Schoepges, who endorsed the project during her period in office. I would like to express my gratitude to Patrick Sanavia, the Director of the Service des Sites et Monuments nationaux, in whom I found a resolute and reliable partner in this extraordinary enterprise. Special thanks go to Françoise Poos, my assistant on *The Bitter Years* project, for her invaluable help, as well as to the architects Claudine Kaell and Jim Clemes, and to the whole team of collaborators from the CNA and the Service des Sites et Monuments nationaux for their advice and suggestions. I would also like to express my appreciation of my friend Gabriel Bauret, with whom I began to work in 1991 on the rebirth of "The Family of Man" and who has been a great support in my efforts to exhibit both Steichen collections ("The Family of Man" and "The Bitter Years") in Japan.

Finally, a huge thank you to Mars di Bartolomeo and Georges Calteux for their audacity, as well as cultural and patrimonial awareness, which led to the choice of the Château d'Eau for the exhibition site and to one decisive phone call.

Antoinette Lorang

My warmest thanks to Jean Back and Françoise Poos from the Centre National de l'Audiovisuel for their help with research, as well as to Edouard Back and Victor Kolb for their valuable insight into the steelworks and water tower. I am grateful to Claude Kugeler (Archives de la Ville de Dudelange) and to Christine Muller (Centre de Documentation sur les Migrations Humaines) for the use of photographic material. I would also like to express my gratitude to Christiane Wagner and Joëlle Schwinnen for reading this essay.

Ariane Pollet

I want to thank Jeff Bridgers from the Library of Congress, Washington, D.C., for his invaluable iconographic research, as well as Olivier Lugon, Professor at the University of Lausanne, for his perspicacity and generosity.

Françoise Poos

I would like to thank the whole team at Thames & Hudson for their commitment to the production of this book. Jean Back entrusted me with the coordination of this important project. I want to thank him for his confidence, and my colleagues at the CNA who readily offered their help.

INDEX

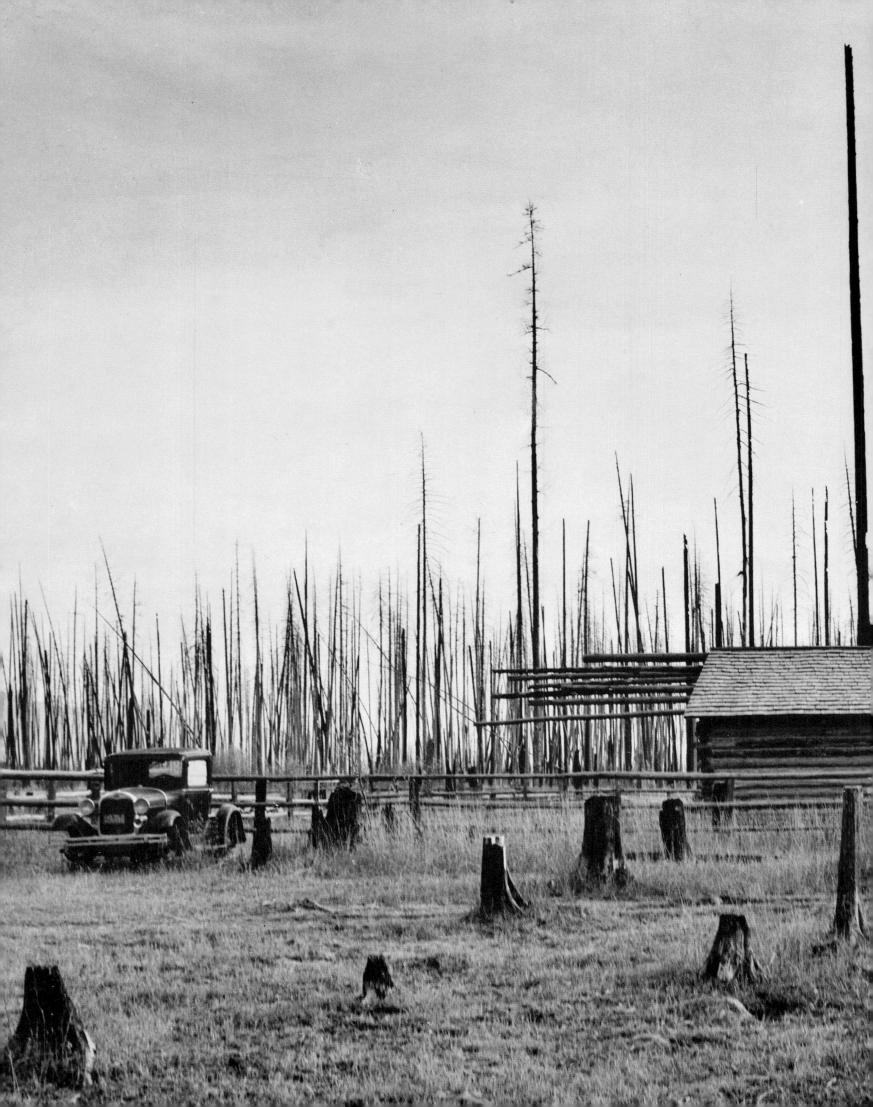